SUCCESS WITH

WILDLIFE

PHOTOGRAPHY

STEVE & ANN TOON

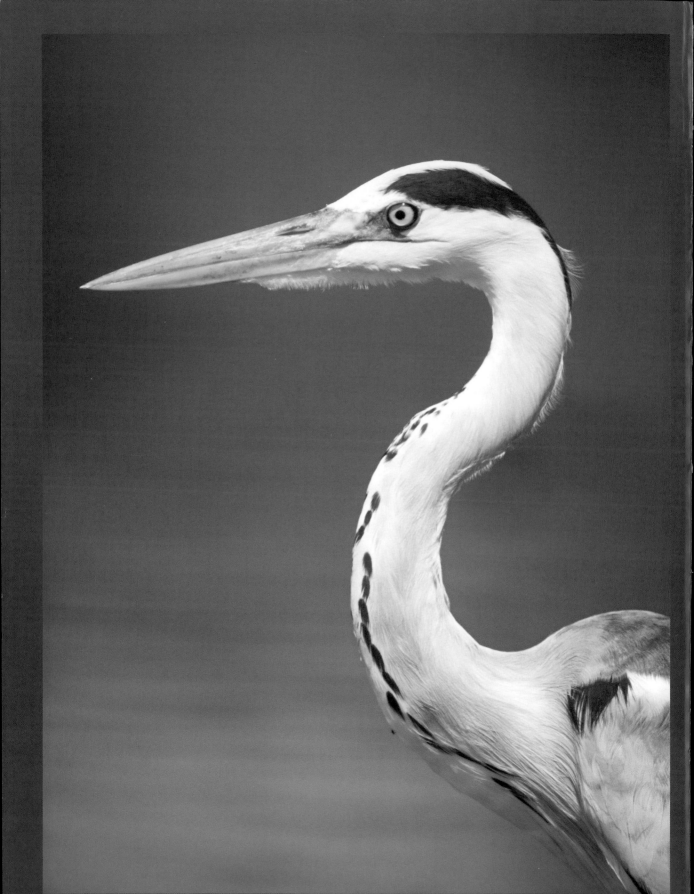

SUCCESS WITH

WILDLIFE

PHOTOGRAPHY

STEVE & ANN TOON

photographers'
pip
institute press

First published 2009 by Photographers' Institute Press
an imprint of The Guild of Master Craftsman Publications Ltd
166 High Street, Lewes, East Sussex BN7 1XU

ISBN 978-1-86108-554-2

A catalogue record of this book is available from
the British Library.

Associate Publisher: Jonathan Bailey
Production Manager: Jim Bulley
Managing Editor: Gerrie Purcell
Editor: Ailsa McWhinnie
Managing Art Editor: Gilda Pacitti
Design: Studio Ink

Colour origination: GMC Reprographics
Printed and bound: Hing Yip Printing Co. Ltd.

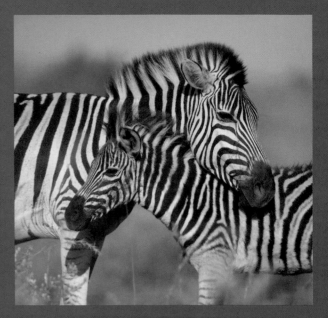

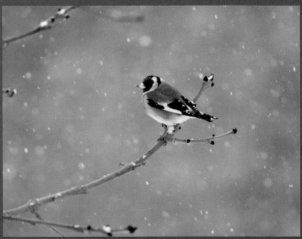

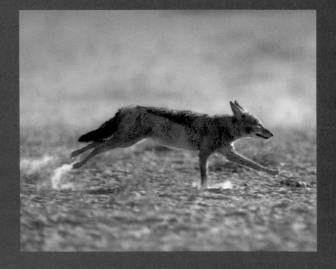

Previous page: Grey heron close-up
Canon EOS-1Ds Mk II // 500mm lens with
1.4x teleconverter // 1/640sec at f/6.3 // ISO 100

Top: Zebra with foal
Canon EOS-1Ds Mk II // 500mm lens // 1/3200sec at f/5 // ISO 200

Goldfinch in falling snow
Canon EOS-1Ds Mk II // 300mm lens with 1.4x teleconverter
// 1/400sec at f/5.6 // ISO 640

Blackbacked jackal running
Canon EOS-1Ds Mk II // 500mm lens with 1.4x teleconverter
// 1/640sec at f/7.1 // ISO 250

 CONTENTS

INTRODUCTION

There are no hidden secrets to successful wildlife photography, but there's definitely magic. The magic is what it's really all about. It's what got us interested in the first place. The magic in seeing your first wild badger, water vole, lion cubs or elephants; in waiting patiently for dark so you can hear the howl of hyenas, the shriek of an owl, the song of breeding toads, or so you can make out the flittering shadows of bats criss-crossing the twilight as your eyes adjust to the gloom. The magic in waiting quietly at dawn near a black grouse lek site, by a misty sea-loch, scanning for signs of a feeding otter, or on safari, when you don't know quite what exciting wildlife encounters (or nothing at all) that morning's drive is going to present you with.

There's magic in tailing the same pride of lions for week. There's magic too, as well as numb fingers and toes, in sitting for hours in a hide during autumn on the Solway in southwest Scotland as thousands of geese take noisily to the air just in front of you, or in a cliff-top blind in a South African winter with vultures and Verreaux eagles wheeling around at eye level. There's magic in shadowing researchers as they track rare marsupials through ancient woodland on the opposite side of the world, or in riding out on elephant back to approach within metres of an armour-plated Indian rhino with her four-week-old calf. There's magic in accompanying an elite team of bush-rangers capturing rare and truculent black rhino for translocation, or going out with field researchers at the real-life Meerkat Manor, collecting data at a burrow, as a family of habituated and hyperactive meerkats, plus offspring, forage at your feet. There's magic in watching a greater-spotted woodpecker or

a weasel or a family of pheasant chicks visit the back garden, or seeing butterflies and bees feeding on the nectar-producing plants on a warm, sunny day.

Quite simply, for us, wildlife photography begins and ends with the passion for wildlife and wild places. This is where we watch and learn; where we recharge our batteries, where we find our inspiration and ideas and the motivation to continue improving our photography. This is why we set the alarm for the wee small hours in summer, look forward to frost, ice and snow in winter, end up covered in guano and midge or mosquito bites, get stuck in bogs, camp in the desert when it's minus eight and colder at night, and share the highs and lows of being cooped up together in tight and often uncomfortable spots simply waiting for the picture.

In the ten years or so we've been doing this for a living we've learned, pretty much from scratch, what works and what doesn't when stalking subjects, taking pictures and finding markets for our work. And these are the experiences we've attempted to distil into this book. It's simply about the way we do things and what has worked for us.

In recent years the journey has had added magic, if you like, with the advent of digital technology. This now puts us in complete control of the whole creative process, from image capture to final output, and offers us all as wildlife photographers the intriguing potential to free up the boundaries of wildlife photography in the coming years in a unique and exciting way.

→ **Young elephant, Addo, South Africa**
Canon EOS-1Ds Mk II // 500mm lens // 1/320sec at f/8 // ISO 320
It's magical moments such as this intimate encounter with an elephant calf, not yet quite in control of its trunk, that fuel our passion for wildlife photography

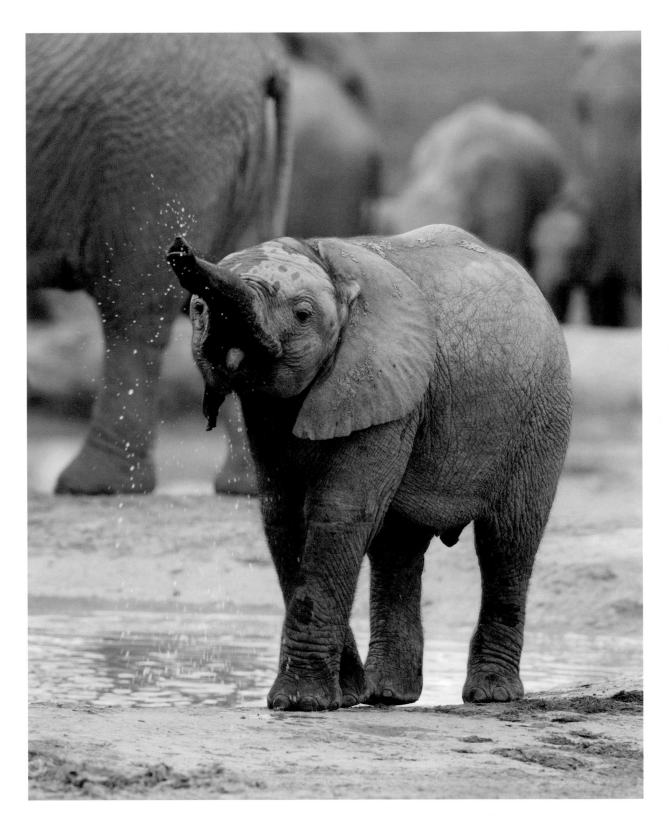

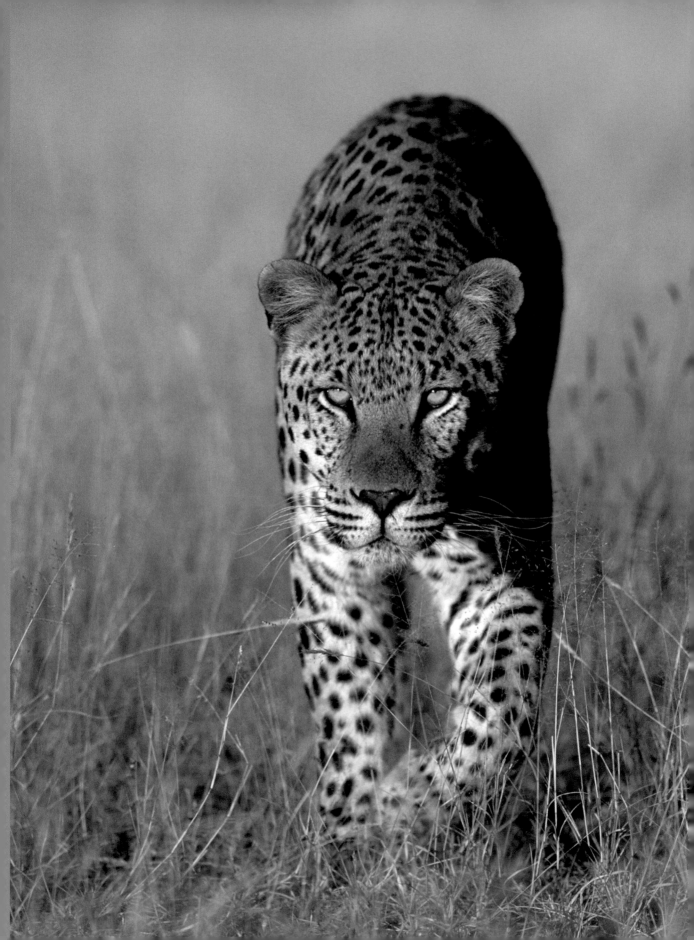

CHAPTER

01.

EQUIPMENT FOR THE WILDLIFE PHOTOGRAPHER

Leopard stalking, Namibia
Canon EOS-1N // 300mm lens // 1/250sec at f/8 //
Fuji Velvia 50

When you're faced with a good photo opportunity you
need confidence in your equipment. That confidence
comes partly from investing in the best kit you can
afford, but also from familiarity with your camera.
There really isn't time to consult the manual when
a leopard is stalking you!

THE CAMERA

Good equipment won't guarantee you good wildlife images, but it certainly helps. There's a bewildering array of kit available, and it doesn't come cheap, so it makes sense to think carefully about what you really need, gradually adding to your system as your specific wildlife interests develop. The good news is that even the entry-level cameras produced by the leading manufacturers are now so technically advanced they can produce high-quality images.

For many years the 35mm SLR format was the system of choice for wildlife photography. Today the overwhelming majority of serious wildlife photographers have switched to digital cameras. Most of these are recognizably based on the traditional SLR design, and will accept the lenses used on their 35mm film camera cousins, though the majority of consumer models have sensors smaller than the 35mm format. In this book we're assuming the majority of readers are using DSLRs, but many of the techniques we discuss can equally be applied to film.

It's often said of film camera systems that you should spend your money on good-quality lenses and film, and not worry too much about the camera. Image quality depends largely on the optical quality of the lens, on film speed and grain structure and on the quality of processing. This is a little simplistic, as camera characteristics – such as accurate exposure metering – are also important in achieving technically strong images, but it does serve to emphasize the importance of top-quality glass.

With digital cameras it's a little more complicated. Of course, the quality of your lens is still very important, but properties of the camera body – such as the size, resolution and manufacturing quality of its sensor and the performance of its internal processor – will also play a significant role. More expensive cameras generally produce more reliable colours, less noise in shadows and overall better image quality.

Good equipment is a good investment, so buy the best you can afford. Nikon and Canon remain the brand leaders for wildlife photography, with excellent cameras and a huge array of lenses and accessories, but you'll find some excellent cameras from other leading marques.

← **Steenbok, Karoo, South Africa**
Canon EOS-1Ds Mk II // 500mm lens // 1/400sec at f/6.3 // ISO 100

As photographers who sell our work, we need professional-quality equipment to ensure we deliver the best possible images. But spending time on location also costs money, so we have to strike a balance between investing in gear and investing in travel. Any new piece of kit has to be able to justify its cost.

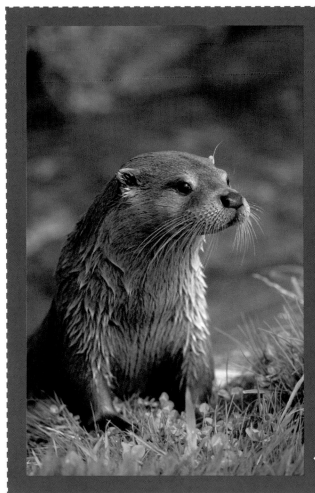

CAPTIVE WILDLIFE

We use a 500mm f/4 Image Stabilization lens frequently but, for several years after we first turned professional, we could afford nothing longer than a 400mm f/5.6 lens without Image Stabilization. We made up for our limited equipment by spending a lot of time in the field, and we didn't turn our noses up at occasionally photographing captive wildlife, such as at this otter centre.

The point is that success in wildlife photography isn't just about owning the latest whizz-bang camera and kit. Even if your budget is limited, you can still achieve excellent results with a little imagination and a lot of perseverance.

←Otter, captive, UK
Canon EOS-1N // 400mm lens // 1/250sec at f/8 // Fuji Velvia 50

PRO TIP

Treat the rapturous reviews that invariably greet a new model DSLR with a pinch of salt. It sometimes takes a few weeks of use by working photographers to reveal bugs in the camera. Prices are also at their highest when cameras are first released. Unless you want to pay through the nose for the privilege of being a guinea pig for a new camera's faults, wait a couple of months and check independent websites for user feedback before investing in the latest model.

PRO TIP

With camera manufacturers constantly bringing out new models, and plenty of photographers eager to trade up to the latest cutting edge equipment, there are plenty of used cameras on the market. However, digital cameras contain a lot of sophisticated electronics, which means plenty of scope for things to go wrong, so we'd recommend buying from a reputable dealer who offers a decent guarantee. Pro-quality lenses hold their value well, so there's less scope to make savings buying second hand.

FILM OR DIGITAL?

Digital technology has taken wildlife photography by storm, to the extent that there are few wildlife enthusiasts and almost no professionals still using film routinely. Digital SLR technology has advanced to the point where arguments over whether it can compete with film on image quality are now redundant.

Most commercial end-users now require images to be supplied in digital form, and many picture libraries will no longer accept transparencies. While it's possible to digitize

images from film, high-quality drum scans are very expensive, and more affordable desktop scanners simply don't compare with digital captures in terms of quality. If your goal is to supply wildlife images for commercial use, then shooting digitally is almost mandatory.

The ability to review shots as you take them, rather than wait days for film to be processed, is a great asset, especially if an obliging subject then allows you to have another go, putting right any errors in exposure, composition, etc. The flexibility of being able to increase sensor sensitivity (ISO) for individual shots is also very useful, and the superb low-light performance of the latest digital models means we can photograph in conditions where, with film, we would have packed up and gone home.

Film always seemed to run out at a critical moment, meaning we lost shots while reloading. Large-capacity memory cards allow us to carry on shooting for several hundred frames before having to switch to a second card.

Don't, however, be taken in by the argument that digital photography is cheaper. You may not have the ongoing cost of film and processing, but set-up costs (computer hardware and software) can be considerable, printing consumables (ink and paper) are expensive, and there are other ongoing costs in image storage and keeping software up to date.

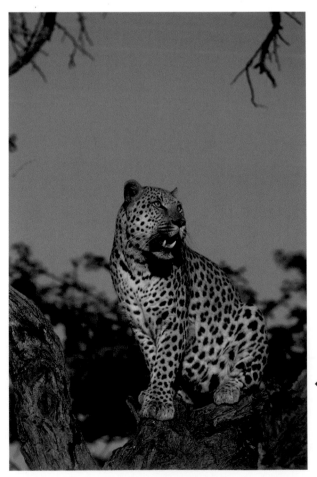

← **Leopard in tree, Namibia**
Canon EOS-1N // 300mm lens // 1/1,250sec at f/8 // Fuji Velvia 50

Fuji Velvia's rich, saturated colours can look stunning, but it's an unforgiving film which demands very accurate exposure. Digital photography isn't a substitute for good technique, but its flexibility and the ability to tweak exposures in processing have increased our 'keeper' rate significantly.

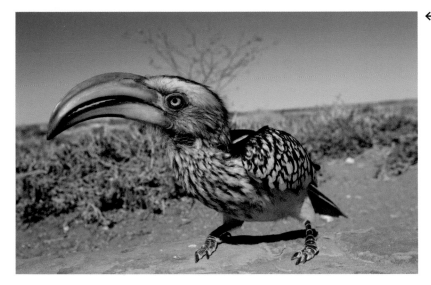

← **Southern yellowbilled hornbill, Kgalagadi, South Africa**
Canon EOS-1Ds Mk II // 17–40mm zoom lens // 1/200sec at f/1.4 // ISO 100

This image of a precocious southern yellowbilled hornbill was captured on a top-end digital SLR costing £5,000. It could just as easily have been captured on a digital compact costing no more than £100, at a quality perfectly adequate for making an A4 print. Compact cameras are capable of decent results in the right situation, such as when photographing an approachable animal in bright light.

COMPACT CAMERAS

A compact camera isn't great for wildlife photography, but that doesn't mean you can't take good wildlife photographs with one.

Compacts lack the versatility of their SLR cousins. Most significantly, you can't change lenses or use long telephotos, which rules out a lot of wildlife subjects. Don't be taken in by specifications that state impressive digital zoom capabilities. Digital zoom simply takes the central part of an image and enlarges it with software (interpolation), which will never give the same quality image as a genuine optical zoom. The largest optical zoom you are likely to find on a compact camera is equivalent to about a 300mm lens on a film SLR.

Until recently, digital compacts didn't compare well with compact film cameras, as their small sensors and relatively low megapixel counts couldn't compete with the quality of a 35mm film frame. More recent compacts are better specified, however, some with sensors of 12 megapixels or larger. Although pixel count isn't everything (trying to cram too many pixels on a very small sensor can be counterproductive), they certainly offer improved quality and make cropping images more feasible.

Most compact cameras shoot in JPEG and possibly TIFF formats, but very few allow you the considerable benefits of photographing in RAW. The simplest, cheapest compacts are highly automated, which leaves the photographer with little scope for creative control.

Compact cameras, by their nature, give a lot of depth of field in images, which makes it hard to isolate a wildlife subject from its background. But, on the plus side, they focus at very close range, which makes them good for photographing insects, small flowers and other macro subjects. Compact cameras are handy if you are photographing in an area where professional gear isn't allowed, or want a small, discreet camera for photographing wildlife reportage. And they can also be used with a scope for digiscoping.

SLRS

The SLR is the camera of choice for the serious wildlife photographer, offering a combination of intuitive handling, performance and flexibility unmatched by any other format. Sophisticated tools such as through-the-lens (TTL) exposure metering, and fast, accurate autofocus now allow even the most inexperienced wildlife photographer to achieve shots that, technically at least, would have been almost impossible a few years ago.

Camera manufacturers constantly launch new models of digital SLR, and raise the bar in terms of performance and specifications, but don't be seduced by ever-larger megapixel sensors. Larger pixel dimensions do allow you to make big prints and give you more scope to crop into images, and it's true that many picture libraries demand that supplied images be taken on a camera of at least 10 megapixels. But size isn't everything. The quality of the sensor and the

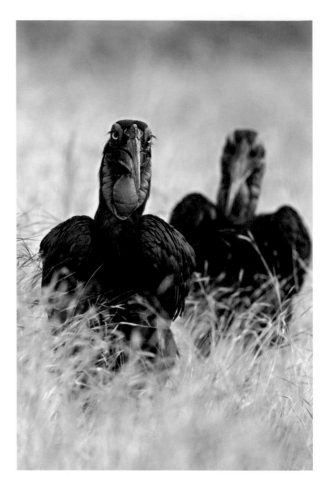

camera's internal processor are equally important in determining image quality. A good, clean, noise-free image that can be upsized by interpolation, is preferable to an image with larger pixel dimensions but poorer quality. Most current model DSLRs offer sensors of at least ten megapixels, and for most purposes that's plenty.

If you plan to photograph a lot of wildlife action, look for a camera with a high continuous shooting speed – some models boast ten frames per second. But look, too, at the maximum burst, the number of shots that the camera can take in fast succession before its internal buffer fills up and shooting has to pause while the image data is written to the card.

PRO TIP

Most consumer (and some pro) DSLRs have a sensor that is smaller than a conventional 35mm film frame. This gives the illusion of increasing the focal length of any lens attached which, on the face of it, is an advantage for wildlife photography. In reality, the smaller sensor simply captures a smaller, central part of the image that passes through the lens. The field of view is smaller, the subject fills more of the frame, but it is a smaller frame to fill. Shoot with a full-frame sensor and your subject may fill less of the frame, but you've more pixels to start with, so you can crop in if required.

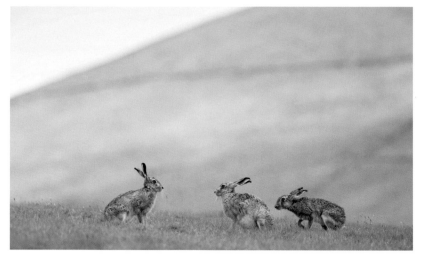

← Southern ground hornbills, Kruger National Park, South Africa
Canon EOS-1Ds Mk II // 500mm lens //
1/100sec at f/8 // ISO 250

Ground hornbills stalk through the grass in search of insects, reptiles, birds' eggs, or whatever else they can catch. They often patrol roadside verges, so the best way to photograph them is from a vehicle, keeping ahead of them and framing them as they walk towards the camera. In this situation we'll work with two or three SLRs, with lenses from 70mm to 500mm, to capture a variety of compositions and perspectives as the birds move closer.

↑ Brown hares, Lancashire, UK
Canon EOS 5D // 300mm lens with
1.4x teleconverter // 1/4000sec at
f/5.6 // ISO 800

This image was part of a photo essay about hares on a Lancashire farm. We wanted a range of pictures, from close-ups to wider shots showing the scenery. The only way to approach the nervous animals was to crawl slowly across open ground, and photograph handholding the camera. Only the SLR system's combination of lens-reach and portability allows us to work like this.

ADVANTAGES OF THE SLR

- » A wide range of interchangeable lenses
- » Lenses can be changed quickly
- » A wide range of accessories
- » Portable and relatively light
- » Camera bodies have many useful features
- » Can shoot large numbers of frames quickly
- » What-you-see-is-what-you-get viewfinder
- » Cheaper than larger format cameras
- » Easy to use
- » Easy to expand your system as your interest and budget grows

We give our cameras heavy use in some fairly inhospitable conditions, sometimes hot and dusty, sometimes cold and wet, so the rugged build and weatherproofing of professional models is important. But build quality comes at a price, and pro cameras are heavy and bulky. If your style of photography involves a lot of hiking with your kit, a lighter camera might be a better bet. Similarly, heavy cameras can be tiring to handhold for long periods, so if you are slightly built or find it hard to hold a camera steady, a lighter model may reduce problems of camera shake.

If we've invested a lot of money in a trip, we want to be able to shoot even if weather or light conditions are difficult. The latest professional DSLRs produce excellent, low-noise images at high ISO settings, which makes them a worthwhile investment, improving our productivity in the field.

Absolutely vital in an SLR camera body is full exposure control, the ability to set apertures and shutter speeds manually. So, too, is the ability to manually focus lenses, even though for 90 per cent of our work we use autofocus. A depth of field preview button, remote release facility and mirror lock-up capability are other essentials.

DIGISCOPING

Digiscoping involves taking extreme telephoto images of wildlife with a digital camera and spotting scope. It's mainly used to photograph birds, as many birdwatchers already own a scope and it's a relatively affordable way to record sightings of small birds at long range. By placing an inexpensive digital compact camera against the eyepiece of the scope you can achieve magnifications as great as 90x, much more than is possible with a DSLR and telephoto lens.

You can connect a DSLR to a scope, but this doesn't work terribly well. Although it effectively gives you a very powerful telephoto lens, the aperture is very small, which makes for impracticably slow shutter speeds and a viewfinder that's too dark for easy focusing, which is a particular problem given that depth of field is minimal.

Instead, most digiscopers use compact digital cameras. Not all digital compacts are suitable, so if you're thinking of buying one with this in mind, check a digiscoping website for advice on which of the latest models will work. You want a camera with a small diameter lens, and an optical zoom of about 3x, allowing you to zoom in to avoid vignetting from the eyepiece.

↗ **Bokmakierie, Addo, South Africa**
Canon EOS-1Ds Mk II // 500mm lens with 2x teleconverter // 1/200sec at f/8 // ISO 100

Whether you're using a digiscope set-up or, as here, a DSLR with a very long telephoto, the narrow depth of field at high magnification can make it difficult to find a small bird in the viewfinder in a hurry. One solution is to spend time observing the bird's behaviour and identify its favoured perches. Then simply pre-focus on a perch and wait for the bird to come to you.

PRO TIP

Digiscoping works best on a bright sunny day, when there's plenty of light to ensure a high shutter speed and less chance of camera shake. Bright sun may produce bleached colours and excessive contrast, but at least the images are more likely to be sharp.

Compacts with more powerful optical zooms usually have lenses that are too large in diameter. Your camera should have a decent-sized LCD screen on the back, to make focusing easier.

The biggest problem with digiscoping is avoiding camera shake. At such large magnifications, even a tiny wobble will give you a soft image. Using a sturdy tripod to support your set-up is vital, and a cable release to fire

↗ **Redbacked shrike, Pilanesberg, South Africa**
← Canon EOS-1Ds Mk II // 500mm lens with 1.4x teleconverter
// 1/100sec at f/6.3 // ISO 100

These images show a redbacked shrike captured using a DSLR with a 500mm lens and 1.4x teleconverter, and a cropped version which illustrates what could be achieved with a digiscope. The SLR set-up has a magnification of 14x, whereas anything between 30x and 90x is possible with digiscoping. However, the digiscoped image would be of poorer quality.

the shutter without having to touch the camera is a very good idea. Set your camera to aperture priority (AV or A) and select the widest possible aperture, to give the fastest available speed.

Although it's possible to simply hold the camera against the eyepiece of the scope, it's tricky to line up the two lenses, and very difficult to avoid camera shake. Much better is to use a purpose-built adaptor to fasten camera and scope together. A wide range is available; most screw onto a camera's external filter thread and then simply slide over the scope's eyepiece.

Framing the subject can be quite tricky with a digiscoping set-up, because the field of view is so limited at high magnification. Some photographers locate their subject using the scope, then attach

the camera to take the photograph. This means they can focus the scope while looking through its eyepiece, but risks the animal moving while the camera is set up. Others search for the animal with the camera already attached, but have to focus using the LCD screen on the back of the camera, which isn't so accurate.

Either way, photographing any sort of movement is difficult. Even with stationary subjects, image quality is inherently significantly poorer than pictures captured on a DSLR with a decent telephoto lens. If your main interest is making record shots of rare bird sightings, digiscoping may be for you. If you aspire to more creative wildlife photography of a wider range of subjects, you will find it very limiting.

LENSES

Lenses have a huge impact on the quality of your images. It's a waste of money investing in a camera with a top-class digital sensor, if your lens is projecting a poor-quality image onto it – it's like a glass ceiling on image quality. You get what you pay for with lenses, so invest in the best you can afford.

One of the prime advantages of the SLR system is that it supports a wide range of lenses, so much so that the choice can be a little disconcerting. If you're starting from scratch, then a couple of zooms – say, 28–105mm and 75–300mm – would be an affordable way to start out photographing general wildlife. You can then move on to specialized lenses – say, a wide-aperture telephoto for shooting animal action in low light, or a macro lens for insect close-ups – as your interests develop.

Like many professional photographers, we manage with a fairly small selection of lenses. Whether travelling by air, or hiking across rough country, carrying too much weight isn't fun, and can, in fact, be a positive discouragement to actually getting out and photographing!

The leading independent lens manufacturers offer excellent lenses at cheaper prices than the camera manufacturers, though at the very top end they aren't quite as good. Most manufacturers offer lens ranges in different price bands. The 'professional'-level lenses are optically superior, and their build quality is better – an important consideration if your gear gets hard treatment.

WE USE THE FOLLOWING RANGE OF LENSES:

17–40mm f/4 zoom

28–80mm f/2.8 zoom

80–200mm f/2.8 zoom

180mm f/3.5 macro

300mm f4 telephoto

500mm f/4 telephoto

1.4x teleconverter

2x teleconverter

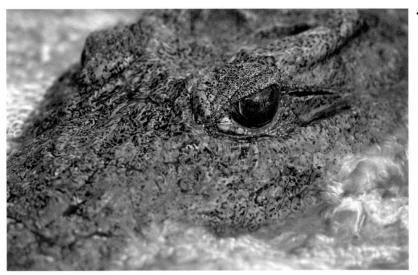

← **Nile crocodile, Kruger, South Africa**
Canon EOS 5D // 300mm lens with 1.4x teleconverter // 1/40sec at f/5.6 // ISO 100

Many dangers await the adventurous wildlife photographer, but it's kit that tends to suffer most. We've been impressed by the optical quality of lenses from manufacturers such as Sigma and Tokina, but we've also had third-party lenses which unscrewed themselves into their component parts after bumpy drives along corrugated jeep tracks. Now we only invest in Canon 'L' Series lenses, which are tough enough to hammer nails with.

WIDEANGLE LENSES

A wideangle lens might not be the first you'd think of using for wildlife photography, but they're incredibly effective at capturing striking close-ups of tame subjects, or for placing animals in a broader landscape.

The small sensors on most consumer DSLRs effectively reduce the field of view captured by that lens compared with using the same lens on a traditional 35mm format SLR. So, to obtain the same wide angle you'd get with a 24mm lens on a 35mm camera, you'd need a 16mm lens on a DSLR. Fortunately, camera and lens manufacturers have introduced a number of very short focal length lenses specially designed for small sensor DSLRs.

Bear in mind, though, that if you buy one of these specially designed ultra-wideangle lenses, it won't work with a full-frame sensor, so if you later upgrade to a top-end SLR model that has a full-frame sensor, your lens will become redundant.

We use a 17–40mm wideangle zoom lens on our digital SLRs – which do have full-frame sensors – so the field of view isn't reduced. An equivalent lens on a small sensor DSLR would be a zoom of around 10–25mm in focal length. Although this doesn't sound like a massive range, the visual effect varies considerably from moderate to extreme wideangle, making this lens a very versatile tool.

LENS TYPES

Camera lenses fall into one of three types. A standard lens reproduces an image with a very similar perspective to how it appears to the naked eye. It has a focal length approximately equal to the diagonal of the film format or digital sensor with which it is used. For a 35mm film camera (or DSLR with full-frame sensor) a 50mm lens is a standard lens. For a DSLR with a smaller sensor, a lens of 30mm or 35mm focal length is 'standard', depending on the exact sensor size. Anything with a shorter focal length is a wideangle, anything longer a telephoto.

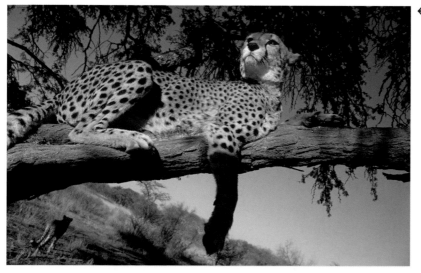

← **Cheetah, Namibia**
Canon EOS-1N // 17–40mm lens // 1/250sec at f/8 // Fuji Velvia 50

Getting this close to big cats in the wild is rare, but these were habituated animals, raised in a rehabilitation centre after their mother was killed by a Namibian farmer. It was an ideal opportunity to use a wideangle lens for an image with added impact.

STANDARD LENSES

The 50mm fixed lens that used to be supplied as standard with almost every new camera body has long been superseded by the standard zoom, often 28–80mm, sometimes up to 28–105mm. More recently still, zooms of around 18–55mm or 17–85mm offer similar functionality for small sensor DSLRs.

These lenses are often overlooked by wildlife photographers, who tend to be attracted by the frame-filling capacity of larger telephotos, or the dynamic compositions of extreme wideangles. Yet with subjects that allow a close approach, or which can be framed small in a complementary landscape, they can produce images with a perspective and field of view that is very close to how we see the world through our own eyes.

Zoom lens technology has advanced in leaps and bounds, and nowadays the image quality it's possible to obtain from a good zoom is virtually indistinguishable from a fixed focal length (prime) lens. We have no hesitation in using zooms to cover the focal length range up to 200mm. They are flexible to use, and more portable than a range of prime lenses would be. They also involve fewer lens changes than when using an array of primes, so there are fewer opportunities for dirt to enter the camera.

The low-cost standard zooms supplied as kit lenses are conveniently lightweight and small, but they usually have fairly small maximum apertures (f/3.5 or smaller) and a plasticky build quality which isn't as sturdy as it might be. If your budget allows, and you don't mind the extra weight, it's worth investing in a sturdier lens with a maximum aperture of f/2.8, which gives you better low-light capabilities.

← **Gannet on nest, Bass Rock, UK**
Canon EOS 5D // 28–80mm zoom lens // 1/1.250sec at f/10 // ISO 320

We are always wary of approaching sensitive wildlife, particularly if there's a risk of an animal abandoning its eggs or young. On Bass Rock we were accompanied by an expert guide who gave us clear advice on what was and wasn't acceptable. Signs of stress can be subtle and easily missed if you don't know what you're looking for.

TELEPHOTO LENSES

Telephotos of 300mm and longer are the workhorse lenses of many wildlife photographers. They're not cheap, but they do greatly increase the potential wildlife subjects and techniques available to you.

We use prime lenses of 300mm and 500mm, adding 1.4x and (occasionally) 2x teleconverters when we need a little extra pulling power. There are some high-quality long telephoto zooms available, which offer flexibility and relative affordability. We'd recommend avoiding zooms with very large ranges unless they are top quality, as they are heavy and have limited maximum apertures, which means they only perform well in bright light.

Telephoto lenses demand excellent technique if you are to get the best out of them. It's easy to suffer camera shake, unless you take appropriate precautions such as using a stable support, or shooting at high shutter speeds. At wide apertures depth of field is very limited, especially on close range subjects, so accurate focusing is critical.

'Fast' telephotos have wider maximum apertures, which makes them especially good in low light and for photographing wildlife action. But a 300mm f/2.8 lens is likely to cost three times the price of a 300mm f/4 lens, and is considerably heavier and bulkier to carry. It's a lot cheaper to use the f/4 lens and simply uprate the camera's ISO setting to achieve faster shutter speeds.

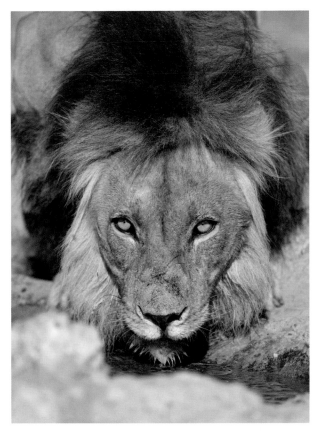

↗ **Lion drinking, Kgalagadi, South Africa**
Canon EOS-1Ds Mk II // 500mm lens // 1/1,000sec at f/5.6 // ISO 100

Long telephotos foreshorten perspective, 'flattening' the image. This isn't necessarily a bad thing, and can increase the impact of frame-filling portraits, such as this Kalahari lion slaking his thirst.

WHAT TO LOOK FOR IN A TELEPHOTO LENS

» Fast, accurate and quiet autofocus.

» Internal focus mechanism (external parts don't rotate): faster, focuses closer and is easier to use on a beanbag.

» Reasonable close focus capability: useful for creative close-up photography.

» Revolving tripod collar: allows you to quickly rotate from landscape to portrait format when shooting with a tripod.

» As wide a maximum aperture as you can afford, but balanced against size, weight and portability.

» Shake reduction technology.

SPECIALIST LENSES

Macro lenses

Macro lenses focus at very close range with minimal distortion. They are ideal for close-up photography of insects and flowers, but also function as high-quality lenses for subjects at longer range.

Macro lenses are generally available in fixed focal lengths between 35mm and 200mm. Their design means they are heavier and larger than corresponding non-macro lenses. A short macro lens, while portable, has to be used very close to your subject. A focal length of 180mm or 200mm (or 100mm for a small sensor DSLR) gives you a greater working distance, making you less likely to disturb your subject, and doubles as a useful telephoto portrait lens, but is heavy to carry and support. A macro lens of about 100mm (60mm for small sensor DSLR) is a good compromise. If you choose a longer lens, make sure it has a rotating tripod collar.

There are cheaper alternatives for close-up work. These include magnifying filters, which screw onto the front of a normal lens, and extension tubes – hollow cylinders which fit between lens and camera body to allow closer focus. These reduce the amount of light reaching the sensor, but are a handy accessory when you can't carry much gear.

Extension tubes

Faster telephotos can be used with 1.4x and 2x teleconverters ('extenders') to increase their magnification. A 300mm plus 2x converter is a much cheaper option than a 600mm lens. We use 1.4x converters a lot, but try to avoid using the 2x unless absolutely necessary, as it does soften the image a little. Teleconverters magnify the subject without increasing the minimum close focus distance of a lens, so can also be useful for photographing small subjects at close range.

A 1.4x converter knocks one stop off the maximum aperture of a lens so, for example, an f/4 becomes an f/5.6 lens. With a 2x converter you lose two stops, so the f/4 becomes an f/8 lens. Many cameras need a maximum aperture of at least f/5.6 for autofocus to function, so be aware that using a converter may mean you lose autofocus capability.

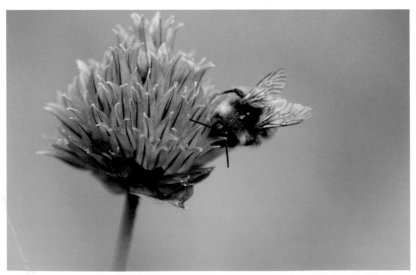

← Bumble bee on chive flower, UK
Canon EOS-1Ds Mk II // 180mm macro lens // 1/1250sec at f/5.6 // ISO 500

A macro lens isn't a cheap investment, but it opens up a world of photographic opportunities, including wildlife on your doorstep.

Lens technology

Autofocus comes as standard with modern lenses and is a massive boon for wildlife photographers, especially predictive continuous autofocus, which is excellent for fast action shots of running mammals or flying birds. Autofocus tends to be fastest and most accurate on the faster telephotos, as their wider apertures allow through more light.

A growing number of Canon and Nikon lenses feature shake reduction technology. Canon's is called Image Stabilization or IS, Nikon's is Vibration Reduction or VR. These work by detecting lens movement and then moving a floating lens with small motors to compensate. Shake reduction dramatically reduces the problem of camera shake at slow to medium shutter speeds. It's possible to obtain sharp images with a handheld 300mm f/4 lens at shutter speeds as low as 1/60sec or even slower. The downside is that these lenses are heavier and more expensive, but it's money well spent. Some other manufacturers, such as Pentax and Olympus, incorporate shake reduction technology into the camera rather than individual lenses.

PRO TIP

Autofocus is great, but don't become hooked on it. There are times when it's easier to focus manually, for example, when an animal is partially obscured behind grass or leaves, or when light levels are low and the subject doesn't have a lot of contrast. Cameras rely on contrasty edges to autofocus, so even an elephant might be a struggle for them in flat light! Manual focus can also be better for wideangle shots and landscapes, when it can be easier than fiddling with off-centre focus points, and it is pretty much mandatory for macro work.

More expensive lenses feature optical elements manufactured using advanced glass technologies, often described in impenetrable jargon – fluorite, low-dispersion, diffractive optical glass, APO, ED, UD and so on. These improve image contrast and reduce problems such as ghosting, flare and chromatic aberration. If you are still in doubt, spend a bit of time looking up independent lens reviews on the internet.

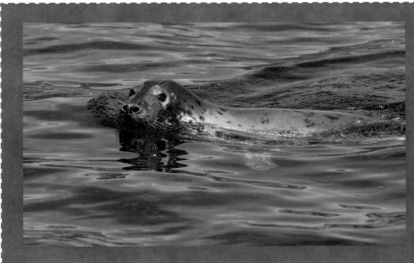

IMAGE STABILIZATION

This grey seal was photographed from a crowded tourist boat on a pleasure cruise to the Farne Islands. Ocean swell and engine vibrations make photographing from small boats tricky, but an Image Stabilization lens is a huge help, dramatically reducing the risk of camera shake.

← **Grey seal, Farne Islands, UK**
Canon EOS-1Ds Mk II // 300mm with 1.4x teleconverter // 1/500sec at f/9 // ISO 250

FILTERS

Filters alter the colour or quality of light that is transmitted to the digital sensor or film. They are usually made of glass or plastic and are placed over the front of the lens, but large telephotos have a slot in the barrel into which drop-in filters can be inserted.

We tend to the view that placing a relatively cheap piece of glass in front of an expensive lens doesn't make much sense, and don't use them very often. Digital photographers can, in any case, now replicate the effects of many filters in postproduction, with a lot more control.

Polarizing filters

The one type of filter we do still use occasionally is a circular polarizing filter. This consists of two glass elements, the degree of polarization being controlled by rotating the front element. A polarizer can be effective in bright light, reducing glare and reflections from water and green vegetation, beefing up a blue sky, and making white clouds stand out in striking contrast. These effects can be time-consuming to reproduce on computer.

A polarizer can reduce the amount of light entering the lens by anything up to two stops, but as we're usually using one to photograph a wide view, rather than fast action, the slower shutter speed isn't generally a problem. If you use a polarizer on a lens with a barrel that rotates as you focus, be sure to focus first, then adjust the filter to give the desired effect. On very wideangle lenses, excessive polarization can lead to vignetting.

Warming filters

A warm-up filter can add a subtle orange-brown tint to an image photographed on an overcast day, add a little oomph to a sunset, or counteract

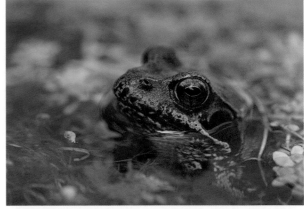

↗ Without polarizer

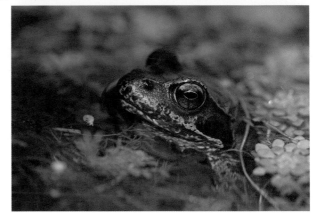

↗ With polarizer

the overly white light of a flash. Warm-ups are available in different strengths, from 81A, the weakest, to 81C, which is too strong for natural-looking results. However, this is definitely one type of filter that can be applied with far greater control on the computer, and has, for us at least, become a redundant tool in the field.

↗ **Common frog, UK**
Canon EOS-1Ds Mk II // 180mm macro lens // 1/160sec at f/6.3 (without polarizing filter) // 1/60sec at f/6.3 (with polarizing filter) // ISO 100

These two images of a common frog show how a polarizing filter can be used to reduce the reflective sheen of water (and wet skin), and deepen the colours. In this case, using the filter was at a cost of more than one stop in light, but the slower shutter speed didn't matter for the static subject.

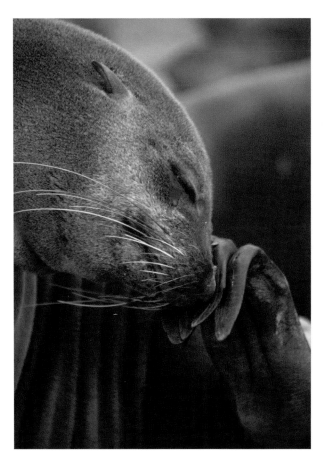 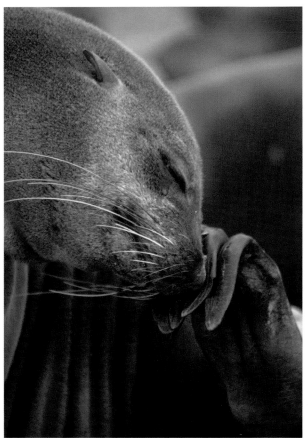

Neutral-density filters

Graduated neutral-density filters are popular with landscape photographers, in situations where it's impossible to expose correctly for the land and a bright sky. The filter is two or three stops darker in the top half, so balances the brightness of land and sky. These filters are quite fiddly to use, so only really lend themselves to use in wildlife habitat and scenic shots. Again, their effect can be reproduced using various digital manipulation techniques, though these are a little more involved than digitally warming-up an image.

Ungraduated neutral-density filters reduce the amount of illumination across the whole frame. These can be used in bright conditions if you want to set a slow shutter speed to blur an animal's movement. On a sunny day, setting a low ISO (100 or 50) on a DSLR isn't always enough to produce a shutter speed of 1/30sec or slower. However, we rarely shoot motion blur shots in sunny conditions, preferring softer, low-contrast light.

↑ **Cape fur seal, Cape Cross, Namibia**
Canon EOS-1N // 300mm lens // 1/200sec at f/8 // Fuji Velvia 50

We photographed this cape fur seal on a typically foggy day at Namibia's Cape Cross breeding colony, and the image had a cool blue cast. Applying a little 81A warming filter in Photoshop made the image more appealing and marketable.

TRIPODS AND OTHER SUPPORTS

An instant way to improve your wildlife photography and increase your proportion of pin-sharp 'keepers' is to make sure your camera is well supported whenever possible.

A good-quality tripod is an invaluable piece of kit, a bad one is an accident waiting to happen. Make sure that any tripod (and tripod head) you buy is designed to carry the weight of your largest camera and lens combination. Big, heavy tripods are the most stable, but are liable to be left at home if they are too cumbersome to carry. Carbon-fibre tripods are much lighter and more portable than aluminium, but come at a hefty price. Even a carbon-fibre model needs to be chunky and robust.

Keep your tripod clean, especially after using it on mud or sand, which can clog up the leg joints. If you photograph in cold weather with an aluminium tripod, insulated leg wraps (available tailor made, or improvise using pipe insulation) will make it a lot more pleasant to handle, and also cushion your shoulder when carrying.

Tripod heads

There are various types of tripod head available to attach your camera to your tripod and allow it free movement. Old-style pan and tilt heads are adequate for smaller lenses, but a little fiddly to use. For large telephoto lenses, fluid or video heads offer extra stability thanks to internal dampening, but are expensive. Ball and socket heads are popular with wildlife photographers, but work best with smaller lenses; with large lenses it can be tricky striking the balance between stability and freedom of movement.

Gimbal heads, such as those manufactured by Wimberley, Dietmar Nill and Kirk, are excellent for supporting large, heavy telephoto lenses. They make it easy to pivot the lens in horizontal and vertical planes with no effort, and are ideal for panning on moving subjects such as flying birds. They don't work well with smaller telephotos, as it's difficult to balance the set-up. A good compromise is the Wimberley Sidekick, a cut-down version of the Wimberley head, which attaches to a ball head. For smaller lenses you can remove the Sidekick and just use the ball head.

Quick-release devices make switching between lenses easy and fast, especially if you keep a quick-release plate permanently attached to the tripod mount of each lens.

Monopods

Monopods are useful when space is at a premium, such as when photographing from the back of an open game vehicle, or when stalking through thick bush. They offer much less support than a tripod, but save your arms from fatigue when holding a camera to your eye for long periods.

WHAT TO LOOK FOR IN A TRIPOD

» Robust and heavy enough to be stable, but balance this with portability.

» Tall enough to use without extending the centre column. Better still, no centre column.

» Ability to splay individual legs at different angles, more flexible for working on uneven ground.

» Ability to work at very low level.

» A good make: Gitzo and Manfrotto are built to last.

Beanbags

Beanbags are essential kit, excellent for working from vehicles, in hides, for impromptu support on rocks, fence posts or walls, and for photographing at ground level. You can buy purpose-made ones, or do as we do and sew sections from the legs of old pairs of jeans. We fill ours with rice (uncooked!). Sand is too heavy, dried beans are too fluid, and polystyrene beads too light and fluid.

Window mounts

A variety of window-clamped mounts and brackets is available for working from a vehicle. They allow a tripod head to be attached, which makes panning with large telephotos a lot easier than when using beanbags.

↘ **Curlew, Upper Teesdale, UK**
Canon EOS-1Ds Mk II // 500mm lens with 1.4x teleconverter // 1/640sec at f/6.3 // ISO 160

On spring days or summer evenings, a slow cruise along a quiet moorland road can produce some excellent bird photography opportunities. Beanbags are perfect for supporting a large telephoto lens on a vehicle's window sill.

↘ **Barn owl, captive, UK**
Canon EOS-1Ds Mk II // 300mm lens // 1/500sec at f/7.1 // ISO 100

Working with falconry birds isn't as satisfying as photographing truly wild subjects, but it does give us the opportunity to make close-up portraits without unduly stressing the subject. In such controlled situations there's no excuse not to use a tripod.

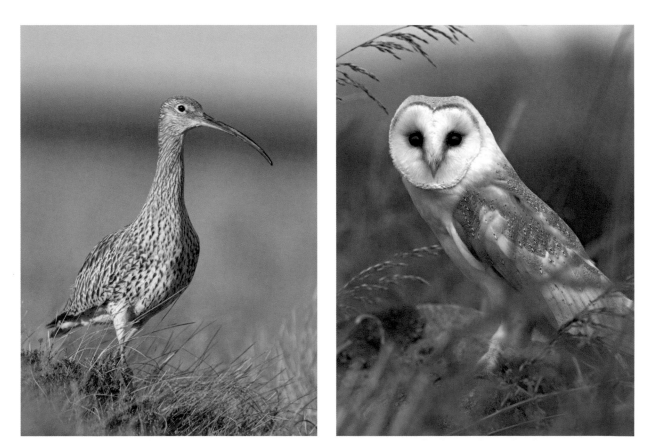

ACCESSORIES

Memory cards

Compact Flash (CF), Secure Digital (SD) and Secure Digital High Capacity (SDHC) are the most widely used card formats in digital SLRs, and are available in high capacities capable of holding hundreds of images in RAW format, or thousands of JPEGS. Size isn't the only factor to consider when buying cards – write speed (the speed at which data is transferred from the camera's internal memory buffer to the card) is important. If you photograph a lot of wildlife action, a fast write speed means the camera is less likely to lock up when you fire a rapid burst of shots.

Downloaders

High capacity memory cards are now so cheap that it's affordable to have sufficient for even a busy day's shoot. But if you're away from home for longer, then a pocket-sized portable hard drive is great for dumping images on to.

Even if you travel with a laptop, it's risky to store all your images in only one place, so a downloader is a worthwhile back-up. The most basic are simply hard drives with a slot for inserting a memory card and basic operating controls. More sophisticated models from manufacturers such as Epson and Jobo have small screens for reviewing images, allowing you to delete obvious mistakes (though they are not good enough to judge critical sharpness). We save all our images to two downloaders, so if one fails we're covered. An alternative is a portable CD or DVD burner with a card slot, but these are more fragile, slower and require you to carry blank CDs or DVDs.

Film

If you're still using film, then you probably already have your favourite emulsions. Our advice is to stick with leading brands such as Fuji and Kodak, and use the lowest ISO you can get away with, to minimize film grain. We were devotees of Fuji Velvia 50, with its very fine grain and saturated colours, or Fuji Sensia 100 or 200 when we needed more speed.

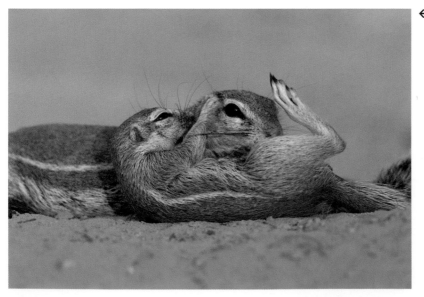

← Ground squirrel grooming baby, Kgalagadi, South Africa
Canon EOS-1Ds Mk II // 300mm lens with 1.4x teleconverter // 1/200sec at f/8 // ISO 320

Getting sand into the moving parts of your lens, or inside the camera body, are real dangers when photographing at low level on sandy ground. In these situations we try to avoid using zooms, which have more rotating components, never change lenses at ground level and never place the camera directly on the ground. A good clean with a soft brush immediately afterwards is essential.

Batteries

DSLRs consume battery power at a fearsome rate, especially when used with large autofocus lenses and in cold weather. Most DSLRs come with rechargeable batteries. It's well worth carrying a fully charged spare (in a warm pocket in cold weather). Be wary of cheap third-party rechargeables, which often don't hold their charge so well. An inverter, which allows you to run your battery charger off a vehicle's cigarette lighter, is useful if you're travelling to wilderness areas with limited or no power supply. Don't rely on buying batteries in developing countries, they tend to be unreliable.

Cable release

An electronic cable release that plugs into a dedicated port on your DSLR allows you to fire the shutter without touching the camera. It's a very useful gadget for reducing camera shake, and some wildlife photographers use one for almost every picture. We tend to use them for shutter speeds of 1/30sec or slower.

Cleaning kit

We use a soft blusher brush or paintbrush to gently remove dust from camera bodies and lenses, and a microfibre cloth to clean fingerprints off optics. Dust on the sensor is the bane of a wildlife photographer's life. Many newer DSLRs have internal sensor cleaning systems, which do reduce the dust problem, but a periodic manual clean is hard to avoid. Following the camera manufacturers' advice to send your camera in to them for cleaning is expensive, takes your camera out of action, and in our experience is no guarantee of good results. If you're prepared to grasp the nettle of cleaning the sensor yourself there are various systems available,

including brushes, swabs and special cleaning fluid. We use swabs. Some photographers also use blowers, but this can simply redistribute dust. On no account use compressed air, which can damage the shutter and spray liquid onto the sensor.

USEFUL EXTRAS

» Leatherman tool or Swiss Army penknife

» Jeweller's screwdrivers

» Small torch

» Notebook and pencil

» Superglue

» Bin bags for leaning on wet ground or protecting gear from rain

» Small foam kneeling mat

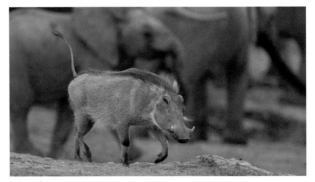

↗ **Warthog, Addo, South Africa**
Canon EOS-1Ds Mk II // 500mm lens with 1.4x teleconverter // 1/500sec at f/6.3 // ISO 250

During this trip to Africa a freak explosion took out the generator of the camp where we were staying, and left us without electricity for three days. Fortunately, we had been careful to top up our batteries at every opportunity, and carried spares and an inverter to allow us to recharge using our vehicle.

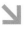

CAMERA BAGS

Wildlife photography frequently involves working in hard weather or rough country. A good waterproof camera bag that protects your precious gear from water, dust, heat, cold and knocks is an essential.

We favour a soft backpack that can be customized inside with flexible partitions. We mainly use the Lowepro Nature Trekker AWII, which has plenty of useful pockets, provides good protection, and fits into aircraft overhead luggage compartments. Soft bags can be crammed with more gear than similarly sized hard cases, and we can even fit a 500mm f/4 lens (minus its lens hood) into a Nature Trekker.

The downside of the larger camera bags is that they encourage you to pack a lot of gear. As they are quite heavy even when empty, this can make for a crippling experience on a long day in the field. If we're planning to concentrate on, say, macro photography of wildflowers, we'll take out smaller bags (Lowepro Mini Trekkers) and discipline ourselves to limit the amount of gear we carry. That way we're less likely to pack up too early with backache.

One advantage of a backpack is that you can, if need be, photograph while wearing one, whereas traditional shoulder bags tend to get in the way. Backpacks also tend to blend in, drawing less attention to the fact that you are carrying valuable camera gear. However, you do need to take them off to change lenses. Try not to make the mistake we regularly do of leaving them unzipped on the ground while photographing – it's all too easy to pick up an open bag and spill the contents. Even zipped up they can be vulnerable – we've had ours scentmarked at various times by lemurs, leopard and labradors!

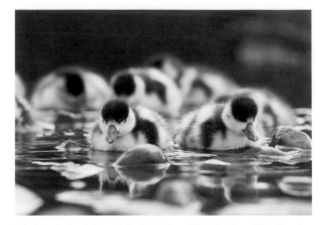

↗ **Shelduck ducklings, Martin Mere Wildfowl and Wetland Trust, Lancashire, UK**
Canon EOS-1Ds Mk II // 300mm lens with 1.4x teleconverter // 1/1,000sec at f6.3 // ISO 800

These shelduck ducklings were photographed at the Wildfowl and Wetland Trust reserve of Martin Mere in Lancashire, where there are lots of easily accessible wild and captive birds. With so many potential subjects it's tempting to pack everything but the kitchen sink, but carrying 25lbs (11kg) of gear on your back all day gets very tiring. Instead we'll often carry small Lowepro Mini Trekker backpacks, with just a couple of lenses, and concentrate on subjects that fall within their range.

Some designs of camera backpack have pull-out showerproof covers, but if yours doesn't, pack a plastic bin bag in one of its pockets, in case of sudden downpours.

If you plan to travel abroad, make sure your bag fits within airline hand baggage limits. These tend to be rigidly enforced, and the last thing you want is to have fragile gear shunted into the hold because it's oversized. International flights usually allow a bag of maximum dimensions 22x14x10in (55x35x25cm), but if you have a domestic connection the limit can be smaller, so check before you travel. Watch out for weight limits, too – these can vary from 13lbs (6kg) to 26lbs (12kg). Some heavy backpacks weigh up to 6lbs (3kg) on their own.

Hard cases offer greater protection, but are larger and heavier, and also advertise themselves as being worth stealing. If you're planning an

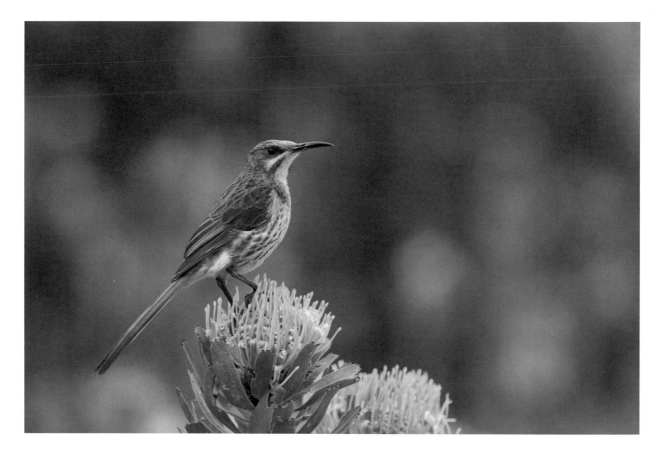

expedition in tough terrain where heat, rain or dust will be major problems, a hard case may be worth considering. They are not very practical for working on foot, but fine if you are using a vehicle as a mobile hide.

PRO TIP

Bad weather needn't stop you photographing, but you do need to look after your camera and lenses in rain or snow. You can buy rain covers tailored to specific models of camera and lens, or improvise using a plastic bag or even a shower cap.

↑ **Cape sugarbird, Kirstenbosch National Botanic Garden, Cape Town, South Africa**
Canon EOS-1Ds Mk II // 300mm lens with 1.4x teleconverter // 1/85sec at f/5.6 // ISO 200

Cape Town's Kirstenbosch National Botanic Garden is a great place to photograph nectar feeders such as this Cape sugarbird. The best approach is to stalk them on foot, and handhold the camera, rather than use a tripod. We leave any unnecessary kit securely locked out of sight in our car, and carry the minimum we need in backpacks, so we're hands-free to photograph and not overloaded.

ANIMAL TRACKING KIT

Dress to unimpress

Wildlife photography isn't for the fashion conscious, unless disruptive pattern camouflage fabric happens to be 'in'. Clothing should be all about comfort and unobtrusiveness.

Actually, we both feel faintly ridiculous in all-over camouflage fatigues, and for most wildlife subjects it really isn't necessary to go to such extremes. Animals with keen eyesight, such as deer, may take instant flight if they spot a human form, and camouflage material will help to break up your outline when stalking. But if you're shooting from a fixed position, avoiding sudden movements is often more important, and clothing in subdued natural colours – especially greens and browns – is usually fine, with darker colours best.

Animals such as otters and badgers have poor eyesight but keen hearing and senses of smell, so what you wear is far less important than keeping still and quiet, and avoiding them catching your scent. Clothing made of cotton or wool mixes rustles less than some of the modern waterproof materials, and pockets fastened by press-studs or heavy-duty zips are easier to open quietly than Velcro.

Whether you photograph in a Northern Hemisphere winter or a Southern Hemisphere summer, inclement weather is a fact of life, and can throw up some interesting photographic opportunities. It's worth investing in good-quality clothing that will keep you warm (or cool) and dry, so discomfort doesn't drive you to pack up too early. A lot of heat is lost through the head, hands and feet, so a woolly hat, fingerless gloves and good waterproof footwear are essential winter wear. Sitting in a hide for a long period in midwinter can be particularly cold!

Hides

Hides for wildlife photography come in a range of shapes and sizes. Most are based on simple tent design, using sprung poles to support the camouflaged material. Dome hides are the most popular, they are quick to erect, easy to move if you need to reposition for changing light and fold away for easy transport. If you're choosing

→ **Red deer stag in velvet, Isle of Mull, UK**

Canon EOS-1Ds Mk II // 500mm lens with 1.4x teleconverter // 1/160sec at f/6.3 // ISO 100

Wild red deer can be very challenging to stalk, particularly when they are in a herd with lots of pairs of eyes, as was this Isle of Mull stag. Rather than go to them, the solution in this case was to position ourselves ahead of the grazing herd, using natural cover, and stay absolutely still as they came towards us. We were fortunate that there was dead calm, so our scent wasn't a problem.

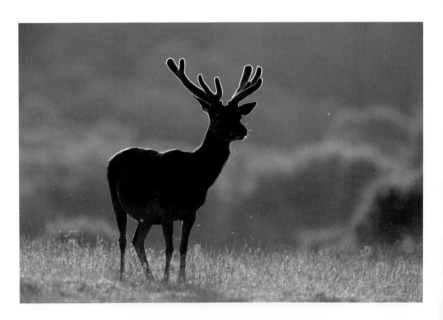

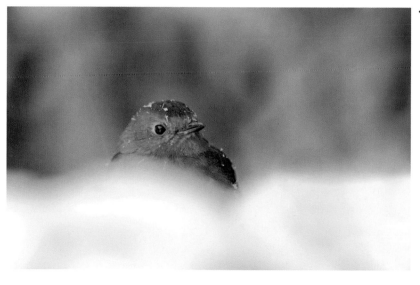

← Robin in snow, UK
Canon EOS-1Ds Mk II // 300mm lens
// 1/40sec at f/5.6 // ISO 200

We love photographing in snow, when even commonplace garden birds can become special subjects, but it's essential to keep fingers warm for changing camera settings. One useful trick is to use an electronic cable release, which can be fired without even taking your hands out of your pockets!

a dome hide, make sure it is big enough for you to use comfortably for hours on end, ideally with room for a foldaway seat, as well as your tripod.

Bag hides don't use poles, you simply throw the material over yourself. You can use them standing, sitting, or lying prone, and they provide a lightweight, inexpensive way of improvising cover, but they are not comfortable enough to use for anything but short periods.

With basic DIY skills it's quite possible to build a portable hide, but bear in mind the need to keep weight and packed size to a minimum, and to be able to erect it quickly on location. Alternatively, you can use available natural materials, such as wood, stone and vegetation, to build a semi-permanent structure in situ. Make sure you have the landowner's permission, and that the construction process is not going to damage habitat or disturb the resident wildlife.

Vehicles

Chances are that even if you regularly use a vehicle as a mobile hide, you aren't going to make suitability for wildlife photography a major criterion when buying your next car. But what about hiring a car when travelling abroad? Road conditions will determine whether you need a vehicle with four-wheel drive, high clearance, long-range fuel tanks, etc. But it's also worth considering whether all the windows wind fully down (especially if you are photographing in company), whether there's seat room for keeping your gear to hand, whether you can flip the wing mirrors out of the way of your lens and so on. Even the car's colour may be significant – we're convinced that elephants charge red vehicles more than any other!

PRO TIP

There's not much point clothing yourself in drab, natural colours, if you're then going to wave a big, shiny, white Canon lens around in front of a nervous animal. You can buy tailor-made covers for lenses in a range of camouflage colours, which will also offer some protection against the elements, or simply use camouflage tape, available from army surplus stores. Black lenses aren't such a problem.

Binoculars

We always carry compact binoculars, to help spot and identify potential subjects, but also to enjoy observing their behaviour when conditions don't allow us to photograph. Binoculars are like camera gear in that you get what you pay for, but there are some decent value-for-money, mass-market products available.

Binoculars are described in terms of magnification and the size of the front optic, so a 7x35 pair enlarges the image by seven times, and has a front optic of 35mm diameter. With high-magnification binoculars it's hard to avoid a shaky image, the field of view is narrow so finding the subject can be tricky, and the overall image tends to be less bright. A larger front optic increases image brightness, but makes for larger, heavier binoculars. With all the camera gear that we carry, it's important for us to keep size and weight to a minimum, so a durable compact 8x32 pair is perfect. Binoculars come in two types of construction, the traditional porroprism, with an angled body shape, and the roof prism, where you look straight through. Good-quality roof prisms are more compact and robust, but if you are looking for inexpensive binoculars, porroprisms will give a better-quality image.

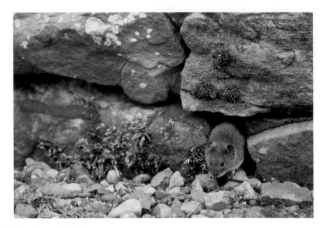

↗ **Bank vole, UK**
Canon EOS-1Ds Mk II // 500mm lens with 1.4x teleconverter // 1/250sec at f/5.6 // ISO 400

With many small mammals, what you wear isn't so important, provided it's reasonably subdued. Keeping still and quiet is the key. Small rodents will sometimes run right up to the feet of a hunting heron that is standing stock still, without being aware of it until too late. The same silent hunter approach can work for the wildlife photographer.

Field guides

The more you know about wildlife, the better your images will be, so collecting a small library of good field guides and natural history primers is well worthwhile. A good field guide will not only help you identify something you've photographed, but will also tell you when and where you are likely to find different species, and what sort of specific behaviour to look out for.

We hate to admit it, but for ID purposes we find field guides illustrated with drawings and paintings are better than photographic guides. There's also a lot of online information that can help in tricky IDs, but be aware that there are plenty of mislabelled images and ill-informed 'experts' on the internet, so make sure you only use reliable websites for help with identification. The same goes for general natural history information – there's a wealth of information on animal behaviour, ecology and wildlife-watching locations, but not all of it is accurate.

PRO TIP

A lightweight waterproof sheet that can be folded fairly small is a handy accessory. You can use it as a groundsheet on wet ground in a dome hide to keep you and your gear dry, but also for lying on when doing low-angle work, such as photographing insects, fungi or flowers, or when using a bag hide in a prone position.

PRO TIP

Common and scientific names of flora and fauna do change occasionally. Genetic research may reveal that two races of a species are in fact two different species, for example. Or naturalists may decide to standardize common names, such as happened when many southern African birds were renamed with east African common names. If you supply images to agencies it's essential they be accurately labelled, so make sure any field guides you use are up to date. Double check names on reliable websites if in doubt.

We keep a range of field guides in our vehicle, and more at home. It's impractical to take everything when on foot, but if we anticipate photographing trickier subjects, such as butterflies, fungi, or wildflowers, we will carry an appropriate field guide with us. Certain species can only be positively identified by looking at parts you might not photograph – for example a butterfly's underwing, the gills of a toadstool, or the leaves of a flower. There's nothing worse than getting home to find you can't ID your beautiful shot of a butterfly's spread wings because you don't have an image of its underside.

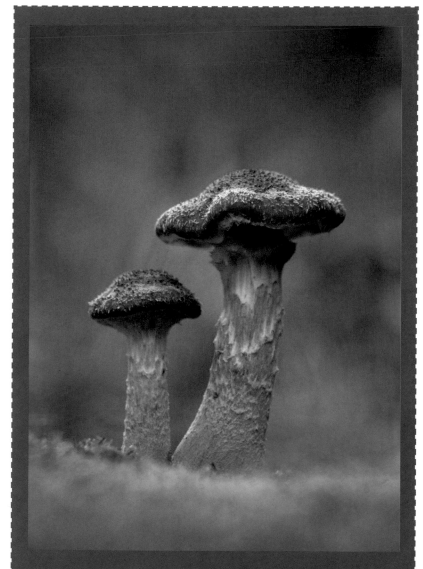

IDENTIFYING YOUR SUBJECT

We're certainly no experts on identifying fungi, so carrying a small field guide is essential when we go out on autumn forays. If the guidebook doesn't give a definitive ID, it's also worth taking some snaps of diagnostic parts of the subject which might not show in your primary photograph. These don't have to be aesthetically appealing, just accurate, so you can use them to make a firm ID when you've got access to more reference material back at home.

Cortinarius malicarius, Gait Barrows Nature Reserve, Lancashire, UK
Canon EOS-1N // 300mm lens with extension tube // 1/60sec at f/8 // Fuji Velvia 50

COMPUTER CPU

If you're shooting digitally, or digitizing film, you'll need a computer to process your images. Operating systems take up ever-more hard drive space and image-processing software is memory hungry, but with the lightning-fast processors and cheap memory now available, even the most basic off-the-shelf computer will work pretty well. However, the cheap monitors packaged with low-end desktop computers do not give the sort of accurate, consistent colour reproduction needed for image work, so buy a monitor separately.

Two things will determine how easy and enjoyable your computer makes image processing – its processing speed and random access memory (RAM). Go for the fastest processor you can afford, and an absolute minimum of 1GB RAM – preferably more. Dual-core processors work very well with Photoshop, the newer quad-core processors may prove even better. If you plan to store all your digital images on your computer's hard drive, make sure it's large enough, at least 250GB.

The Mac vs Windows debate is about as useful as the equally long-running Canon vs Nikon argument. There's little to choose between Mac and Windows PC, so go with whatever suits you. The Windows Vista operating system was plagued with problems when first released, but most of these have now been resolved. However, if you do buy a computer with Vista rather than XP, be aware that some older peripherals such as printers may no longer work and will need upgrading.

A laptop computer or netbook can be useful for storing and reviewing images when away from home, but it's not really suitable for image processing. Laptop screens have poorer and less consistent image quality than good-quality desktop monitors, with colour temperature and contrast varying depending on your angle of view and the ambient light. If you must use a laptop for image processing, buy a good-quality stand-alone monitor to plug into it.

Make sure your computer has sufficient USB2 and Firewire interfaces for all the peripheral items you need now or in the future – printer, scanner, external hard drives, camera, card reader, etc.

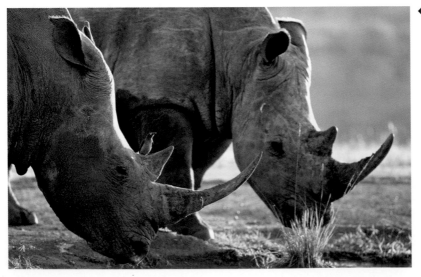

← **White rhinos drinking, Hluhluwe Umfolozi Park, South Africa**
Canon EOS-1N // 300mm lens // 1/200sec at f/8 // Fuji Velvia 50

This TIFF image scanned from a 35mm transparency is 108MB in size in 16 bit, and even when reduced to 8 bit for archiving is 54MB. With files this large, a fast processor will save you a lot of time waiting for images to open, Photoshop changes to be applied and so on.

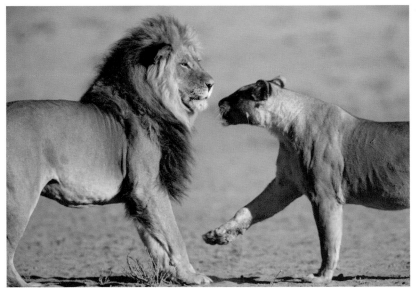

← **Lions courting, Kgalagadi, South Africa**

Canon EOS-1Ds Mk II // 500mm lens with 1.4x teleconverter // 1/1,000sec at f/5.6 // ISO 100

Back-up storage is fine, but efficient data retrieval is also important. We use a system of nested folders. This image has the reference 'AMPL159 Lions courting', which translates as Africa Mammals Predators Lions #159 'Lions courting'. It's kept in a folder called 'Lions', which itself is in a folder called 'Predators', within a folder called 'Mammals', within a folder called 'Africa'.

DATA STORAGE

Storing all your digital images on your computer hard drive alone is a recipe for disaster, so backing up is essential. External hard drives provide large capacity storage and are very convenient. We copy all our digital images to two external hard drives in our office and a third, kept off site, in case of fire or theft.

Some photographers prefer burning images to DVD or CD. However, with the ever-increasing file sizes produced by the latest DSLRs, even a dual-layered DVD won't hold many images. Most worryingly, the life expectancy of CDs and DVDs is uncertain, with some developing data corruption in as little as two years.

An alternative form of back-up is to store your images online. A number of products are available through internet service providers. For a large collection this could prove expensive – but as an extra off-site back-up for your favourite images, it's worth considering.

SAFE BURNING

CDs or DVDs are a convenient way to send images to clients, family or friends, but if you do use them, avoid using rewriteable discs, which are less reliable and may have compatibility issues. Burn at the slowest speed available, and don't use sticky labels on discs, as these can come off in the disc drive and cause problems. Write on discs with special CD marker pens, which won't damage them.

SOFTWARE BACK-UP

It's not only your digital images that are worth keeping safe. If your computer crashes, the cost and inconvenience of replacing operating software, image-processing programs, and all the other applications that you collect on your computer is considerable. It's well worth investing a few pounds in software that will periodically back up your whole system to an external drive, making it simple to restore if disaster strikes.

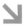

MONITORS

A good-quality, properly calibrated monitor will go a long way towards enabling you to reproduce accurate, natural colours in your wildlife images. Cheap monitors give poor colour reproduction and may not even reproduce the full gamut of colours captured in your digital image, so buy the best you can afford.

Until recently, traditional cathode ray tube (CRT) screens were considered superior to flatscreen liquid crystal displays (LCDs) for demanding colour work. Today LCDs have totally superseded CRTs, and the best, from manufacturers such as Eizo, Mitsubishi and Lacie, offer excellent image quality, combined with greater colour stability. Don't be tempted by second-hand CRTs, as even top-end models had limited lifespans, becoming unstable after only a few years of use.

Bigger is definitely better in monitors, and we'd suggest a minimum screen size of 19 inches (48cm), more if you can manage, with a minimum screen resolution of 1024x768 pixels, 1600x1200 if possible. If you want to maximize on-screen real estate, it's possible to set up a dual monitor system, with the image you are processing on one screen, and Photoshop tools and panels on a second.

Look for a monitor that can be adjusted for both height and screen angle, to ensure comfortable viewing.

PRO TIP

If you are still using a CRT and find yourself suffering from eyestrain, a flickering screen is probably causing it, although this may not be obvious. LCDs don't suffer from this, so consider changing.

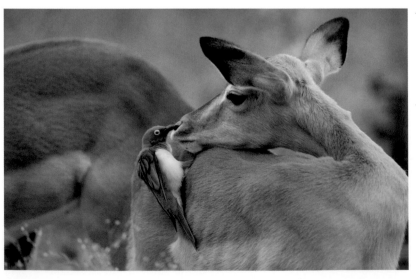

← Redbilled oxpecker on impala, Kruger National Park, South Africa
Canon EOS-1Ds Mk II // 500mm lens with 1.4x teleconverter // 1/250sec at f/5.6 // ISO 400

Even with the most expensive, properly calibrated monitor, you won't always be able to replicate exactly the colours as you saw them in nature. Wildlife photography isn't like photographing fashion, where colour reproduction is critical. The colour of an animal's fur can in any case appear quite different as the quality of ambient light changes, or if it gets wet, muddy, or dusty, for example. What you do want in your images are colours that are natural-looking and pleasing.

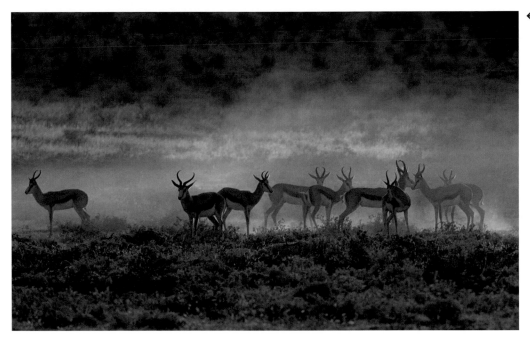

← **Springbok herd at sunrise, Kgalagadi, South Africa**
Canon EOS-1N // 500mm lens // 1/1.25sec at f/8 // Fuji Velvia 50

This image was scanned on a Nikon Coolscan 5000 ED film scanner from an original 35mm transparency. The quality is more than adequate for a double-page magazine spread, but the scanner doesn't fully capture the richness of colour in the original Velvia slide.

SCANNERS

Whether you're still using film, or have a back-catalogue of wildlife transparencies or negatives, a scanner will allow you to digitize your images. However, scanning is very time-consuming, so treat it as a long-term project, and edit hard before you start!

If you want to scan prints, a flatbed scanner with a resolution of at least 600 dots per inch (dpi) will produce adequate results. You can also buy flatbeds with adaptors to take transparencies and negatives – look for a resolution of at least 2000dpi. The quality of film scans from the more expensive flatbed scanners has improved greatly in recent years, but if you plan to digitize a reasonable amount of film we'd still recommend a dedicated film scanner.

Unfortunately, most scanner manufacturers have dropped film scanners from their range and concentrated on producing flatbed scanners.

However, the Nikon Coolscan range is still available, and produces excellent results, scanning 35mm transparencies at a quality that is more than adequate for glossy magazine spreads. A more expensive version will also scan larger film formats. The Coolscan's ICE technology does an effective job of removing spots, scratches and dust, saving you a lot of time in Photoshop.

For ultimate scan quality, you can send film to a bureau for drum scanning. This is expensive, but you can usually obtain discounts for large quantities. A cheaper alternative is a bureau scan made on a Hasselblad Flextight scanner. This is similar to a drum scanner, but with an optical sensor of the type used by desktop film scanners such as the Coolscan. Drum and Flextight scans offer the best colour accuracy and better detail in shadow and highlight areas.

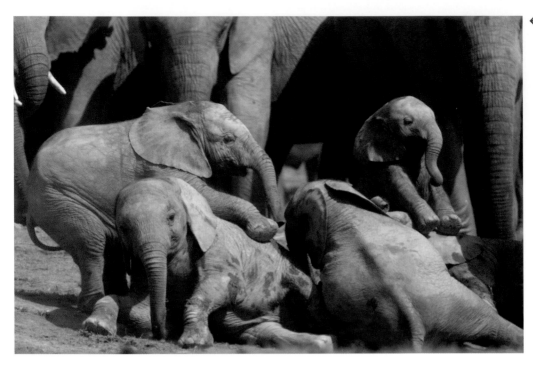

← **Elephant calves playing, Addo, South Africa**

Canon EOS-1Ds Mk II // 500mm lens with 1.4x teleconverter // 1/500sec at f/8 // ISO 100

Latest model inkjet printers designed for photo-quality printing have resolutions of at least 1440 dots per inch, which is more than sufficient to render fine detail. Higher resolutions will not deliver any noticeable improvement in print quality, but may mean slower printing.

PRINTERS

Affordable inkjet printers can produce prints that are virtually indistinguishable from traditional photographs, and if you buy a model designated for photo-quality printing from Epson, Canon or HP you should be able to produce excellent results, provided you work with a calibrated monitor.

Look for a model with six or eight colour inks, rather than four, as these produce better colours. Cheaper printers tend to use dye inks, which are fairly trouble free in operation, but tend to fade over a few years. If print longevity is important to you – if you are selling prints to the public, for example – then pigment inks offer much improved archival properties.

Home printing your digital wildlife images is not a cheap alternative to getting them printed commercially, quite the opposite. Ink and paper are expensive, and you can probably get cheaper prints from a lab, especially if you only want small sizes. A single set of refill inks for a mid-range photo printer can cost as much as one third of the original cost of the printer itself, so bear this in mind when budgeting.

What you do get with home printing is convenience, speed and, most importantly, quality control. That being the case, it isn't worth the false economy of using cheap compatible inks, which tend to produce inconsistent results and may clog the print heads. We'd recommend sticking with the printer manufacturer's ink, and using good-quality paper.

However, you can reduce ink costs a little by choosing a printer that takes multiple ink cartridges, so you can replace individual colours as they run out. If all the colours are in a single cartridge, you have to replace the whole thing when one colour is finished, which can work out very wasteful if you've been printing, say a series of images with large expanses of blue sky.

Whether you choose an A4 or A3 printer really depends on the print sizes you wish to be able to produce, there's no other real difference between corresponding models. Larger format printers are available, but at much higher cost and, unless you have a commercial need to produce very large prints regularly, it makes more sense to work with a good lab for the occasional poster-sized image.

Don't be taken in by the impressive printer resolution figures quoted by manufacturers. Print quality depends on much more than just resolution, and you'll get more idea by looking at printed samples and reading independent product reviews. It's also a mistake to assume that more expensive printers necessarily mean better-quality prints – sometimes you are simply paying for extras such as faster print speeds, or built-in memory card slots.

COLOUR CONTROL

We find that even with a fully colour-controlled system, properly calibrated monitor and custom printer profiles, it's rarely possible to get the 'perfect' print without a bit of tinkering. With images containing a lot of dark tones, such as this mute swan, we might need to darken or lighten the overall image in Photoshop to produce a satisfactory print – only trial and error will tell.

↑ **Mute swan, UK**
Canon EOS-1Ds Mk II // 300mm lens with 1.4x teleconverter // 1/500sec at f/5.6 // ISO 100

PRO TIP

Printers come pre-loaded with software profiles for different paper types (glossy, matt, etc.) which aim to ensure the correct amount of ink is applied, allowing for variations between papers in absorbency, reflectivity and so on. These canned profiles are often fine, but you may get better results by creating custom profiles using a printer calibration system (or through an online company). Canned profiles apply to the printer manufacturer's own papers, so if you use other brands of paper, custom profiles are even more worthwhile. You'll need a separate profile for every combination of ink and paper you use.

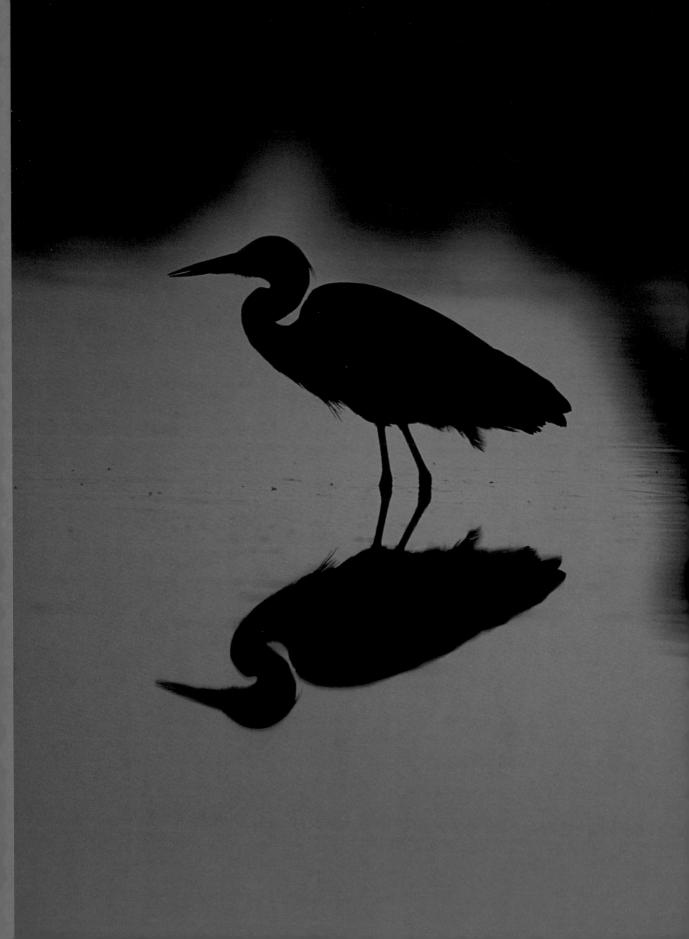

CHAPTER

02

TECHNIQUES FOR WILDLIFE PHOTOGRAPHY

Grey heron silhouette with reflection, Kruger National Park, South Africa
Canon EOS-1N // 500mm lens // Fuji Velvia 50

It may mean we miss supper, but beautiful light is the key to photographic success, so we generally try to stay out until well after sunset when conditions are right, working the light for as long as possible. To exploit the best light and make the most of nature's brief but magical moments you need to know how your camera responds in different lighting conditions and the techniques you can use to maximize the effects, such as underexposing to saturate sunset colours, and turn recognizable subjects into crisp silhouettes.

GENERAL CRAFT

Most wildlife photography requires pretty fast reflexes. We don't have time to stop and think about our camera settings when the animal action kicks off, so we really do need to know our equipment and how to use it. Unless you're photographing flowers or still life images in nature, you need to have the relevant techniques and technical know-how at your fingertips for use in that vital split second.

This doesn't mean to say you need to know everything there is to know inside out at the get-go, before ever setting foot out the door. Like all crafts, the techniques used in wildlife photography are best learned and honed over time – largely through experience, regular practice and, as we've discovered, by making lots of mistakes.

We've built up our technical know-how step-wise over a number of years and we're still adding to our skills as both cameras, the digital era and our own personal approach to wildlife photography develops. We certainly don't think of ourselves as technical photographers, however, and we'd never advocate becoming in thrall to your gear above your vision. Using our eyes, and following our passion for wildlife, is as important in our photography as being masters of our equipment, if not more so.

We prefer to think of wildlife photography techniques like a toolbox – a range of stuff you can select from to achieve the results you want and to which you can add as you go along. There's a basic set of tools that'll get you started and a more sophisticated set you can gradually acquire as you become more advanced and experienced; as and when you need them. Although the theory of f-stops, shutter speeds, exposure and depth

of field can seem pretty daunting, the following chapter will hopefully clear up any remaining mysteries and help you get to grips with the key things you need in order to progress and improve.

Before going any further, we want to stress the importance of getting a technically correct image at the point of capture. While it's reassuring to know you can do a great deal to rescue a less than technically perfect shot, or remedy a small mistake, in the digital darkroom, anything you do to your original at the conversion and processing stages risks damaging image quality. At the end of the day you can't turn a bad shot into a corker. There's just no getting round the fact you need great raw material to produce a great photograph.

Success is never simply about the workings of your camera gear, and how to get the most out of it in any given situation. As much care and consideration goes into finding and getting close to the subjects you want to photograph. More often than not, given the sophistication of today's digital SLR cameras, this is actually the really tricky bit of the equation and the stuff we probably spend most time on.

Researching your subjects, finding out where they live and working out a successful and ethical strategy for photographing them involves detective work, patience, dedication, a huge investment of time and dogged determination. Good fieldcraft skills are as critical to your success as good technical know-how and a keen eye for composition.

Finally, let's not lose sight of the fact that photography is, first and foremost, about the light. Learning to read the light and work with it to produce the best image possible is where the true art of nature photography really lies – and where the real fun, for us, begins.

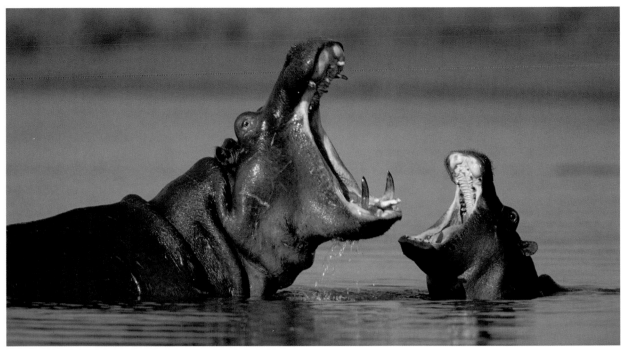

↗ **Hippos yawning, Kruger National Park, South Africa**
Canon EOS-1N // 500mm lens with 1.4x converter // 1/250sec at f/6.3 // Fuji Velvia 50

The real craft of wildlife photography lies in learning to anticipate your subject's next move. We spend as much time as we can in the field observing wildlife and primed ready for the split-second moment.

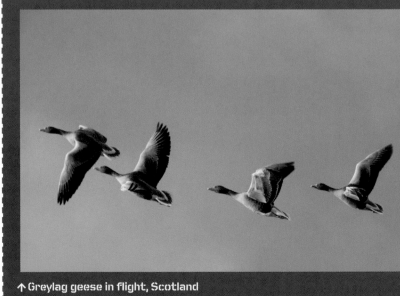

↑ **Greylag geese in flight, Scotland**
Canon EOS 5D // 300mm lens with 1.4x converter // 1/800sec at f/7.1 // ISO 400

MAKING A PICTURE

We always advise people on our workshops not to forget to use their eyes. Open yourself up to the creative possibilities and think of the technical stuff simply as the tools of your craft. We'd been watching geese fly in formation to a wetland area one grey winter's afternoon, wondering for ages how best to capture them. Suddenly a burst of sun turned the sky a marvellous, moody charcoal shade. This fired our imaginations as the birds looked just like a decorative frieze painted across the stormy sky.

↘

EXPOSURE BASICS

On paper, exposure can appear to be a mind-numbingly complicated area. In fact, putting the theory into practice is not as difficult as it might seem, particularly when using digital cameras. This is because we now have the welcome reassurance of being able to instantly check if we're getting correctly exposed images, and make any necessary adjustments, as we photograph, by checking the histogram – a graphic representation of exposure – on the LCD screen on the back of our cameras.

In essence, and for most occasions, obtaining the right exposure is all about getting just the right amount of light onto the camera's sensor to reproduce a full range of tones, from darks to lights. There are a number of ways this can be achieved, using a balanced combination of shutter speed, aperture size and ISO in conjunction with your camera's in-built metering system.

It's really important to remember here that, depending on the end result you wish to achieve, you may not actually choose to replicate exactly what you see through the camera. For example, you may want to deliberately overexpose (lighten) or underexpose (darken) an image to obtain a desired creative effect. For this reason, developing a clear understanding of the way exposure works, and what you can do to control it, will really set you on your way to producing the sort of wildlife pictures you have in your own mind's eye.

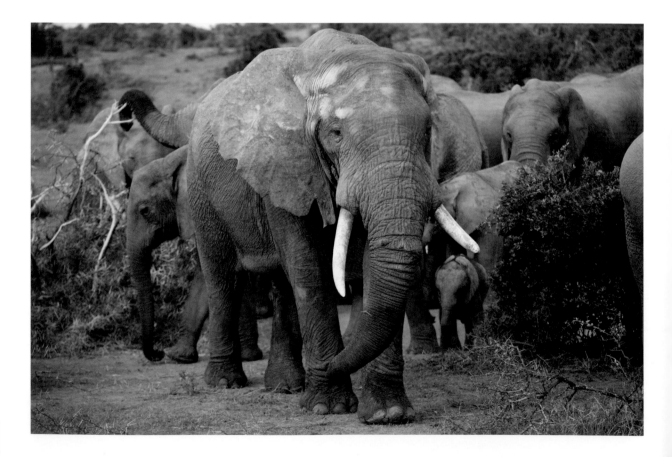

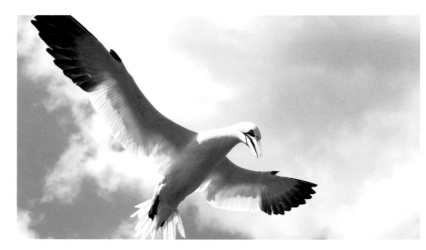

↗ **Overexposed gannet
and clipping histogram (above)**

This image of a gannet at Bass Rock has been overexposed, and this is immediately obvious in the Levels histogram seen in Photoshop. The curve busts out of the grid on the right-hand side, often referred to as 'clipping'. The highlight areas are 'burned-out' or 'blown'. If the image was clipped on the left side the picture would be underexposed, with insufficient detail recorded in the picture's shadow areas. Checking the camera's LCD when the shot was taken would have shown a similar histogram, and we'd have known to dial in some negative exposure compensation for subsequent shots.

← **Bull elephant with breeding herd, South Africa**
Canon EOS-1Ds Mk II // 70–200mm zoom lens // 1/100sec at f/5 // ISO 100

Mid-toned subjects like great grey elephants generally don't present any real problems when it comes to exposing the tonal range correctly, but we still check the histogram to make sure. A wet elephant, for example, can appear much darker, or one that's just been dusting itself, much lighter – so it always pays to be alert to your LCD reading.

↘

METERING

Modern cameras have pretty reliable in-built metering systems that will generally provide correct exposures across a wide range of situations. Not all cameras react in the same way, however. With experience you should get to know your own camera's response in different lighting conditions. Digital SLRs commonly have a range of metering modes including evaluative (matrix), centreweighted and spotmetering. For a good deal of the time we're happy to use the evaluative metering mode and can rely on our camera to provide accurate exposure readings.

No camera is as sophisticated as the human eye, however, when processing the varying light intensities in any scene, so we don't rely on our cameras' readings in every case. Cameras are designed to take correct exposure readings from mid-toned subjects; so when there's a barn owl or a black grouse in your frame, depending on the light conditions, your camera is going to try its best to turn the pale or dark plumage in either shot into various shades of grey – underexposing the light tones and overexposing the dark tones. You may not get the feathers looking as you would like them if you simply let your camera do the thinking for you. This is why it's important to check your histogram. You will need to make exposure adjustments if the curve busts out of the grid on the right or left side.

EXPOSURE COMPENSATION

One way to compensate for the camera's tendency to overexpose a dark subject is to manually underexpose the picture by moving the exposure dial in the minus direction. The darker the picture the more underexposure you may need – it could be anything from 1/3 to two stops.

To compensate when photographing pale-toned subjects, you will need to move the exposure dial in the plus direction to provide a degree or two of overexposure. This will ensure white subjects record as white and not grey. But it's a tricky business getting this balance exactly right. While your aim is to record whites and dark tones correctly, in doing so you risk losing vital detail in these areas at the same time. Because your camera is probably already providing some degree of exposure compensation if you're using

it in an evaluative metering mode, there's a danger you could over-egg things when making any manual corrections.

This is why it's vitally important to keep checking your histogram. It's also why we quite often find ourselves, contrary to received wisdom, underexposing rather than overexposing when photographing light-toned subjects in bright light, simply to ensure we retain important tonal detail in the paler areas of our image and don't burn out the whites. We know we can always brighten any whites if necessary at the processing stage.

It's probably more critical to get things right when photographing pale subjects. This is because it's generally more acceptable to have a few shadow areas in your picture where little or no detail is recorded, but less acceptable if you fail to hold detail in the lighter areas. What's more, if the highlights are burned out altogether your image will be unusable and you won't be able to recover anything at the processing stage.

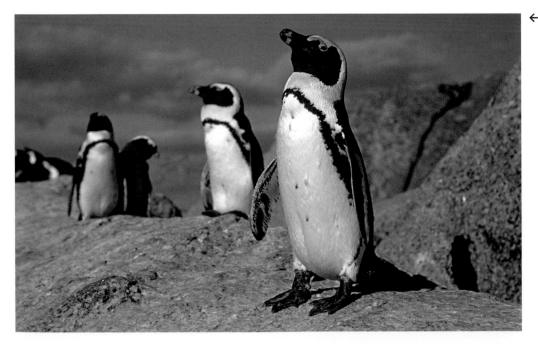

← African penguins, Cape Town, South Africa
Canon EOS-1N // 28–80mm lens // 1/250sec at f/7.1 // Fuji Velvia 50

For a shot like this we know we definitely can't afford to blow the whites of the birds' chests, but we could sacrifice some detail in the dark plumage, so we would generally opt to underexpose the picture a fraction. Photography is often about such trade-offs.

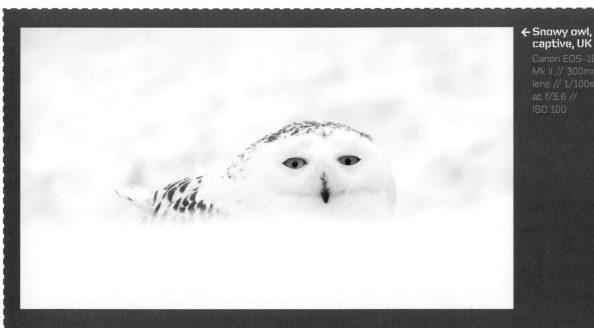

← Snowy owl,
captive, UK

Canon EOS-1Ds
Mk II // 300mm
lens // 1/100sec
at f/5.6 //
ISO 100

USING EXPOSURE CREATIVELY

With experience you begin to previsualize the sort of pictures you want. A falconer we work with has a snowy owl and one day, when we knew there would still be patches of snow on the fells near his home, we set off to get a shot in a really wintry setting. We knew what we wanted – a white on white image punctuated only by those two yellow raptor eyes. Although the thaw had started, and we only had a small patch of snow to work in, by getting down low with a medium-length telephoto it was possible to convey the sense of snow all around, framing the bird. We overexposed the shot by a third of a stop having checked the histogram to make sure the whites weren't clipping, then processed the picture without bringing up the dark tones in Photoshop. This helped ensure the whites in our picture were bright and that tonal detail in these areas was minimized.

There are many different ways to obtain a good exposure when photographing light- or dark-toned subjects, or a mixture of the two. One approach we use quite commonly is to take a reading from a mid-toned object in the same light as our subject. We then adjust this where necessary, for example, underexposing slightly where we want to hold key detail in highlight areas.

When there's no time to check our histogram, or make a considered choice on how best to expose for difficult situations, we bracket. This means taking a range of exposures at slightly different readings in rapid succession so we increase our chances of getting a 'correct' one. Many models allow you to set your camera up so it will automatically do this as you photograph. When you're really firing frames under pressure and are worried about the exposure, set your camera to routinely underexpose your images slightly, say, by a third of a stop. You can generally salvage an underexposed image but you can seldom save an overexposed one.

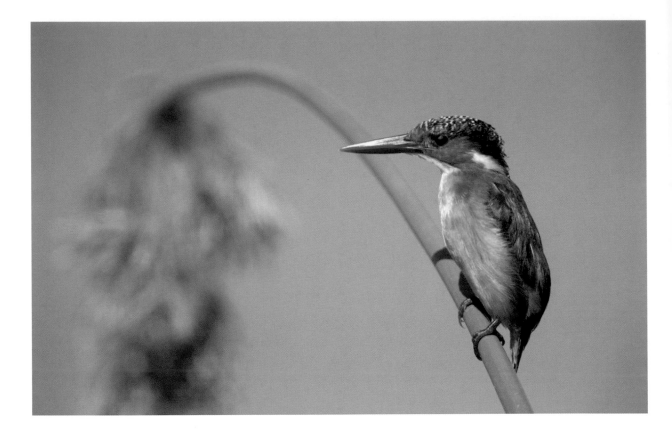

APERTURE AND DEPTH OF FIELD

Three things determine the exposure of an image – the size of the lens aperture, how long that aperture is opened for (shutter speed) and the sensitivity of the camera sensor or film (expressed as an ISO value). But aperture size also has a second important creative role to play, in controlling the depth of field in your image.

Depth of field is the space in front and behind the plane of best focus within which objects appear acceptably sharp. It's not, as some photographers mistakenly believe, an exact measure, but rather a subjectively defined zone. When you focus on an animal, anything that's not exactly the same distance from your lens will not be completely sharp, with the level of softness increasing the further from the plane of focus you go. But our eyes aren't perfect, and objects that are only slightly soft may appear 'acceptably sharp', giving the impression of an in-focus zone, the depth of field.

In most images we compose, we're looking for some parts of the image to appear sharp, and others to appear soft and out of focus. If, for example, we're composing a portrait of a fox's face, we'll probably want sufficient depth of field for the animal's eyes, nose and ears to be sharp. But we won't want the depth of field to be so great that the background is clearly focused, distracting the viewer's eyes from the main subject. It's finding this balance that is the key to creative use of depth of field.

← **Malachite kingfisher, Kruger National Park, South Africa**
Canon EOS-1Ds Mk II // 500mm lens with 2x teleconverter // 1/500sec at f/8 // ISO 100

Creative use of depth of field is as much about controlling how much detail you can and can't see in the background, as it is how much you see in the main subject. In this case the out-of-focus reed suggests context and leads the eye to the malachite kingfisher, but isn't sharp enough to distract.

F-stops and controlling depth of field

Depth of field increases as aperture size decreases. So we can achieve more depth of field by 'stopping down' a lens, to a smaller aperture. Aperture sizes are measured in f-stops. Just to confuse matters, a small f-stop (for example, f/2.8) equates to a large aperture, a large f-stop number (for example, f/16) to small aperture. But think of this as a small f-stop number giving a small depth of field, and a large f-stop number giving a large depth of field, and it's easier to remember.

Each time you stop a lens down through the sequence f/2, f/2.8, f/4, f/5.6, f/8, f/11, f/16, f/22, f/32, you are halving the amount of light passing through the lens with each step. To maintain a constant exposure, you also need to halve the shutter speed (i.e. keep the shutter open for twice as long). At very small apertures, this can mean working with very slow shutter speeds, with the attendant risks of camera shake or subject blur.

So adjusting aperture size to control depth of field comes with a trade-off, and it's often necessary to find an acceptable compromise between enough depth of field to render your subject acceptably sharp throughout, and enough shutter speed to stop it blurring because of camera shake or movement. If you're trying to freeze action, you'll be biased towards a fast shutter speed, and may have to accept less depth of field in your subject.

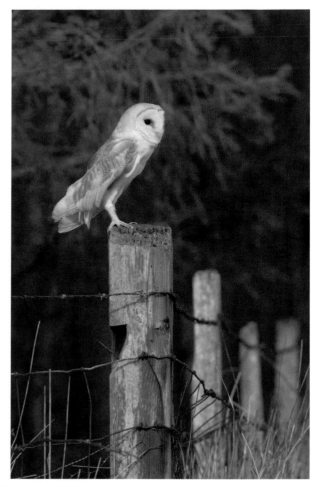

↗ **Barn owl, UK**
Canon EOS-1Ds Mk II // 300mm lens // 1/320sec at f/7.1 // ISO 100

Backgrounds are always important, but particularly so when your main subject is quite small in the frame. Here, the line of fence posts is an important element of the composition, leading the viewer's eye into the subject. But we didn't want the background to be too much in focus, or the barn owl would have been lost against the branches. An aperture of f/7.1 did the trick.

Choosing the right aperture

A lot of our wildlife photography is carried out at apertures of between f/5.6 and f/11, with f/8 a good general starting point. These sorts of figures tend to give nicely out-of-focus backgrounds, but sufficient depth of field in the subject. But, of course it varies, and there's no one-size-fits-all solution. A portrait of a long-nosed animal, such as our red fox, may need greater depth of field, all other things being equal, than a flatter-faced animal such as a wildcat. But if we're shooting a side-view of the fox we'll need less depth of field than a frontal portrait.

For any given lens depth of field increases with distance, which means we can get away with a larger aperture at distance than if we're framing our frontal fox portrait at close range.

Conversely, for extreme close-up work, like photographing insects, it can be necessary to stop down to very small apertures.

It's important to remember when you're composing an image, you're seeing it through the viewfinder with your lens wide open, showing minimal depth of field. By pressing the depth of field button on your camera (if it has one), the lens iris is manually stopped down to the aperture you've selected, giving you an idea of what the actual depth of field will be. This preview image can be very dim, but is a useful tool. Otherwise, predicting depth of field comes down to experience.

↓ **Cape river frog, Western Cape, South Africa**
EOS-1Ds Mk II // 180mm lens // 1/1.25sec at f/5.6 // ISO 100

A fairly wide aperture of f/5.6 gives minimal depth of field on a close-range subject, which was exactly what we wanted to focus attention on the wonderful eye of this Cape river frog.

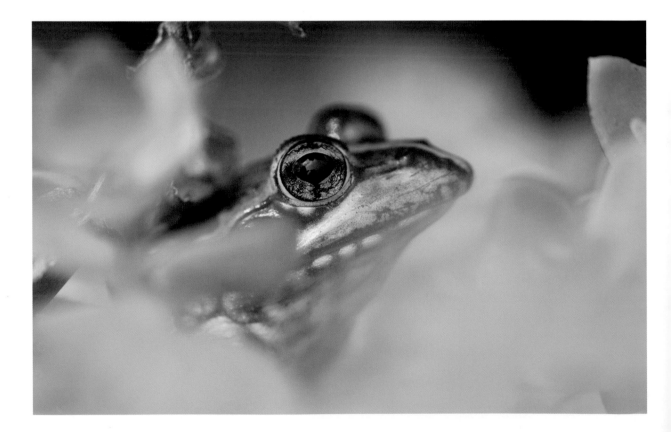

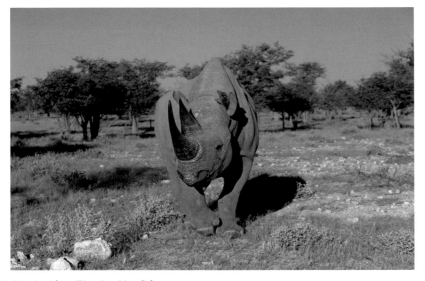

↗ Black rhino, Etosha, Namibia
Canon EOS-1N // 28–80mm lens // 1/250sec at f/8 // Fuji Velvia 50

PRO TIP

We keep our cameras set to the widest available f-stop value when we're in the field, which means we have the fastest possible shutter speed in the event of sudden unexpected wildlife action. It's easy enough to stop down for more depth of field when we encounter a portrait opportunity.

PRO TIP

Every lens has a maximum aperture size – a 300mm f/2.8 lens has a wider maximum aperture than a 300mm f/4 lens. For big telephoto lenses, a wide aperture necessitates large optical elements, which is why that f/2.8 is so much larger and more expensive than the f/4 lens. Lenses with wide maximum apertures are known as 'fast' lenses. Because they let in more light when opened right up, it's possible to shoot at faster shutter speeds. This makes them very useful in low light conditions, helping to avoid camera shake and subject motion blur.

In practice, shooting at a very wide aperture such as f/2.8 gives very little depth of field, which for wildlife photography is fine for throwing the background out of focus, but may mean the subject isn't sharp throughout. With the latest digital cameras capable of producing very good-quality images at high ISO settings, it's arguable that you can achieve fast shutter speeds by increasing ISO, while maintaining a smaller aperture and doing away with the need for a heavy and expensive fast telephoto.

COMMON EXPOSURE MODES

Program The camera selects both shutter speed and f-stop. This is OK for beginners and is reliable for night-time flash photography, but otherwise gives you little creative control

Aperture priority Allows you to select an aperture and the camera chooses a shutter speed to give the correct balance of exposure. The most frequently used mode for wildlife photography.

Shutter speed You choose the shutter speed and the camera selects the appropriate f-stop to balance exposure. Useful if you want to select a slow shutter speed for a blurry motion image, or for maximum depth of field.

Manual You choose both aperture and shutter speed, using an indicator in the viewfinder to check for correct exposure. Gives you total control and can be useful if an animal is moving past variably lit backgrounds. Can be tricky if light levels are constantly changing, such as at sunrise or sunset, or when clouds are drifting across the sun.

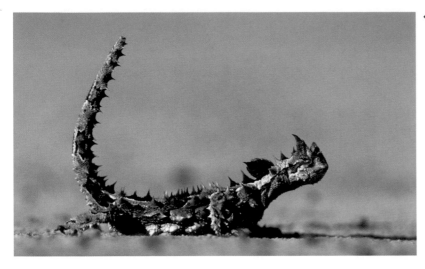

← **Thorny devil, Western Australia**
Canon EOS-1N // 300mm lens // 1/250sec
at f/8 // Fuji Velvia 50

Limiting depth of field by controlling your
aperture isn't the only way to keep the
background subdued. This shot of a thorny
devil was taken from ground level, so that
the background was distant. A shot from
higher level would have not only been
less intimate, but would have introduced
distracting detail in front of and behind
the animal.

Depth of field and close-up work

Photographing very small subjects, such as
insects or flowers, is technically challenging,
because depth of field is so limited at very close
range. It's often necessary to stop down the
lens to an aperture of f/16 or f/22, to get a
reasonable amount of detail in focus. Some lenses
allow you to stop down to f/32, or even f/64, but
at these very small apertures diffraction effects
can soften the image, especially if your camera
has a small sensor (less than 35mm frame size).

Choosing a suitable viewpoint can help
minimize the required depth of field. For example,
if we're photographing the open wings of a
butterfly we'll often shoot so that the wings are
in a plane parallel to the front of the lens.

A very small aperture generally means a
slow shutter speed if you're shooting in available
light. We might occasionally stalk butterflies
using a handheld camera in bright sunshine, but
otherwise a tripod, or other solid camera support,
is essential to avoid camera shake. Close-up
photography is not only unforgiving of camera
shake, but also shows up tiny movements of your
subject. Even a breath of wind can be a problem.
Selecting a higher ISO may allow you to shoot

PRO TIP

Improving backgrounds
*Using a wide aperture to throw background (and
foreground) out of focus is a powerful tool for the
wildlife photographer. But there are other alternative
or complementary ways to improve backgrounds:*

» Move your position sideways, upwards or
downwards. Even a slight adjustment can avoid
out-of-focus dead twigs or bleached grass or bright
sky highlights showing through branches.

» Try to establish feeding stations and hides with
the background in mind.

» Use a longer lens to make a tighter crop of the subject.

» Blur the background of a moving subject by panning.

» Do a little gardening – remove dead grasses or twigs
from a baited position before the animal arrives.

» Do a little digital gardening – cleverly used clone
and healing brushes can remove unwanted blades
of grass, out of focus highlights, etc.

» Differentially altering the contrast of your subject
and its background on the computer can also
reduce distractions.

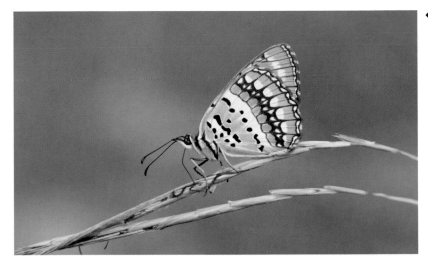

← Spotted joker butterfly, Marakele, South Africa
Canon EOS 5D // 300mm lens with 1.4x teleconverter // 1/400sec at f/7.1 // ISO 200

Choosing a viewpoint in which the butterfly's folded wings were in a shallow plane, it was possible to photograph this spotted joker butterfly at only f/7.1, ensuring the background remained nicely blurred.

at a high enough shutter speed to freeze this movement, but if that's not enough you'll need flash to achieve a shutter speed of 1/60sec or 1/125sec and have a fighting chance of a sharp image. For close-up work a specialist macro or ring flash is ideal.

Even with a very small aperture, depth of field can be limited, so accurately focusing on the most important part of the subject is critical. It's a lot easier to get this right by focusing manually than by using autofocus. And it's another reason to use a tripod – trying to hold accurate focus on a tiny insect while handholding a heavy camera and macro lens and waiting for the wind to drop just isn't a recipe for success.

If you're very keen on macro work, then you can invest in software that enables you to take a series of shots of a subject at various points of focus, then blend these together, combining the in-focus elements of each to produce a single image with much greater depth than you could achieve in-camera.

PRO TIP

Small sensors and depth of field
Most consumer DSLRs have 'partial-frame' sensors – sensors that are smaller than the traditional 35mm film frame and capture a narrower field of view. This means that to compose a frame-filling portrait of an animal you need to stand further away than a full-frame 35mm user with the same focal length lens. Since depth of field increases with distance, your shot will have greater depth of field than the full-frame user's shot, assuming you both used the same aperture value. If you both photographed from the same distance, and the full-frame user then cropped their image to give the same view as yours, the depth of field would be identical.

Is this greater depth of field a problem, given that wildlife photographers often prefer limited depth of field to blur the background? Not really. Partial-frame sensor DSLRs still offer plenty of scope to control depth of field, you might simply have to 'open up' by an extra stop.

Compact digital cameras are another matter. They often have tiny sensors, and very short focal length lenses to match, which give massive depth of field, so the scope for creative aperture control is very limited.

SHUTTER SPEED

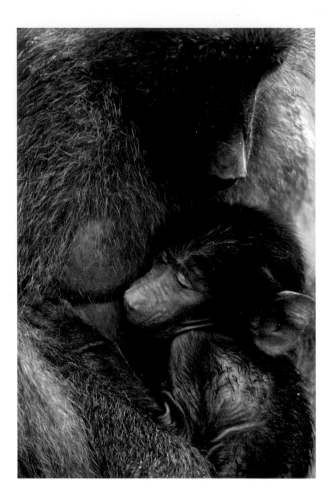

Shutter speed has important roles to play in terms of exposure, sharpness and creativity. We've already looked at how shutter speed and aperture together control the amount of light reaching the sensor or film, and how changing one requires a corresponding shift in the other to maintain a constant exposure value.

This exposure role is important no matter what the subject. But shutter speed's other two roles depend very much on whether the wildlife you are photographing is still or moving.

Shutter speed and the stationary subject

If you're photographing an animal that's perfectly still, then there's no creative role for shutter speed. You can adjust the aperture to alter the depth of field, but adjusting shutter speed is then about maintaining a correct exposure, and won't in itself alter the appearance of the final image. But shutter speed does have a vital role in ensuring the technical excellence of your image. This is two-fold: first in avoiding camera shake, and second in avoiding blur due to slight movement of the 'still' subject.

We can't stress too highly the importance of shutter speed in minimizing camera shake. Long focal length lenses, such as we often use in wildlife photography, are unforgiving of any camera movement, magnifying its effect and producing a soft image.

There's a rule of thumb that suggests the minimum necessary shutter speed to avoid camera shake when you're handholding is equal to the reciprocal of the lens focal length. In other words, for a 50mm lens you need a shutter speed of 1/50sec or faster, for a 300mm lens a speed of 1/300sec or faster. But the ability to hold a camera steady varies from person to person, so it's worth experimenting to find your own limitations.

Using a tripod, monopod or beanbag can considerably reduce the minimum necessary shutter speed, as can using a lens (or camera) with in-built shake reduction technology. We've managed to get pin-sharp images using a 500mm Image Stabilization lens at 1/8sec in very low light, simply by bracing well on beanbags. But solid camera supports won't deal with the problem of subject movement. Again, long telephotos are particularly good at picking up slight movements of an animal, such as a feather blowing in the breeze. Using as fast a shutter speed as you can get is the only way to avoid this.

← Chacma baboon with infant, Kruger, South Africa

Canon EOS-1N // 300mm lens // 1/15sec at f/7.1 // Fuji Sensia 100

These baboons had been caught out in a heavy downpour and were looking decidedly sorry for themselves. There was very little available light under the heavy cloud cover, and it was essential to brace firmly on beanbags to obtain a sharp shot at only 1/15sec.

→ Ostriches, Kgalagadi, South Africa

Canon EOS 5D // 300mm lens with 1.4x teleconverter // 1/1,000sec at f/6.3 // ISO 200

These male ostriches were squabbling over a group of females, and were moving fairly quickly. It took a shutter speed of 1/1000sec to render them sharp.

→ Barnacle geese at sunset, Solway Firth, UK

Canon EOS 5D // 180mm lens // 1/250sec at f/6.3 // ISO 400

Once the sun has set, it's very difficult to capture sharp images of moving subjects. By framing these flying barnacle geese against the brightest cloud in the dusk sky it was possible to get a shutter speed of 1/250sec and a little extra depth of field, just about enough for acceptably sharp silhouettes of the fast-flying birds.

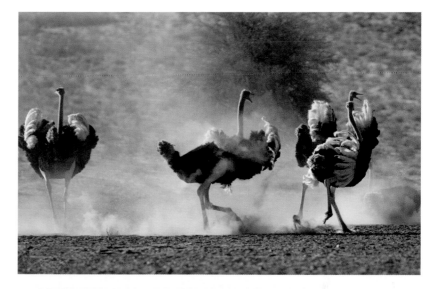

PRO TIP

If you want a fast shutter speed, select aperture priority mode (Av or A), and set the widest aperture your lens allows. Don't be tempted to choose shutter priority mode. If you do, and set a very fast shutter speed, your camera might not be able to open the aperture wide enough to compensate, and you will end up with an underexposed image. Although cameras will warn you (usually by a flashing symbol in the viewfinder) that your chosen shutter speed is too fast, it's easy to overlook this warning in the heat of the action.

Shutter speed and the moving subject

If you're photographing a flying bird or a running deer, then you essentially have two choices: a fast shutter speed to freeze movement, or a slow speed to create motion blur. Either way, camera shake ceases to be a problem.

How fast a shutter speed you need to freeze movement depends on the subject. A large, slow-flying bird, such as a soaring eagle, may only need 1/500sec, whereas a fast-flapping flock of finches may still not be wholly sharp at 1/2000sec. The closer the creature is to your camera, the faster it's relative velocity within the frame, whether it's flying across or towards you, and the faster a shutter speed you'll need.

Sometimes the level of available light can dictate the creative approach we take to shooting a moving subject. If, for example, we want to photograph a skein of geese flying in to roost at sunset, we may not be able to achieve a fast enough shutter speed with the setting sun behind us. But shooting into the sunset and exposing for the brightest part of the sky gives much faster shutter speeds, and enables us to capture sharp images of the flying birds, albeit as silhouettes.

An alternative in low light is to choose a shutter speed of 1/30sec or slower, to create a blurred motion image. Finding the best shutter speed takes a bit of trial and error, but 1/15sec is usually a good starting point.

ISO sensitivity

One of the big advantages of digital SLRs is the ability to adjust ISO rating for individual shots. ISO measures the sensitivity of the sensor. A higher ISO setting enables us to photograph in low light, or with higher shutter speeds and smaller apertures.

Modern cameras offer very fast maximum shutter speeds, generally at least 1/4000sec. It's the maximum available aperture that tends to be the limiting factor. On a bright sunny day, at ISO 100, a maximum aperture of f/4 might give you a shutter speed of 1/1600sec. But by increasing ISO to 400 you can shoot at 1/6400sec. Or you could shoot at 1/1600sec, but with the aperture stopped down to f/8, for greater depth of field.

You can do the same thing with film, by loading a high ISO emulsion, but this means having to shoot a whole roll of 36. Alternatively, it's possible to uprate the film, telling the camera to treat an ISO 100 film as ISO 200, for example. This effectively underexposes each frame. The film then has to be specially processed to compensate. Again, the down side is that you have to shoot a whole roll uprated.

'Fast' film has the disadvantage of producing grainier images. Digital images have a corresponding quality issue when shot at high ISO, that of noise. This is most apparent in shadow areas and mid-tones, as the signal-to-noise ratio is higher in highlights. Nonetheless, the sensor and processor quality of DSLRs is improving all the time and the latest top-end models produce astonishingly noise-free images even at 800 ISO and beyond.

↗ **Blackbacked jackals playfighting, Etosha, Namibia**
Canon EOS-1N // 300mm lens // 1/640sec at f/4 // Fuji Velvia 50

This was a grab shot, responding to a sudden and unexpected flurry of activity as we drove past these jackals. The ambient light, although golden and attractive, was quite low, and the camera was loaded with a slow film, so it was necessary to shoot with a wide-open aperture of f/4 to obtain sufficient speed to freeze the action.

THE CORRECT COMBINATION

Arriving at the right combination of ISO, aperture and shutter speed typically involves answering the following questions:

» Do I have the correct aperture setting to give me the best depth of field for a sharp subject and out-of-focus background (or whatever other focus effect I'm looking for)?

» Do I need to dial in any exposure compensation to adjust for a light- or dark-toned subject?

» Am I left with a shutter speed that's fast enough to avoid camera shake or subject motion blur?

» If not, can I increase the ISO to give me an adequate shutter speed, without producing an overly noisy image?

» If I can't increase the ISO any more, can I settle for less depth of field (a wider aperture) to allow a faster shutter speed?

PRO TIP

Anticipation and patience can both help in ensuring a sharp picture. If you're shooting in very low light, such as at dawn or dusk, it can be difficult to get a fast enough shutter speed to freeze animal movement, even with a high ISO. But even an animal or bird busily feeding will occasionally stop momentarily to scan for danger. Learning to expect and anticipate this behaviour can give you the vital edge needed for a sharp shot. Similarly, when shooting close-ups of insects or plants, even the slightest breath of air can be a problem, especially since you often need a small aperture (and therefore relatively slow shutter speed) to get enough depth of field. Being patient, and waiting for a temporary lull in the breeze, often solves the problem.

PRO TIP

At slow shutter speeds, large telephoto lenses are very vulnerable to camera shake. Using a shutter release cable, or remote electronic release, reduces the chances of this happening. You can also set mirror lock-up, which causes the internal mirror to flip up at the first press of the shutter release, and stay out of the way when you then press the button a second time to take the picture. This eliminates the effect of internal vibration caused by the mirror movement, which can affect images shot at speeds slower than 1/15sec. However, you lose the viewfinder image before you fire the shutter, so while it's effective for static subjects, it's not very practical for photographing active animals when you need to be able to judge the exact moment to fire.

→ **Blackheaded gulls attempting to mate, UK**
Canon EOS-1N // 300mm lens // 1/250sec at f/4 // Fuji Velvia 50

Setting your camera to a wide-open aperture when you're out and about means you will get the fastest possible shutter speed should you need to react quickly to unanticipated behaviour, such as this gull attempting to mate with a female.

↓ **Grey heron, UK**
Canon EOS-1Ds Mk II // 300mm lens with 1.4x teleconverter // 1/30sec at f/29 // ISO 100

This image was captured at a location where grey herons are regularly fed to supplement their natural diet. The bluebells were a seasonal bonus, but with conventional high shutter speed shots of the birds flying in, the background was too fussy and distracting. By panning with a slow shutter speed of 1/30sec it was possible to capture an impressionistic shot, in which the bluebells still contribute to the image but don't overwhelm the main subject.

↘

STALKING AND FIELDCRAFT

To a large degree, success in wildlife photography is all about finding the best ways to get close to subjects that are generally shy, elusive and extremely wary in the presence of humans.

It helps if you're blessed with good fortune out in the field, and you can improve your luck quite simply by spending as much time as possible outdoors, putting yourself in positions where you're likely to encounter good photographic prospects.

There's a range of skills and techniques to help you get close enough to photograph without scaring subjects away, but you can make things easier for yourself by doing your homework first. We always research subjects thoroughly before heading out; learning about their behaviour, the best locations to find and photograph them, and the times of year they're in peak condition or most active.

We now have a small library of wildlife books we can refer to, along with notebooks and wildlife diaries we've made about subjects and locations we've photographed or plan to photograph in future. The internet is often our first port of call when we're researching a species or location we might not have tackled before. Basically anything that can provide us with shortcuts to success is valuable, including tapping into the specialized knowledge of conservationists and other photographers who are quite often surprisingly willing to share their knowledge with peers.

Where possible, we encourage as many subjects as we can to come to us. It sounds simplistic, but turning your own green space, however small, into a haven for wildlife – by establishing feeding stations, erecting nest boxes and putting in wildlife-friendly plants – is a welcome bonus. And the great thing about photographing on home turf is that you're in much greater creative control over the whole photographic process.

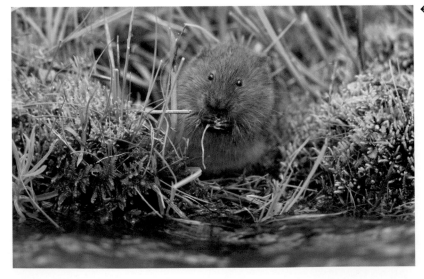

← **Water vole eating, Cumbria, UK**
Canon EOS 5D // 300mm lens with 1.4x converter // 1/250sec at f/6.3 // ISO 400

Look for shortcuts. Networking, for example, can save a bunch of wasted time and frustration in the field. We only found this colony of upland water voles because we'd worked before with the conservationist who'd just got the job of protecting them. Through her we were fortunately given permission to photograph at the site and she was equally grateful for the free photographs and the subsequent publicity we gave to her project.

STALKING SUBJECTS

Making yourself invisible – or simply getting your subjects to tolerate you long enough to get a picture – is a challenge, but the satisfaction is really great when you do pull it off.

The golden rule is to pick your moment. When we're stalking subjects we look for a pair, or small group, busily interacting because we know our subjects will be more preoccupied with each other than with us. Wait until a single subject's actively engaged – eating or foraging, perhaps – before starting your approach. In woodland, where it's impossible to creep quietly, a windy day will help conceal your sounds as you sneak up.

It's pretty obvious stuff: dressing to blend into your environment, keeping downwind, staying low, moving obliquely rather than directly towards your target and using ground cover and trees to conceal your outline are all important. Don't be impatient. It's crucial to advance slowly, in small stages, with a slight pause, as subjects often begin to tolerate you this way.

The hardest stalking is across open terrain. We usually find it's easiest to crouch low, or move on all fours, when furthest away from our subjects, switching to uncomfortable and awkward belly-crawling as late as possible. Keep your head low and move forward only when your quarry is looking the other way. Nine times out of ten the return on your effort here will be zilch, but it's a real privilege on the few occasions subjects are obliging.

PRO TIP

We generally don't bother with tripods when stalking – they're just too cumbersome. With pro-build cameras now producing quality images at high ISO ratings, we'd even suggest swapping an unwieldy 500mm or 600mm fixed-length lens for a 300mm IS lens with a top-quality 2x converter to give you the focal length you need without restricting or impeding your movement.

← **Brown hares mating, Lancashire, UK**
Canon EOS-1Ds Mk II // 300mm lens with 2x converter // 1/1250sec at f/8 // ISO 400

It takes time, patience and some degree of fitness to cover open ground crouched low when stalking wary subjects like hares. Increase your chances of success by choosing to stalk animals that appear to be more interested in each other than they might be in you, like this male and female during the courtship season!

USING HIDES

Your success rate will be a lot higher where you can use a hide. Ideally this should be portable, weatherproof, easy to erect and suited to the way you photograph. Practise by using a hide in your back garden before embarking on a bigger project and get comfortable with it.

Always get the landowner's permission before erecting a hide and put it in place well before your subjects arrive on the scene so as not to disturb them. It helps to get a friend to walk you in and out so subjects are fooled into thinking nobody's home while you're there (many animals can't count). Make sure ports for lenses and fabrics used are rustle-free.

There are tons of situations where you don't need a hide of your own so it makes sense to investigate simpler alternatives first. For example, since we moved house, we can photograph birds visiting our garden quite easily from a low, open window at the front of our cottage.

The hide we use most often, whether at home or overseas, is our vehicle. We can drive our 'mobile hide' into just the position we want and silently crawl up to the huge range of subjects that simply don't associate humans with cars.

↗ **Female blackbird in falling snow, UK**
Canon EOS 5D // 500mm lens with 1.4x converter // 1/250sec at f/7.1 // ISO 250

By placing feeders closer to our house we don't need to use a hide and can photograph the garden birds visiting them from an open window. We stay concealed and equipment stays dry in the event of a snowstorm.

PRO TIP

Make a point of checking out ready-made hides at any nature reserves or parks you visit as a matter of course. Keep a list of the ones with potential for good photo opportunities, noting what time of day and season is best for shooting both frontlit and backlit images.

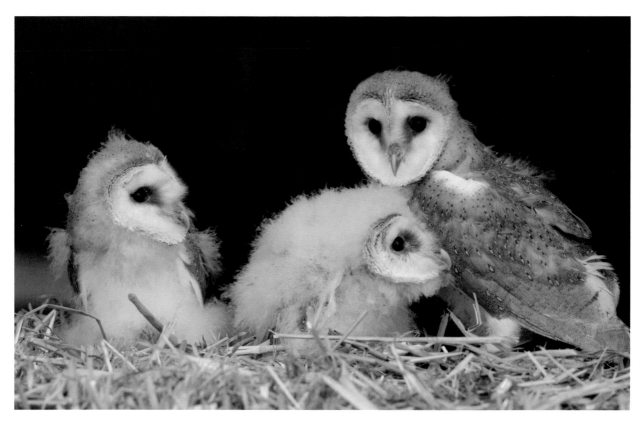

↗ Barn owl chicks, captive, UK
Canon EOS-1D Mk III // 300mm lens //
1/200sec at f/5.6 // ISO 800

Under the law in the UK a licence is
required to photograph barn owls at
the nest. This shot is a set-up using
captive barn owl chicks. We believe
it's often better to work with captive
subjects than risk disturbing wild birds
just for a photograph.

← Redshank, North Pennines, UK
Canon EOS-1Ds Mk II // 500mm lens
with 1.4x converter // 1/200sec at f/9
// ISO 100

Perhaps because of the time we've
spent honing our craft in African game
reserves – which, more often than not,
means photographing from vehicles – we're
extremely experienced using our car as a
mobile hide. With care, it's a great way to
steal up close to birds like this shy wader.

WILDLIFE PHOTOGRAPHY: ETHICS AND THE LAW

Wherever you come from, and wherever in the world
you photograph, the number one priority of all wildlife
photographers should be to respect the welfare of their
subjects at all times, above and before your photography.

» Keep any 'gardening' to a minimum and always leave
a site as you found it.

» Always get the necessary permission or permits from
landowners before you photograph.

» Photographers working in the UK should be fully
aware that pretty much all wildlife is protected under
the law. You should also bear in mind that under the
Wildlife and Countryside Act of 1981 there are three
lists of protected species it's illegal to photograph in
certain circumstances unless you get a special licence.
Birds are covered under Schedule 1 of this act, animals
under Schedule 5 and plants under Schedule 8.

» To obtain any necessary legal permission you must
approach the national body responsible (see page 173).

LIGHT QUALITY

Photography's three magic ingredients are light, subject and composition, but it's light that brings true star quality to this mix.

The short, sweet periods of golden light around dawn and dusk are the best times to be out as a wildlife photographer, not only because this is when the quality of light is at its most impressive, but also because it just happens to be the time of day many subjects are most active and alert.

In our view, one of the huge advantages of the digital revolution over film, certainly for wildlife photographers, has been the increased opportunity and flexibility for obtaining high-quality images in low-light situations. In essence, this has meant a welcome extension of the time we can be out photographing at the extreme ends of

↗ **Wren, Leighton Moss RSPB Reserve, Lancashire, UK**
Canon EOS-1D Mk III // 500mm lens with 1.4x converter // 1/200sec at f/5.6 // ISO 800

Using digital cameras has enabled us to extend our working times as professional photographers, allowing us to get good-quality images in very low-light conditions. Given a lot of our subjects are most active at dawn and dusk this opens up new possibilities for us as wildlife photographers.

↓ **Cheetah resting, Kgalagadi, South Africa**
Canon EOS-1N // 500mm lens // 1/1.60sec at f/6.3 // Fuji Velvia 50

Dawn light is special. The toffee-coloured glow gilds subjects and backgrounds alike and particularly works well with colours from the warm end of the spectrum, as in this image of a resting female cheetah in the Kalahari desert.

the day and offers additional creative potential for subtle, but powerful effects working at the edges of the light.

Of course, this doesn't mean to say you can't get great wildlife photographs at other times of day, too. One of our favourite lighting conditions for photographing wildlife portraits, close-ups and flower studies is the muted light afforded by a bright but overcast day, where thin cloud cover acts like a huge diffuser, softening any harshness and flattening out areas of high contrast. The 'shadowless' quality of light on days like this renders fur, feather and skin detail beautifully and prevents colours looking as bleached as they do in harsh sunshine.

We rarely use filters on our lenses in our wildlife photography now, but a good-quality polarizer still goes in our bags on very bright days. A circular polarizing filter helps reduce glare and cuts reflections on water and bright green foliage. We don't use warm-up filters any more – since going digital we prefer to tweak the white balance or correct colour casts at the processing stage – it's much simpler this way and can be less degrading to the image, particularly if your filter is inexpensive.

↑ Impala males allogrooming, Kruger National Park, South Africa
Canon EOS-1Ds MkII // 500mm lens // 1/200sec at f/5 // ISO 200

Flat, overcast light is a favourite for animal, flower and bird portraits. On duller days the bonus is that we can stay out photographing throughout the day and can even have a lie-in since there's generally no sweet light at dawn or dusk on these days!

WHITE BALANCE

Observe a swan towards the end of a winter's day and you'll notice the white plumage appears honey-coloured in the late-afternoon light. You'd still describe the swan as white but, as the quality of light progresses throughout the day, there are subtle changes in the way its feathers appear. Seen in the shade on a bright day, for example, the swan's white feathers will have a bluish cast.

The white balance settings on a digital camera allow you to correct for the subtle colour changes caused by varying light conditions. The thing is, you don't always want to. You might be happy with the results in some situations, for example, if you use the 'shade' setting to adjust for the cold blue cast, but not so happy in others.

If you shoot JPEGs you're stuck with the white balance used at the point of capture. This is a strong argument for shooting in RAW, because you can alter the white balance at the processing stage. We shoot in RAW, with the camera's white balance set to AWB (auto). This gives us a starting point when we do the RAW conversion, but one that we can adjust easily when processing.

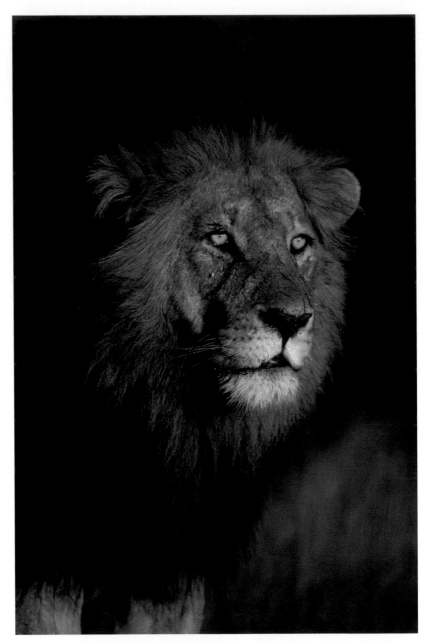

↗ **Lion, Kruger National Park, South Africa**
Canon EOS-1N // 300mm lens // 1/100sec at f/5.6 // Fuji Velvia 50

Not much of a problem when using film like Fuji Velvia, which saturates colour in warm light, there's always a risk these days when shooting digitally in warm light that the camera's white balance adjustment will deaden the impact of the golden hues in your picture. Not what you want if you got up before sunrise to capture subjects in the golden light of dawn. This is one of the reasons we always shoot in RAW.

DIRECTION OF LIGHT

Light direction significantly affects the mood of a wildlife photograph. Play around with this, discovering how to bring out its effects successfully, and you can turn a wildlife image from the mundane to the magical.

The simplest light to work with in wildlife photography is frontlighting, but it's also the most conventional and least dramatic. Photograph subjects with the light behind your shoulder at the best times of day and you're pretty much guaranteed to get pleasing results and rich, punchy colours. Getting correct exposures isn't difficult, and you can achieve the desired catchlights in your subjects' eyes quite easily, simply by moving your position slightly relative to your subject and the light.

Frontlighting tends to flatten out shadows. This can help eradicate areas of deep contrast, but it also means subjects photographed in this way can look fairly one-dimensional.

Sidelighting, on the other hand, adds drama and texture and is useful for highlighting the shapes of subjects. The strong shadows thrown across a subject when you photograph with the light falling obliquely on it add real sculptural modelling, making your subject look truly three-dimensional and alive.

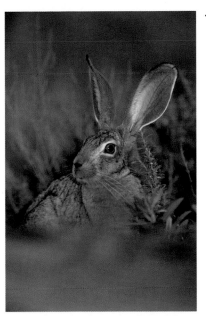

← Scrub hare, Kgalagadi, South Africa
Canon EOS-1N // 500mm lens // 1/60sec at f/6.3 // Fuji Velvia 50

You can't go far wrong photographing frontlit subjects in golden light, as in this shot of an African scrub hare, but you can't really crank up the drama because shadows are flattened and shots can be a bit flat-looking.

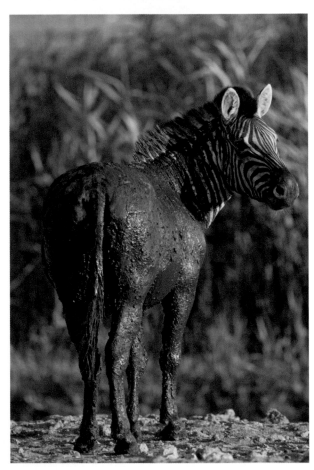

→ Burchell's zebra covered in mud, Namibia
Canon EOS-1N // 400mm lens // 1/80sec at f/5.6 // Fuji Velvia 50

For the most powerful effects using sidelighting, you need to photograph when the light is raking and very low. The contrast between deep shadow areas and the brighter tones in a sidelit shot can make exposing correctly a bit of a headache. To help get round this, decide which areas of the image it's important to hold most detail in and compensate accordingly. Keeping shadow areas dark will add extra drama. In many cases you'll probably want to render most detail on the lit side of the subject.

BACKLIGHTING

Often the most exciting and creative lighting to work with in wildlife photography is backlighting. It's always been the trickiest to deal with, but is worth experimenting with for the rich rewards and depth it can bring to your photography.

Shooting into the light around sunrise and sunset can produce wonderful visual effects. It allows you to render subjects as silhouettes, highlight the hair or fur of their outline with a glowing halo of rim-lighting and emphasize the delicate translucence of a flower petal, ear membrane, outstretched wing or leaf in an almost ethereal way. Backlighting will also turn clouds of dust or mist around your subjects into sheer, veiled curtains of shimmering gold, suggesting at an instant both beauty and movement.

The tricky bit, once again, is exposing correctly. Except in the case of stark silhouettes you will often want to retain some detail in your main subject, so you may need to overexpose a little against what the camera's meter

↗ Male and female mallards at dusk, Martin Mere, UK
Canon EOS 5D // 300mm lens with 1.4x converter // 1/300sec at f/5.6 // ISO 400

We'd been photographing geese coming in to roost at sunset when we suddenly spotted this pair of ducks crossing the pond. We knew that photographing them against such a bright sky would underexpose and silhouette their small shapes in the frame, so were content to go with the camera's metering in this case, further warming up the shot by increasing the colour temperature and contrast at the processing stage.

suggests. If your subject is close enough you can try using a little bit of fill-in flash, which we would set with at least one stop negative flash exposure compensation.

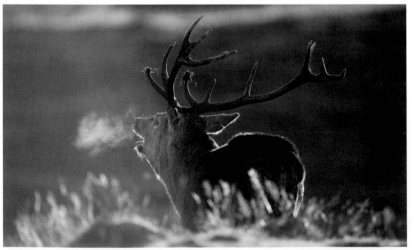

← Red deer stag backlit, Highland Wildlife Park, Scotland
Canon EOS 5D // 500mm lens // 1/100sec at f/4 // ISO 100

This was a grab 'contre jour' shot to capture the breath of the deer stag in the rutting season condensing in the cold air and the halo of rim-lighting that defines the shape of this impressive red deer. You risk flare in these shots but we reckon here it adds to the atmosphere.

↗ **Giraffe silhouette at dusk, Ithala (Ntshondwe), South Africa**
Canon EOS 5D // 300mm lens // 1/1.25sec at f/6.3 // ISO 100

We took a meter reading off a bright part of the sky and locked it in – this ensured the giraffe would be underexposed and completely silhouetted. We then recomposed the shot with the subject looking towards the sunset sky in an effort to recreate that rather wistful and serene feeling that's evoked by the close of another day. Silhouette pictures are often all about mood.

SILHOUETTES

» Keep silhouette compositions simple, with a clear contrast between light and dark areas in the overall design.

» Because you want your subject to render as a true silhouette, you need to take an exposure reading from the brightest part of the picture, such as a sunset sky or the bright reflections of sunrise on water.

» Experiment with a range of different exposures. This sort of photography is pretty subjective and all about mood, so check the effects you're getting on the camera's LCD screen and try a few variations.

» Remember, too, that if you shoot RAW you will have total creative control and can boost the colour temperature of your image at the processing stage to reproduce the effect you want.

PRO TIP

The best subjects for wildlife silhouettes will have distinctive and clearly recognizable shapes. Make sure shapes are not broken up or interrupted by nearby foliage or vegetation, and the graphic outlines of silhouetted shapes are placed cleanly within the frame.

HEAT, LIGHT AND DUST

We've been fortunate enough to spend many weeks photographing in the hot, semi-desert of the Kalahari. Reliable golden light on most days plus dry, arid conditions and a hauntingly beautiful open terrain provide the perfect ingredients for getting dramatic, moody and arresting backlit shots of our subjects as they move through the dusty, empty landscape. It's one of our all-time favourite places to photograph. The techniques we use aren't complex: a fraction of underexposure in the field to highlight the contrast between the dark shapes of our subjects and the golden swirling dust, with a slight increase in temperature and adjustment of Levels at the processing stage to keep things looking punchy and warm. The key in these conditions is to keep equipment dust-free – that means avoiding too many lens changes and taking extreme care when you do – and protecting cameras at all times from the direct heat.

Common wildebeest, Kgalagadi Transfrontier Park, South Africa
Canon EOS 5D // 300mm lens // 1/800sec at f/5.6 // ISO 100

WEATHER

It's always a challenge photographing in different weather conditions, but given that so many wildlife photographs are frontlit, taken in 'nice' weather conditions and with warm light, there's real scope for getting fresh and arresting images by photographing when the weather's a bit more extreme and less pleasant to be out in.

It's fairly obvious, but your first priority when photographing in inclement weather conditions is to make sure both camera equipment and photographer stay dry and warm enough to function optimally. That sorted, you're free to explore the possibilities of photographing subjects when most of your contemporaries will be stuck indoors.

Our first choice of more extreme weather to photograph is the snow – everyone loves a snow scene. Christmas card clichés aside, the soft, reflective light bouncing off snow adds a brilliant quality to wildlife subjects, crisply revealing detail and illuminating images so they appear to glow.

Bear in mind snow takes on an array of subtle colour variations as the light quality changes, so you'll need to make some careful decisions about metering, checking your histogram as you shoot. Everything hinges on the ultimate effect you want to create, of course. As a general rule you need to add light to light-toned subjects, overexposing to get your whites right. However, you may still need to correct the balance with a fraction or two of underexposure to ensure you also hold detail in lighter areas and to prevent whites burning out altogether. Bear in mind if you shoot RAW you will have additional control of being able to tweak white balance and colour temperature at the processing stage.

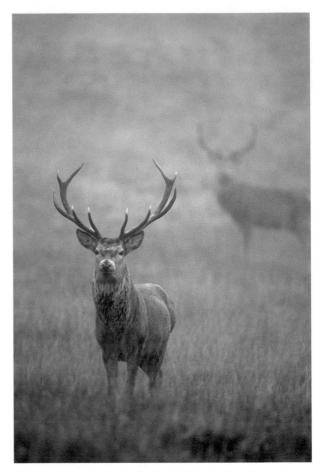

↗ **Red deer stag in mist, Highland glen, Scotland**
Canon EOS-1N // 400mm lens // 1/200sec at f/7.1 // Fuji Sensia 100

Overexpose your image by a half a stop or more if you want to exaggerate the mood and ethereal quality of mist in your pictures.

You can also achieve some interesting effects photographing wildlife subjects in the rain. Pick a day with sunny showers and look for opportunities to isolate a frontlit static subject against a simple, dark background. Simply by altering your shutter speed you can achieve a range of effects. You might elect to freeze the raindrops as they fall by photographing them at a fast speed, or opt to record the rain as impressionistic blurry streaks by slowing down the shutter speed to around 1/30sec or even 1/15sec.

There can be some great photo opportunities either side of an episode of 'bad' weather. We'd normally say no to grey skies as a backdrop for our pictures, but many wildlife subjects look extremely powerful when photographed against the dramatic background of gathering stormclouds, particularly if you wait for the sun to break through and light up the brooding sky. Similarly, scenes of woodland wildlife and wildflower studies, subjects that generally work best photographed in overcast conditions anyway, really come alive immediately after a rain shower, as colours then appear more saturated and intense.

Wind is probably our least favourite weather, despite the fact you can use its noise to mask your approach when stalking, because moving subjects tend to spook more easily and static ones like flowers don't stay static even in the slightest breeze. Your only option with flowers in the wind is to use slow shutter speeds to exaggerate the effect by producing extreme motion blur. The only good thing we can say about wind is that it does help when taking flight shots, as it slows subjects down.

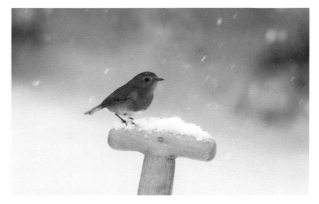

↗ **Robin on spade in falling snow, Cumbria, UK**
Canon EOS-1Ds Mk II // 300mm lens // 1/640sec at f/7.1 // ISO 200

Have subject ideas and good potential locations ready and in mind so you can react fast to photogenic weather conditions like snow. We had placed this spade near garden feeders early on in the winter so birds were already using it regularly as a staging post en route to a free meal.

→ **Frosted seedhead detail, UK**
Canon EOS-1Ds Mk II // 180mm macro lens // 1/640sec at f/8 // ISO 200

Frost flatters the plainest of subjects. We don't normally include pale, wintry skies in our pictures because they're visually unappealing, but here the graphic simplicity of the composition worked much better with the subject framed against a paper-coloured backdrop.

FLASH

Beautiful light is a precious commodity for wildlife photographers and, like all precious commodities, it's sometimes in short supply. That's where flash can help. Flash photography has become a lot easier with the advent of sophisticated modern flashguns, which take a lot of the technical complexity out of the process. There's certainly no longer any need to be afraid of the 'F' word. However, it's also worth remembering that while flash can't create atmosphere, it can kill it, so moderation is the key.

Digital SLRs have, to some extent, reduced the need to use flash in low-light conditions. Top-end cameras produce excellent low-noise images at high ISO settings, and even the relatively noisy images shot on entry-level SLRs at ISOs above 400 can be cleaned up with specialist software. But there are still occasions when careful use of flash can lift an image in a way that post-processing won't.

Using flash at night

For nocturnal photography, flash provides all of the subject illumination. With wild subjects this is a tricky technical exercise, and it can be hard to get aesthetically pleasing images. It's easier to work in the hour or so before sunrise or after sunset, when there is sufficient ambient light to see what you are doing, make good compositions and ensure you are properly focused.

Many cameras have built-in flash units, but these are too weak for most wildlife photography. A single hotshoe-mounted flashgun is OK for stalking nocturnal creatures and we've had success photographing owls, badgers and the like this way. Because the flash duration is less than 1/1000sec, it's fine to handhold the camera.

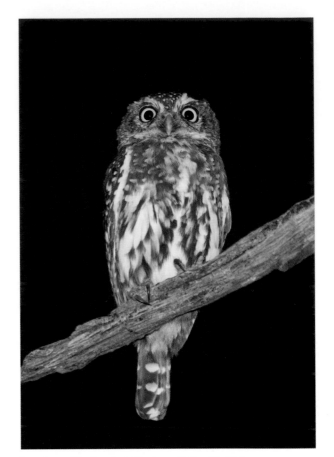

↗ **Pearl-spotted owlet, Kgalagadi, South Africa**
Canon EOS 5D // 300mm lens with 1.4x teleconverter // 1/200sec at f/5.6 // ISO 400 // flash (-1.0EV)

This pearl-spotted owlet was flitting from one hunting perch to another in a bush camp. The only way to photograph it was to stalk it with a handheld camera and on-camera flash, with minus compensation dialled in to avoid blowing the highlights.

We set the camera to program mode and the flash to automatic TTL (through-the-lens) metering. The trickiest problem is focusing, and a good spotlight is essential to light your subject. We've found that a small but powerful head torch is ideal; otherwise you need three hands or an assistant. Torchlight won't have much effect on the flashlit image, but may add a little warmth to counter the cold light of flash.

A single, camera-mounted flashgun tends to produce a flat subject with harsh shadows. It can also result in the dreaded red-eye – the unnatural red, white or green reflections from the eyes of some animals and birds. Moving the flashgun away from the lens axis, by using a flash bracket, can reduce red-eye and add more textural detail, but it can also produce unpleasant shadows.

To get round this problem, and produce more appealing and creative images, it's necessary to use more than one flashgun. Multiple flashgun set-ups are akin to taking studio lighting into a field situation, and are the approach you are likely to need for photographing badgers at a

sett, for example. A typical set-up might include three flashguns linked wirelessly or by cable and set to varying powers, to illuminate the subject and background and avoid dark shadows. As with much flash photography, successful results depend on trial and error.

PRO TIP

Relying purely on automatic flash settings for nocturnal photography invariably seems to result in too much flash, burning out highlights. We generally dial in about -1EV flash compensation (you can set flash compensation either through the flashgun or camera – check your manuals and familiarize yourself with this before you get into the field!). For a small subject surrounded by lots of space you may need even more minus compensation, as the flashgun tries to light the background, or you can spot flash meter if your camera has this facility. If your image ends up a little underexposed, it's possible to fix this on the computer.

← **Natterjack toad, Cumbria, UK**
Canon EOS-1Ds Mk II // 300mm lens with 1.4x teleconverter // 1/200sec at f/13 // ISO 640 // flash (-1.0EV) // photographed under licence

A head torch provided sufficient illumination to allow the camera to focus for this shot of a natterjack 'toad in the hole'. But don't blind your subjects with too much light or you can temporarily affect their ability to hunt or evade predators.

Fill flash

Fill flash is used to supplement natural light. It's particularly useful in harsh sunlight, which creates very bright highlights and deep shadows. Neither film nor digital sensors can cope with this brightness range, so if you expose for highlights you'll lose shadow detail, but if you expose for shadows you'll blow the highlights. Fill flash gives extra illumination to your foreground subject, lightening shadows, revealing detail and colour and reducing the brightness range to something that your camera can fully record.

Fill flash is also useful in flat, low light, such as on a heavily overcast day, to add sparkle, colour and textural detail to a subject and help lift it from the background. It can add life to the eyes of a bird or animal with dark or deep-set eyes by creating a catchlight, enhance the iridescent sheen of a beetle's carapace, or neutralize the bluish cast in the shadows on a seabird's white feathers on a sunny day. And with macro subjects it can boost the light level to enable a fast enough shutter speed and sufficient depth of field.

You can rely on your flashgun's daylight balancing mode for fill flash, but this often gives an over-flashy appearance. Our approach is to set the camera to expose for highlight detail, then manually dial in minus flash compensation. Getting this right isn't always easy, but a value of -1.7EV for a mid-toned subject is a good starting point. A dark subject might need -2.3EV, a white subject as little as 0.7EV. If your subject stays around for long enough then check the LED histogram on your camera and adjust flash exposure as necessary.

↗ **Southern white-faced scops owl, Kgalagadi, South Africa**
Canon EOS-1N // 300mm lens // 1/1.25sec at f/5.6 // ISO 400 // flash (-1.0EV)

Although this southern white-faced scops owl was well habituated to people passing its regular daytime roost, it perched deep among foliage, to avoid the hot African sun. Because there was so little available light it was necessary to use more flash than we'd have liked (-1.0EV flash compensation), but it's better than no picture at all.

→ **Wahlberg's epaulleted fruit bat, Kruger, South Africa**
Canon EOS 5D // 300mm lens with 1.4x teleconverter // 1/1.25sec at f/5.6 // ISO 400 // flash (-1.7EV)

Shooting directly upwards while handholding a heavy camera-lens-flash combination, it's hard to hold your camera steady. For a close-up shot such as this image of a Wahlberg's epaulleted fruit bat, focus is critical. By setting the camera to focus tracking mode (AI Servo), you can ensure that it will maintain focus, even if you sway a little nearer or further from your subject.

← Lion, Kgalagadi, South Africa
Canon EOS 5D // 70–200mm lens at 135mm // 1/30sec at f/5.6 // ISO 400 // flash (-1.7EV)

We encountered this pride male before sunrise, light levels were very low, and flash was unavoidable. But we also wanted to capture the lovely pinks and blues in the sky, so set a slow shutter speed to ensure ambient light contributed as much as possible to the overall image. Fortunately, the lion, intent on watching a lioness, was motionless.

SPECIALIST FLASH MODES

Slow sync flash
Using flash in low light often results in a well-lit subject but a dark background. By setting your camera to Av, Tv, or M mode and selecting a slow shutter speed (1/30sec or slower) the background appears better lit. You'll need a tripod or beanbags to avoid camera shake, and a very still subject.

Rear curtain sync
If you photograph a fast-moving animal with a mixture of ambient light and flash, the ambient light will give motion streaks, and the flash a sharp image. But because the flash fires at the beginning of the exposure, the motion streaks will appear in front of your subject. By setting your camera for rear curtain sync, the flash fires at the end of the exposure, and you get a more natural effect of motion streaks behind the moving subject.

Stroboscopic flash
Some high-end dedicated flashguns allow you to fire a series of rapid flashes during a single exposure. This requires an exposure of more than 1/2sec, and results in multiple images of the moving animal in the frame.

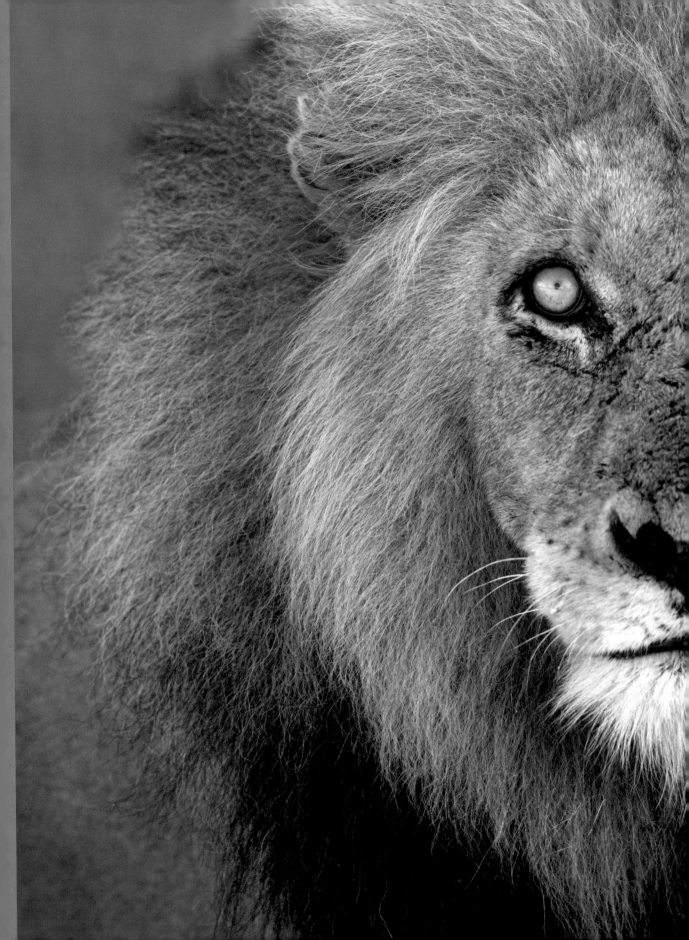

03

COMPOSITION FOR WILDLIFE

Male lion, South Africa
Canon EOS 5D // 300mm lens // 1/50sec at f/7.1 // ISO 100

Dare to be different when framing wildlife pictures. We've
been fortunate enough to photograph lions up close in the
wild on many occasions and we never fail to feel a sense of
awe and vulnerability when coming lens-to-eyeball with a big
male. Framing the shot in this unorthodox way, so all attention
is focused on that single yellow eye, helps put tons of extra
emphasis on the king of mammal's predatory stare.

INTRODUCTION TO COMPOSITION

Composition in wildlife photography provides the opportunity to put a personal stamp on your pictures of the natural world.

The way you choose to order, structure, arrange or design the elements of your picture within the frame will communicate as much to the viewer about your response to your subject, and your own particular passion for wildlife, as it will tell them about the subject itself.

Bear in mind backgrounds are just as important as your subject itself when composing wildlife pictures, and can often be the visual component that makes or breaks your photograph.

Of course there are 'rules' you can follow when organizing the various visual elements of your picture, but it's important not to think of these as anything other than guidelines or starting points. It's useful to know them, since they can help you produce pleasing and successful pictures, but you certainly shouldn't be confined or restricted by them when framing. Think of them instead like a standard composition toolkit, handy for some jobs, but not always essential. Some of the most visually arresting wildlife images are the ones that completely ignore these so-called rules. So have fun tearing up the rulebook – experiment, follow your instincts and emotions and strive for something new, refreshing and different. At the end of the day you are the one in the creative driving seat and it's entirely down to you how you present your subjects and the natural world to the rest of us.

You can develop a greater visual awareness and encourage your eye for composition by immersing yourself as much as possible in the world of wildlife and wildlife imagery. Watch TV wildlife documentaries, pore over magazines, visit wildlife photographers' websites and attend lectures, presentations and galleries featuring top-drawer wildlife images. Be critical – assess what works and why – and develop high critical standards for your own work. Learn to 'work' subjects for as long as possible, looking through your viewfinder from a range of different angles and viewpoints, and using a range of different lenses, to fully explore the creative possibilities of each situation in the field.

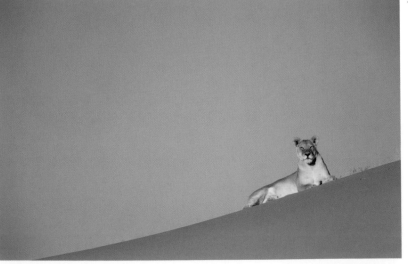

← Lioness on dune, Kalahari, South Africa
Canon EOS-1Ds Mk II // 500mm lens with 2x converter // 1/640sec at f/8 // ISO 100

Think about design when composing wildlife pictures and it will soon become instinctive. Because the lioness here was stationary, there was plenty of time to arrange the visual elements of the image within the frame. The image is cut by a simple graphic diagonal that divides the picture into two bands of colour, one third orange dune and two-thirds blue sky (50/50 splits tend to look too symmetrical). If we then place an imaginary grid, dividing the image vertically and horizontally into thirds, you can see the lioness has been placed on one intersection of these vertical and horizontal lines, which is a visual 'hotspot' in the picture (see also pages 83 and 84).

↗ Reed bunting, Cumbria, UK
Canon EOS-1Ds Mk II // 500mm lens with 1.4x converter //
1/320sec at f/7.1 // ISO 200

Several design elements combine in this simple picture of a bird
perched on a garden fence. Firstly, the colours of the bunting
and its setting are complementary and harmonious. The bird is
positioned close to the junction of thirds and is looking back into
the picture. The fence posts split the picture two-thirds of the
way up and help direct our eyes to the subject. Finally, the
manmade structure of the fence adds a note of formality that
contrasts well with the softer, organic shape of the bird.

TIPS ON DESIGNING WILDLIFE PICTURES

» Balancing the visual components of your picture is
fine, but try to avoid too much symmetry. This tends to
detract from the subject matter and can split the picture
into distinct halves.

» Keep compositions simple with one main focal point or
dominant point of emphasis.

» Give as much attention to how the background is going
to look in your finished picture as you would your main
subject and make backgrounds work hard for you by
helping to make the main subject really stand out.

» Always check for unwanted background clutter and
highlights before you release the shutter.

» Learn to see the subjects in your viewfinder in terms
of their shapes and forms, forgetting their names
and identities.

» Give subjects room to breathe in the frame. Frame-filling
shots and extreme close-ups can be very powerful, but
they do not reveal important clues about a subject's
lifestyle and habitat.

» You can use pattern, repeated shapes and lines (both
straight and wavy) to impose a sense of formality and
stability to pictures of the natural world.

» Bear in mind you can improve some compositions at
the processing stage when shooting digitally by
cropping images.

» Don't be afraid to use the rule of thirds as a general
guide to getting the proportions right in your picture.

» Previsualize wildlife pictures – using your mind's eye
like an artist's sketchbook to map out ideas for the
pictures you'd like to create.

SUBJECT POSITION AND LEAD-IN LINES

You can improve the visual power and appeal of a wildlife image simply by changing the position of your main subject within the frame. It's usually more effective, for example, to place a static wildlife subject off-centre looking into the frame, with space to move into the picture, than slap-bang in the middle of the frame, which makes the subject appear static and lifeless.

Similarly, when photographing a moving subject the picture will work better if the subject appears to be moving into the frame. If the moving subject is placed centrally, or appears to be moving out of the frame, this will lead the viewer's eye out of and away from your picture

It can help to think of your frame as a grid divided horizontally and vertically into three sections. The points on this grid where these lines intersect are the visual hotspots in any picture – the areas within the frame to which the viewer's eye will most readily be drawn. A simple way to improve composition in wildlife pictures is to place the focal point of interest in the picture, either

your subject itself, or the eye of your subject, depending on the subject's size in the frame, on or near one of these imaginary intersections. This is known as the 'rule of thirds'. It's fashionable to knock this rule as a compositional tool, but it's extremely widely used because it works so well.

You can make strong statements in your wildlife photography by confounding the viewer's expectations on occasion, too. Place a subject at the extreme edge of the frame so a significant part of its form is concealed from the audience, for example, or deliberately place an active subject, like a flying bird, so that it's moving out of the frame and it will intrigue and tease the viewer, create a sense of tension and arrest attention. It's always worth pushing the boundaries to see what you can produce, bearing in mind you need to be bold rather than tentative for the most striking effects.

The trick with wildlife pictures is getting to the stage where making such considerations about composition become second nature when

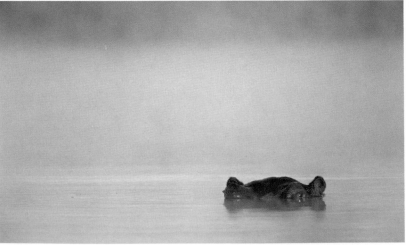

← Hippo in mist, Kruger National Park, South Africa
Canon EOS-1N // 500mm lens // 1/250sec at f/5.6 // Fuji Velvia 50

Here, we placed our subject deliberately off-centre, close to the intersection of the thirds on the imaginary grid, as this is one of the areas in a frame that our eyes are immediately drawn to.

you're out in the field working at speed with a moving subject. The best way to do this is to spend as much time as possible trying out and getting familiar with different framing techniques and taking time out to evaluate your results objectively.

In addition to exploiting the key power points when placing wildlife subjects in the frame there are other compositional devices you can use to draw the viewer's eye to your main focal point. These are sometimes referred to as lead-in lines, where the use of bold shapes and lines within the frame act as a visual map, signposting the viewer's route to your subject and holding his or her eye within the frame. Strong diagonals that direct the reader's eye towards the main subject or curving or snaking sinuous shapes that meander to the focal point can all work well visually, as can continuous shapes such as triangles or circles that take the eye around an image and back again. In wildlife pictures these shapes and lines are usually provided by natural elements in your picture such as streams, rivers, pathways, rocks, tree branches, plant stems, fence-lines and so on. The easiest way to learn how these can be used to strengthen a composition is to look at how other photographers have used them and have a go yourself.

PRO TIP

We frame many pictures like the hippo image opposite, for aesthetic reasons, but also for commercial ones too, because magazine designers like to use them as double-page spreads – running text and headlines over the clean, uncluttered backgrounds.

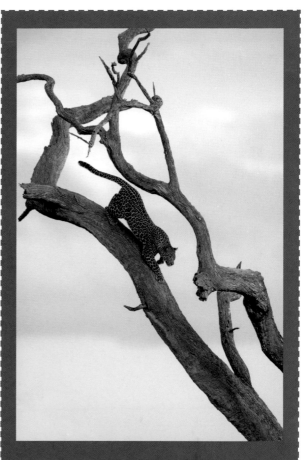

LEAD-IN LINES

The diagonal created in this picture by the trunk and boughs of this dead tree provide a clear viewing route or 'map' for the audience. Your eye is drawn along the branches to the leopard and back round again so your attention is never taken away from the focal point in the picture. There's no need to fill the frame with subjects either – images can still be powerful where subjects are quite small, particularly where compositions are well designed.

↑ **Leopard in tree, Kruger National Park, South Africa**
Canon EOS-1Ds Mk II // 500mm lens with 1.4x converter // 1/320sec at f/7.1 // ISO 125

COLOUR AND COMPOSITION

It always amazes us just how vivid and intense, or soft and subtle, colour can be in the natural world. Couple this extremely wide colour spectrum with the effects produced by the changing colour temperature of light and it becomes clear there is almost endless scope to celebrate colour in wildlife photography. Focus closely on a wildflower petal, for example, or a bird's feather, and colour alone can stand up as the single point of interest within your photograph.

Colour is always an extremely useful tool to have in your composition kitbag, and can actually be a make-or-break factor in the success of many images. Photograph a hare in field of ripening crops, then photograph a hare in a field of poppies, and there's no doubt the latter will attract most attention. This is because warm colours, like reds and oranges, tend to dominate an image, grabbing the viewer's attention first and creating a positive feeling of energy and vigour.

Even a tiny dab of bright red in a picture will shout louder than the other colours. So if there was just a single red poppy in the background of our portrait of the hare, for example, instead

African black oystercatchers, De Hoop Nature Reserve, South Africa
Canon EOS-1Ds Mk II // 300mm lens with 1.4x converter // 1/400sec at f/5.6 // ISO 100

Although these birds are mainly black, this composition is also made by colour. The points of warm red in their beaks and eyes jump out against the cooler blue and aqua colours of the ocean behind them.

← Coal tit on willow, Cumbria, UK
Canon EOS-1Ds Mk II // 500mm lens
with 1.4x converter // 1/640sec at
f/6.3 // ISO 200

The willow branch and bird are quite
monochromatic here. It's the striking yellow
background that brings this picture to
life. We moved our garden bird feeder, to
which the willow branch (from the florist!)
was attached, simply so we could exploit
the out of focus colour from a nearby
yellow blooming shrub to bring a splash of
intense, eye-popping colour to the image.

of a whole bunch, we might have found the flower
in this instance detracting from our picture rather
than enhancing it. This is because the eye is
continually drawn to the distracting flower head
and not to our main focal point, the hare.

From this you can begin to see how colour is
an important building block in composition design
that can be used to arrest attention, create
a particular effect and even manipulate the
viewer's emotional response.

If you look at the colour wheel below you
will see how the darker, cooler colours appear to
recede while the warmer red, orange and yellow
colours appear closer. Colours like greens and
blues appear more calming, tranquil and restful
to the eye because they don't jump forward in an
image and shout 'Look at me!' A blue flower in the
background of our hare picture might well have
proved less of a distraction.

It's helpful to understand the relationship
between different colours because you can
exploit these effects when composing many
of your wildlife pictures. If you want to go for
striking contrasts in a picture choose the
colours opposite each other on the wheel that
are complementary to each other, for example a

red fox against the background of a green field.
Remember when arranging the various elements
of your picture that the warmer colours will
stand out and the cooler ones recede. This is
another reason why it's so important to consider
backgrounds carefully. If, for example, your main
subject is a blue butterfly and you photograph
it against a background of vivid orange flower
spikes, the opposite colour to blue on the
wheel, there's a danger the orange background
colours could dominate and detract attention
from the insect, whereas an orange butterfly
photographed against a background of blue
flower spikes would really stand out.

Colours close to each other on the wheel
will produce less powerful contrast but will work
together harmoniously in your picture.

Study this colour wheel
to learn how certain
colours complement
each other, while
others contrast more
powerfully – then use
this knowledge when
next in the field.

PERSPECTIVE

Most wildlife pictures work best photographed at the subjects' eye level – it looks more natural. In many cases this means working at ground level, often lying prone. Switching to photographing wildlife in this way is a quickfire method to improve your pictures, because it also helps you throw backgrounds out of focus.

You can change the complete mood and look of a wildlife picture simply by shifting your position, changing your viewpoint or switching to a new lens.

Because of this a single subject may provide you with a range of different framing options. All of them may be worthwhile, with potential to produce a usable picture, so it's up to you to make the creative decision as to which route you're going to go down. The key thing to bear in mind is that you will only gain full creative control of a photo opportunity by understanding the different results you can achieve by changing the perspective in a picture. If you're shooting commercially you may well choose to photograph the same subject several times from a range of different angles and using a selection of different lenses. When we're out photographing, for example, we would aim to get as many different shots as possible from a single photographic opportunity to maximize the potential future return.

It's very easy, in wildlife photography, to get hooked on using long lenses. You've made the considerable investment to acquire one so it's understandable that you want to get good use out of it, but the problem comes in becoming over-reliant on them – even in situations where you don't really need them to get close. Telephoto lenses, anything above the 200mm focal length mark, have a narrow field of view and make backgrounds appear closer to your subject by ironing out perspective. Using long lenses can, therefore, make pictures look quite flat and one-dimensional, so if you're using them all the time your images will start to look a bit one-paced and appear to lack depth and dynamism. The upside of this feature of long lenses, creatively speaking, is that you can turn it to your advantage and exploit this foreshortening effect in some of your pictures. For example, if you're photographing carpets of bluebells in woodland the flowers will look as if there are more flowers and they will appear more massed together if you switch to using a longer lens. You can also use the narrow field of view long lenses provide to isolate a single subject from a group, making it stand out more readily from the background.

Wideangle lenses aren't used as often as telephotos in wildlife photography for obvious reasons – you don't generally get the chance to get close enough to use them unless you're shooting flowers or still-life subjects. For this reason alone, wildlife images taken with wide angles generally look refreshingly different, arresting and three-dimensional. The broad angle of view these lenses afford really brings subjects to life and allows you to include lots of in-focus background habitat detail.

The important thing is to experiment with different lenses and viewpoints and to try to vary the 'pace' of pictures in your own personal portfolio.

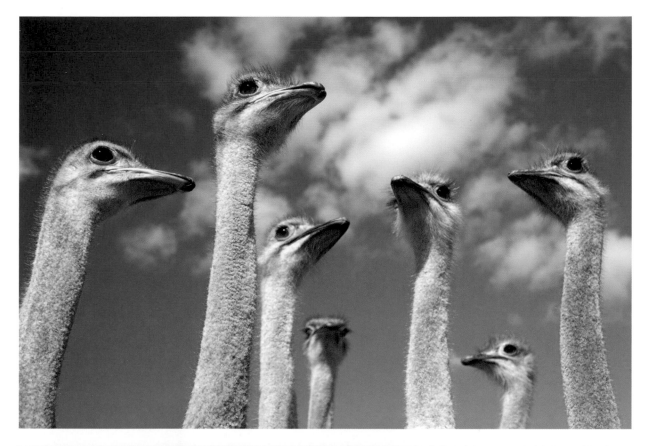

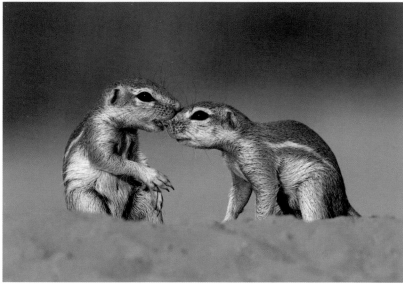

↑ Ostriches on ostrich farm, Western Cape, South Africa

Canon EOS-1Ds Mk II // 28–80mm lens // 1/100sec at f/7.1 // ISO 100

We moved as close as possible to the birds then crouched down low using wideangle lenses to exaggerate the perspective and those endlessly long ostrich necks against a bright blue sky.

← Baby ground squirrels greeting, Kalahari, South Africa

Canon EOS-1Ds Mk II // 300mm lens with 1.4x converter // 1/150sec at f/8 // ISO 125

Longer lenses flatten perspective, appearing to bring background and foreground closer to your subject. This helps gives extra intimacy to this study of the ground squirrel offspring interacting.

DEPTH OF FIELD AND COMPOSITION

The ability to control depth of field is a big plus when taking wildlife pictures. For starters you can ensure your subjects stand out from their surroundings by achieving the perfect balance between a subject that's pin-sharp and a background where the focus falls off.

It pays to have a camera with a depth-of-field preview button so you can review the effects of subtle changes to your pictures as you open or close the camera's aperture before firing the shutter release. Remember (see page 51) that in opening the aperture wider by selecting a smaller f-stop, you will get less depth of field, and, conversely, in closing down the aperture, by selecting a higher f-stop, you will increase depth of field. Using the depth-of-field preview button can be particularly helpful when photographing static subjects, flower studies and close-ups where it's very important to get the subject sufficiently sharp without bringing up the background detail. There's usually time with subjects like these to make any necessary minor adjustments when framing. If your camera doesn't have this function, or it's difficult to see the effects of any changes in low-lighting conditions, it's worth taking a series of frames with small, incremental changes to the amount of depth of field you select. You can then choose the image you prefer at the editing stage.

Creative control of depth of field is not simply about getting the subject/background trade-off right, however. You can also use it to add mood or emphasis to your pictures and to illustrate universal concepts through your wildlife

LESS IS MORE

The only part of our picture in sharp focus here is the warthog, neatly framed by the sturdy, but out of focus, limbs of the huge elephant on the near side of the water. The creative control of depth of field here helps emphasize the diminutive stature of the warthog in comparison with the elephant, while helping focus the viewer's attention right where we want it. If we'd used lots of depth of field here to render both warthog and elephant sharp, our 'creative point' about their juxtaposition in size would have been lost or, certainly, less forcefully hammered home.

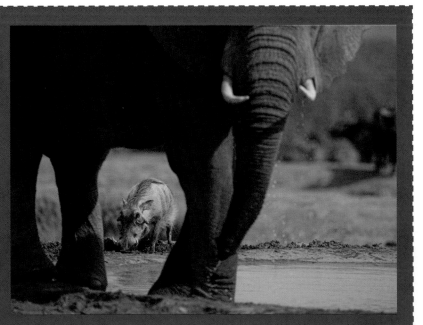

↑ **Warthog drinking with elephant, Addo National Park, South Africa**
Canon EOS-1Ds Mk II // 500mm lens // 1/400sec at f/5.6 // ISO 200

← Brant's whistling rat, Kalahari, South Africa
Canon EOS-1Ds Mk II // 500mm lens // 1/200sec at f/5 // ISO 200

Working from a low perspective with a long lens and minimal depth of field should ensure the subject on which you focus is sharp, and your picture packed with punch, because the background and foreground will be neatly rendered as a pleasing out-of-focus colour wash.

photography. For example, you could choose to photograph a huge seabird colony with lots of depth of field so that all the birds in the picture are sharp from front to back, conveying the idea of a thronging horde or gathered masses. Alternatively, you could opt to use shallow depth of field to isolate a lone bird among the ranks. With only a single seabird within the image in sharp focus you're instantly creating the notion of 'one in a crowd' or a stand-alone individual.

You can achieve quite striking effects using shallow depth of field together with quite simple compositions. Using a technique sometimes referred to as differential focusing, it's possible to concentrate the viewer's attention on a single detail, colour or shape in a picture, or even create wildlife abstracts, simply by taking away sharp detail from certain parts of your picture. The technique involves working with minimal depth of field using very low f-stops. By focusing on just one area of your subject, such as the delicate edge of a petal for example, you can cleverly draw attention to a subject's fragility, as only this portion of the frame will be rendered in sharp focus.

↘ Raindrop on flower petal, UK
Canon EOS 5D // 180mm macro lens // 1/20sec at f/4.5 // ISO 200

Here we used differential focusing to spotlight a single raindrop suspended from the edge of a flower petal after rain.

FRAMES WITHIN FRAMES

In wildlife photography your subjects are the stars. One way to ensure they're truly under the spotlight in your picture is by creating a frame within a frame when you compose your shot.

Photographing a wildlife subject within the open space created by an overhanging branch brushing the woodland floor, the dark entrance to a burrow or den, the gap between foliage and flowers or the shadowy crevices of a craggy rock face is like hanging a picture in a gallery. It will instantly draw attention to your subject and give it pride of place.

Look out for situations in which you can exploit the technique and be prepared to change your viewpoint and your lens to achieve the desired effect. Obviously, it's not always possible to place a wild subject exactly where you want it in the surroundings, but there are a surprising number of occasions where the location or habitat offers you the scope to take advantage of naturally occurring features to frame your subject within the confines of the picture area. This will really help you create a visual power point in your picture.

Creating frames within frames offers you another opportunity to control depth of field creatively to produce different visual effects. You can choose to use plenty of depth of field to ensure both your main subject and the surroundings that frame it are rendered in sharp focus or you can opt to open up and photograph with minimal depth so that while your subject is nice and sharp, the surroundings framing it are pleasingly out of focus and don't distract from the picture's main focal point. Both approaches are valid and can produce striking pictures. It's up to you to make the creative choices as you photograph. If you can't find naturally occurring features to create a frame within a frame, you can still reproduce the effect quite strikingly by throwing the foreground as well as the background in a picture out of focus. This has the effect of framing your subject with a delicate soft focus effect that emphasizes colour rather than form in the background and foreground areas and throws the viewer's attention neatly on your main subject or focal point. To ensure foregrounds are out of focus it helps to use a longer lens to exploit the foreshortening

← **Kestrel, captive, UK**
Canon EOS-1Ds Mk II // 300mm lens // 1/1,250sec at f/7.1 // ISO 200

You can use existing structures or background material to create inner frames in your compositions as here.

effect and to photograph from a low angle. The low angle will also you help throw background detail out of focus, too.

With some subjects you will need to work with your lens quite close to the foreground in order to achieve this out of focus 'halo' effect of background and foreground combined to give a frame to your subject. If you do this when photographing with the lens up close to a patch of wildflowers, for example, this can create a delicate veil of diffused contrasting or complementary colour across the bottom section of the frame which when combined with an out of focus background works to blur the edges around the subject in a pleasing way.

Bear in mind when photographing small subjects using this technique you may need to use an extension tube to help you focus closer using a long lens. This is a great technique to experiment with and a great way to use colour effectively in your wildlife compositions.

PRO TIP

Both the images used here are of captive birds. That's because when working commercially you can 'art-direct' pictures, creating the exact composition you want – like these examples of 'frames within frames' – much more readily when working in a controlled situation. That's not to say we don't use such framing devices with wild subjects, too, when the opportunity presents itself. We always make sure we declare in our captions where subjects are captive or controlled.

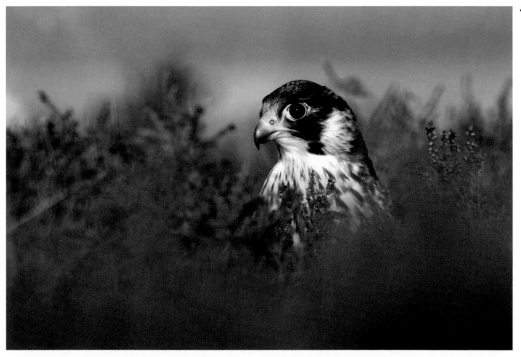

← **Young peregrine in heather, captive, UK**

Canon EOS-1Ds Mk II // 300mm lens // 1/640sec at f/7.1 // ISO 400

You can create inner frames by throwing foregrounds as well as backgrounds out of focus. This is achieved by photographing through foreground vegetation, in this case heather, directly in front of the lens.

MOTION AND COMPOSITION

This composition of a bird in motion breaks all the rules of composition and flight shots. We both reckon – you may not agree, of course – that the image is all the more powerful because of it. The bird is flying out of the picture, which is generally a no-no when it comes to framing moving wildlife subjects, and its wing tips are clipped by the edge of the picture – another black mark since it's generally accepted that you should have every part of your subject safely within the confines of the frame. Most times we'd agree with this received wisdom and, generally, we adhere to it when photographing our action shots of animals and birds. Despite this, the image here works well and has ended up being our favourite from a series of close-up mobbing tern pictures in which the rules of composition were slavishly followed. The other shots work well, but don't have the freshness and dynamism of this one. At the end of day it's probably all down to taste, but we would encourage you to push the boundaries of composition and break with the tried and tested at least some of the time.

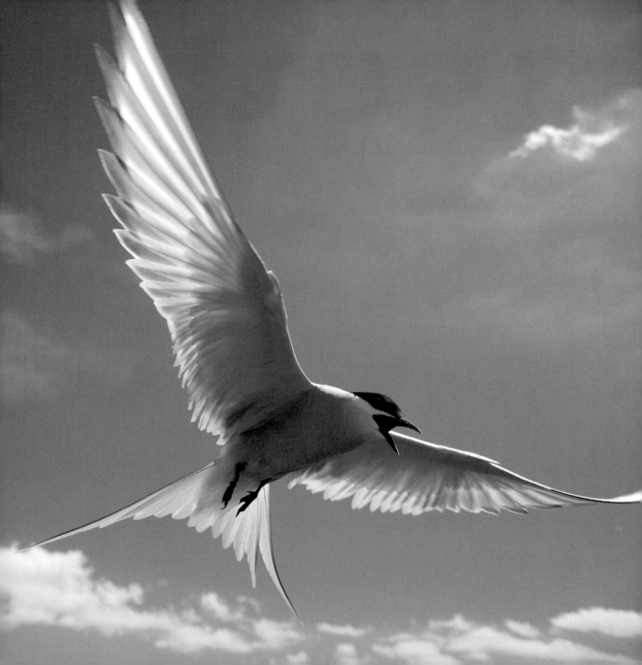

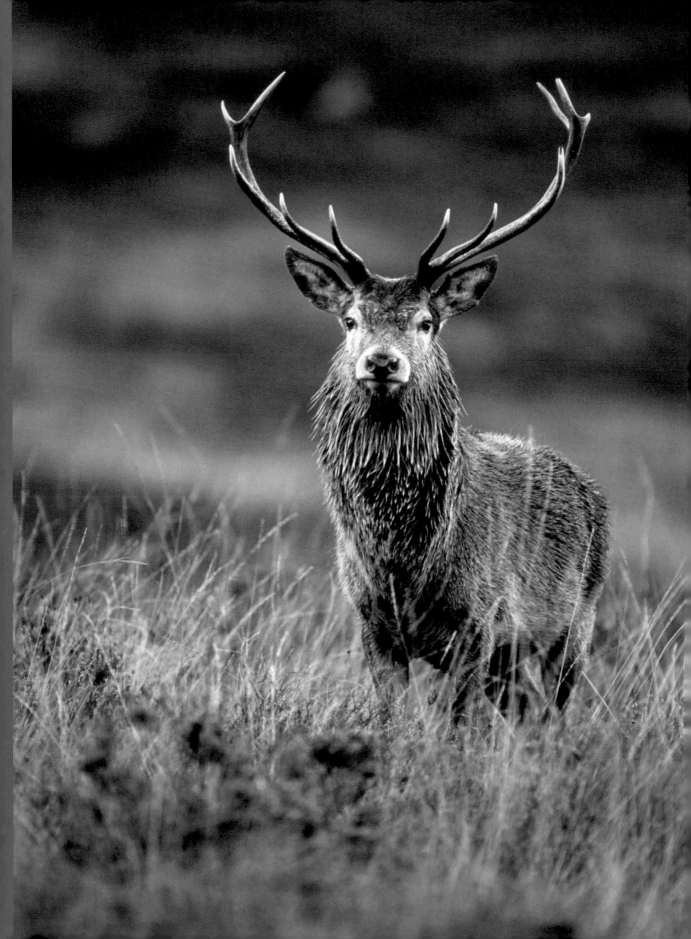

CHAPTER

04

WILDLIFE PHOTOGRAPHY IN THE FIELD

Red deer stag, Glen Strathfarrar, Scotland, UK
Canon EOS-1N // 400mm lens // 1/60sec at f/5.6 // Fuji Velvia 50

Waiting patiently for the situation to develop, the chance to spend time simply observing a species, being outdoors as much as possible and the anticipation and excitement as to whether or not you'll come away with just one of the images you hope for at the end of a day – this is what being in the field is really all about for us. The photography part, framing the picture and releasing the shutter, may be over in a matter of moments, but we're drawing on all our previous experiences, triumphs and abject failures, each time that 'decisive moment' occurs. Nothing beats being out there for improving your skills and pictures.

CLASSIC ANIMAL PORTRAITS

The best animal portraits may appear effortless, but getting them right is a bit like cooking a meal. You need to have all the right ingredients and they've got to come together at just the right time.

A common mistake is to assume portraits are really only about the subject being portrayed, when in actual fact the main subject is really only a part of the whole. It might sound odd, but it's quite amazing how often our starting point or inspiration for a portrait is not the subject itself, but a potentially good-looking background that we can envisage setting off the 'star' of our picture. It might seem a topsy-turvy way to go about things, but it does help illustrate the fact that the location, your subject's surroundings and the background are as important in creating your final composition as a great animal subject in its own right.

The best backgrounds for animal portraits are clean and uncluttered. Simple colour washes that complement or contrast well with the main subject work very well. To achieve this effect you need to ensure the focus in your picture falls away nicely from the main subject. This means using your depth-of-field preview button to check you have enough depth of field to ensure your subject will be sharp throughout, but not so much that that the background detail starts to come into sharp focus too. Generally this means working at f-stops anywhere from around f/5.6 to f/11 for portraits when using longer lenses, depending on your subject and its distance from the background, of course.

Light cloud cover on bright days offers great lighting conditions for portrait work because it irons out harsh shadows, prevents colour from bleaching out and renders fur and feather detail brilliantly.

Take time to get it right. It sounds obvious but look for pristine specimens in their prime and wait for the perfect moment before you press the shutter. A successful portrait stands or falls on the animal's pose. Photograph subjects looking alert – ears pricked, eyes wide awake, etc. – rather than hangdog or half-asleep. Tall, upright subjects are best photographed in portrait mode. If you photograph an animal like a deer in portrait format, however, make sure the animal is front or three-quarters onto the camera – don't chop half of it off, as it will just look wrong. If it's sideways on to the camera it's usually better to photograph it in landscape format.

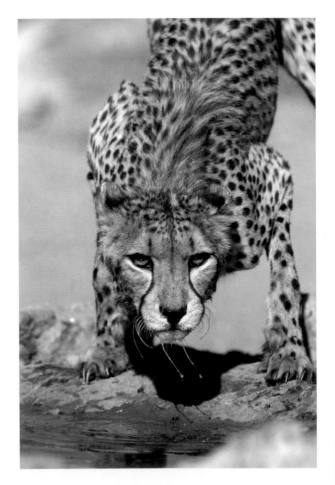

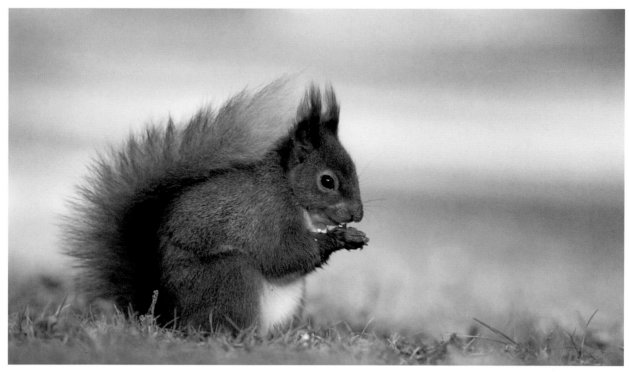

← **Cheetah drinking, Kalahari, South Africa**
Canon EOS-1Ds Mk II // 500mm lens with 1.4x converter // 1/640sec at f/8 // ISO 100

Aim for as alert an expression as possible, and as much direct eye contact as you can.

↙ **Marico flycatcher, Etosha, Namibia**
Canon EOS-1N // 300mm lens // 1/250sec at f/7.1 // Fuji Velvia 50

This bird portrait began with the background. We thought the orange sand would be perfect. Briefly turning on the tap so just the odd drop trickled out, we soon attracted thirsty birds to the waterspout.

↑ **Red squirrel, Cumbria, UK**
Canon EOS-1N // 400mm lens // 1/100sec at f/5.6 // Fuji Velvia 50

We used hazelnuts to lure this red squirrel away from a messy background. The next thing was to wait patiently for a keen eye and its tail to curl up characteristically before pressing the trigger.

PRO TIP

The key to success often lies in getting the eyes right. In those cases where you may have to sacrifice some depth of field in a picture, at least make sure you get the eyes spot-on by always focusing on them or the head of your subject. Go for good eye contact when composing if you can, and always get a catchlight in your subject's eye before releasing the shutter. If you're photographing an upright shot, in portrait format, your picture will be more powerful if you frame it so a subject's eyes are ideally on or around the two-thirds mark. One word of warning – when you're focusing on a subject's eyes, check you have sufficient depth of field to ensure the parts of the subject nearer the camera than its eyes, nose, muzzle, breast etc., will also be in focus.

PERFECTING PORTRAITS

Try not to get caught up in the rather outmoded idea that animal portraits should be ID shots and that the sole purpose of portraiture is to get a technically acceptable record shot of a species for the natural history books.

Identification shots have their place, of course — in the guide and reference books — but unless you're chasing up extremely rare species that have hardly been photographed, there's little reward in repeating images that already exist in the world canon of wildlife images. Having said all that, we still take these shots for our online database so we can build more comprehensive coverage for clients, and for photo libraries where we know they have gaps, but these days animal portraits for us are increasingly about finding fresh ways to capture the essence, spirit and characteristics that sum up an animal.

Another way to approach this is to think about photographing animals in a way that illustrates some of the general concepts they might represent. Obvious examples might be the climax of a lion's roar to represent aggression or power, or a cheetah at full tilt to convey the notion of speed and athleticism. The beauty of this approach, from a commercial as well as an artistic point of view, is that concept pictures have a much wider general audience than 'straight', specialist natural history pictures and sales returns can be much higher when these pictures are done really well.

Remember, there's no written rule that says you must include the whole animal in a portrait. A single eye peering through dense foliage may convey much more about the nature of your subject and its habitat than if you'd waited for the animal to emerge into a clearing. Extreme close-ups, too, while removing context, will force all attention directly on your subject and can be great for exaggerating expression. Be bold if you crop in close when framing these shots. It should look deliberate. If you're too tentative, for example, only slightly clipping an ear when framing, then it can look like a mistake.

← Badger cub, orphan in care, UK
Canon EOS-1Ds Mk II // 300mm lens // 1/640sec at f/6.3 // ISO 100

Another woodland species, although in this case the picture is deliberately contrived. For us this image is as much about design and composition as it about the badger cub peeping through the hole. Here we were simply looking for a novel approach for a much-photographed species.

→ **Long-eared owl,
captive, UK**
Canon EOS-1N
// 300mm lens //
1/100sec at f/5.6
// Fuji Velvia 50

The best animal
portraits say
something about
your subject.
Because so much
of the subject
is hidden in this
shot it helps
communicate to
the viewer the fact
that this owl is
shy, secretive and
seldom seen. The
single, watchful eye
helps emphasize
the alert nature
of this woodland
predator.

PHOTOGRAPHING GROUPS

This is where animal portraiture gets a bit more complicated – but more interesting at the same time. We're often asked on workshops about the best ways to get animal groups right, because, in terms of both composition and technique, they're probably the hardest shots to do really well. Even if a huge herd of deer or antelope appears awesome to the naked eye, all too often photographs of them disappoint, they simply don't match up with our original experience of the scene, and can end up looking like snaps. So how do you make group shots work?

We'll look first at dealing with the numbers. There are several approaches you can take when faced with huge groups of animals. Most involve the photographer imposing some sort of order on what's, after all, a pretty random situation. Given we can't ask subjects to pose for us like wedding guests there are still things we can do when framing to help us arrange individual animals within the group in a pleasing way in our pictures. What we usually do in this situation is to look for a photogenic sub-group within the overall group that catches our eye. It might

be that some animals appear closer together than the others, or we may notice some are engaging in a certain activity, sparring for example, in one part of the 'crowd'. It may be there's a sub-group of mothers with young, or a congregation of males with impressive horns or antlers. Perhaps one animal or small group is completely different from the rest, like zebra in a crowd of wildebeest.

We're basically looking for anything in the overall group we can home in on that could add extra interest to our picture in terms of content, or that could help us impose some structure or design in terms of composition.

The other thing we often try to do is to look at the overall group as a series of shapes, instead of seeing them as an identifiable species. This helps us find the hidden compositions in a big group. For example, there may be repeat shapes, diagonals or bands of colour that suggest a pattern or something you could highlight in your picture. With practice you soon begin to see the photographic possibilities and order that exists within what appears at first a rather random and chaotic scene. Long lenses will help you here because they help compress the picture, appearing to close the gap between subjects so it will appear that animals are even closer together and that there are more of them.

On some occasions you may want to photograph as many animals in the group as possible simply to illustrate the sheer weight of numbers in a scene. Such shots work best where you completely fill the frame with animals, like repeat patterns on wallpaper or gift-wrap. You can create a sense of greater numbers by ensuring subjects break out beyond the edges of your picture so it suggests to the viewer there are even more animals beyond the confines of the frame.

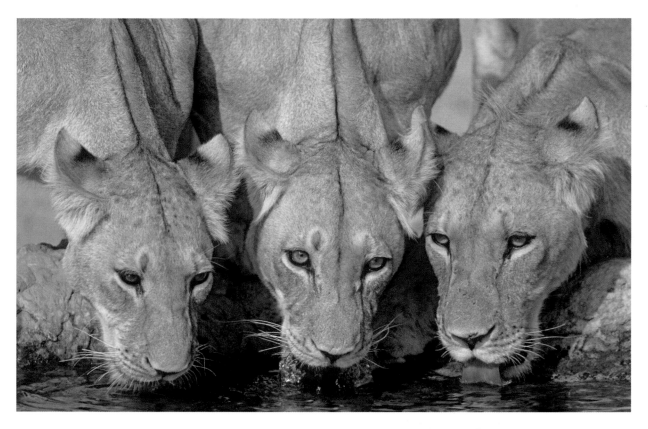

↑ Lions drinking, Kgalagadi, South Africa
Canon EOS-1Ds Mk II // 500mm lens // 1/125sec at f/5.6 // ISO 100

Photograph small animal groups in odd rather than even numbers as this is more aesthetically pleasing to the eye.

← Starlings on telegraph wires, UK
Canon EOS-1Ds Mk II // 500mm lens with 1.4x converter // 1/640sec at f/13 // ISO 200

In this example we've gone for a formal composition, using the manmade structure to provide a useful diagonal and intersection on the thirds.

← Lesser flamingos, Namibia
Canon EOS-1N // 300mm lens // 1/320sec at f/8 // Fuji Velvia 50

Here, we've opted for a more random 'wrapping paper' crop. The fact most of the birds have their heads down helps create repeat patterns, however, that suggest some sense of purpose and design.

PHOTOGRAPHING GROUPS

When it comes to animal portraits the toughest challenge for today's wildlife photographer is producing something fresh. There's no rule that says animal portraits must be taken from the front-end of your subject. When we came across this maternal herd of elephants drinking in a row, the obvious thing would have been to photograph them front on, but, in the end, the less than conventional line-up of fat-bottomed girls, and the almost abstract pattern we could create by tight cropping, was just too hard to resist! Elephants are one of many subjects we've spent a lot of time photographing so we're always looking for a new take on them. We believe that provided you capture and convey the essence of your subject in your final image – in this case sheer size, the sense of a close family bond and the telltale texture of that tough hide – then anything goes.

Elephant tails, Addo National Park,

PHOTOGRAPHING GROUPS: DEPTH OF FIELD

One of the key technical considerations when photographing a group of animals is depth of field. Obtaining enough depth of field to ensure all your subjects are sharp while retaining enough shutter speed to freeze movement or prevent camera shake can be a real headache. Even if you get enough depth of field and shutter speed you still risk ending up with a cluttered shot because, with lots of depth of field, your background also comes into focus more and may start to detract from the subject. Achieving sufficient depth of field for all individuals in the group to be sharp can mean you end up with a fussy, confusing shot.

The first thing to do if you're photographing a small group of animals and want to maximize depth of field is to look around for what we call 'background drop-off'. This simply means looking for subjects where the background focus will fall off nicely — even if you do use a small aperture for lots of depth of field — because it is a long way from the subject. You get instant background drop-off where subjects are raised above their surroundings slightly, so it helps to be on the look out for subjects on mounds, ridges, rocky outcrops or perched on walls or fences. In these situations you should be able to dial in extra depth of field and not worry about the background creeping into focus.

If you can't get enough depth of field to ensure all subjects are completely sharp, the shot isn't going to work. There are no half measures. With digital cameras we can use a high ISO now if we need extra speed when shooting at large f-stops.

There's also an alternative option that works well for many group pictures. If you can't get enough depth of field so all subjects in a group are sharp — be deliberately selective instead and go for just one member of the group in sharp focus. The rest of the group will still be recognizable but will appear more like ghostly suggestions of the other subject, echoing its shape, form and colour. It's up to you here which group member you choose to be in full focus, bearing in mind the guidelines for good composition, but it can be very effective if that subject is not always the one nearest to you as this adds depth to your pictures.

← Springbok drinking, South Africa
Canon EOS-1Ds Mk II // 500mm lens with 1.4x converter //
1/1,250sec at f/8 // ISO 200

Faced with a large herd of thirsty springbok and a small waterhole this picture could have easily have been a confusing mass of antelope legs and heads. Going in tight and deliberately focusing on just one of the drinking herd (the furthest from the camera) helped make a considered picture from a rather messy scene.

→ Herring gulls following fishing boat, Scotland
Canon EOS 5D // 70–200mm lens // 1/8000sec at f/5 // ISO 400

In a grab shot like this, where you may not have time to increase the depth of field as much as you'd like and you need bags of speed to freeze movement and avoid camera shake, make sure you fix on a clear focal point in the picture to give the picture cohesion.

↓ White rhino and wildebeest, Hluhluwe, South Africa
Canon EOS-1Ds Mk II // 500mm lens with 1.4x converter //
1/160sec at f/5.6 // ISO 200

When there's more than one animal or one single species in your frame decide on the bits of the picture you want to emphasize and therefore need to get in full focus. It doesn't matter here that focus on the wildebeest is falling off because the story in this picture still comes across.

PRO TIP

Don't throw away depth of field you could usefully use. Available depth of field extends a third of the way in front of the point you focus on and two-thirds behind. Bear this in mind when selecting where to focus.

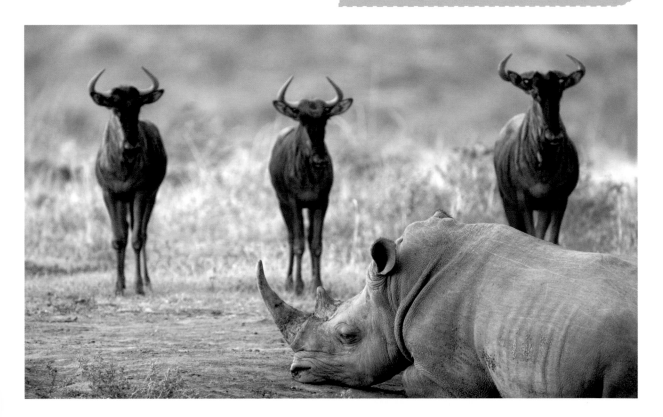

BEHAVIOUR

Observing and photographing animal behaviour is one of the most rewarding aspects of our job. Watching a pride of lions fan out to stalk a buffalo herd or a maternal group of elephants wrapping their trunks around a tiny calf to rescue it from the slippery shallows of a waterhole is a real privilege, and we still pinch ourselves when we witness these things while taking pictures. Just as special is having a young water vole feeding inches from the toe of our boots or a barn owl quartering a meadow near our house at the end of a still summer's day.

And while the marketplace may be getting saturated with simple animal portrait pictures, behaviour shots still attract a premium, particularly if you're prepared to put the effort in to get something that bit more unusual or rare. Animal behaviour covers everything from the fairly static to the blink-and-you'll-miss-it variety. Before we move on to cover fast-moving action we're going to start with basic, 'bread and butter' behaviour.

Getting great behaviour shots begins with a passion for your subject. Photograph the subjects you love to spend time with and it will show in the quality of image you produce.

As we pointed out in the section on fieldcraft (page 44), the more you learn about subjects the better. This is particularly true if you want to photograph different or specific aspects of their behaviour. If you want intimate shots of a mother animal with her young, then it stands to reason you're going to need to know everything about the breeding season of the particular species you're interested in. Familiarize yourself with the body of behaviour pictures already out there for the species you propose to shoot, too. Not only will this alert you to any key aspects of behaviour you need to be ready for when you're in the field but, perhaps more importantly, will highlight any gaps or key aspects of behaviour that may be poorly covered in the marketplace to date.

Perhaps more than anything else, however, you also need to invest time in the field. Quite simply, the more time you spend watching animals, the greater your chances of photographing them doing something remarkable.

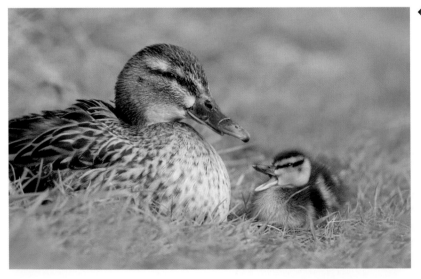

← Mallard with duckling, Martin Mere, UK
Canon EOS-1Ds Mk II // 300mm lens with 1.4x converter // 1/1.25sec at f/8 // ISO 250

Interaction adds value to shots of the commonest subjects, and when it involves a mother and her young, there's always the added 'aah' factor!

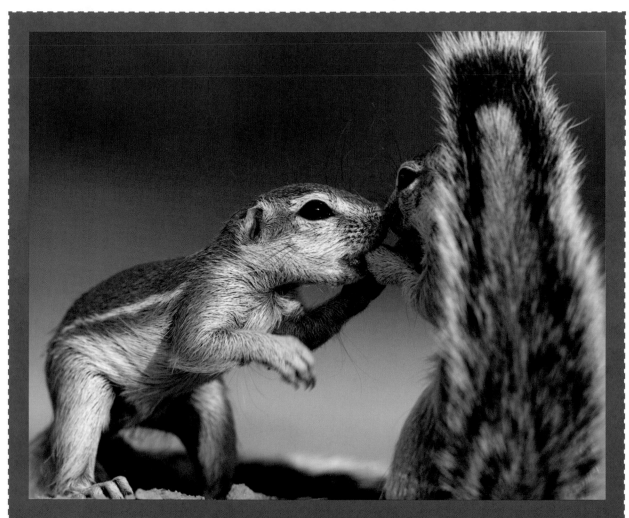

INTIMATE MOMENTS

Get in close if you can to capture the moments when animals interact with each other, to emphasize the intimacy of the moment and to let the viewer in on that intimacy. Tight crops also help concentrate the focus on what your subjects are doing. It helps if you photograph subjects at their eye level and certainly makes images look more natural. We spent an hour or so each evening at this ground squirrel den, spread-eagled on the ground, observing and photographing the end-of-day interactions of these young mammals before they scurried into their burrows at dusk. The little ones soon accepted us and carried on their daily routine as if we weren't around.

↑ Ground squirrels greeting, Kgalagadi, South Africa
Canon EOS-1Ds Mk II // 300mm lens with 1.4x converter // 1/250sec at f/7.1 // ISO 125

↘

BEHAVIOURAL TECHNIQUE

Of course, simply being there when the 'decisive moment' happens is just the first part; you also need to be ready to nail the interesting piece of behaviour as soon as it happens. This means being confident when you fire the shutter that you'll have sufficient speed to freeze the moment. This is why we regularly work in the field with our cameras set to motor drive and the ISO at no lower than 200 as the default. If the light levels are low, and the subject is a rarely photographed one, we may even use ISO 400 as our default.

Similarly, we switch our cameras to aperture priority mode and then set the aperture fairly wide at about f/5.6. This enables us to maximize available speed in the pertaining conditions, increasing our chances of getting a sharp record of the event. Once this first shot is safely on the memory card, we have greater liberty to consider stopping down for extra depth of field if required, the time to make any necessary tweaks to exposure and can consider modifying the picture composition if need be. With practice you should be able to anticipate what changes to your camera settings you're going to need as the situation unfolds and will be able to respond more rapidly by thinking on your feet.

Given we're not talking about photographing fast-paced action shots until later, there's no need to habitually machine-gun the shutter release to capture fairly static behaviour shots. Sometimes participants on our workshops photographing static or slow-moving subjects will glue their index finger to the shutter button instead of training themselves to recognize and anticipate the climax or peak of the subject's 'performance' and pressing the shutter release at and around this point.

PRO TIP

Learn how to switch your camera quickly to focus tracking (predictive continuous autofocus) without taking your eye from the viewfinder. Quite often, simple animal behaviour turns into fast-paced, animal action in a matter of seconds so you need to be ready in case a situation suddenly escalates.

We prefer to photograph behaviour in this more considered way as it allows us to ensure we are well braced, and that the camera and lens are completely stable when the precise moment to fire arrives. This doesn't mean to say we don't fire off several successive frames when the action is explosive and we need to follow it continuously.

↗ **Elephants splashing, Eastern Cape, South Africa**
Canon EOS-1Ds Mk II // 500mm lens with 1.4x converter // 1/500sec at f/7.1 // ISO 100

Whether it's an African waterhole, a European wetland or a coastal seabird colony, animal subjects plus water equals great opportunities for behaviour pictures. Try to put yourself in those crowded places where varied behaviour and repeat interactions are guaranteed.

→ **Hippo 'yawning', Kruger, South Africa**
Canon EOS-1Ds Mk II // 500mm lens // 1/500sec at f/7.1 // ISO 100

Although the hippo's jaws open relatively slowly, and the animal is pretty much stationary at the yawn's fullest extent, you still need fast responses to photograph behaviour like this as it can be impossible to predict where in the water and when a hippo will surface to do this.

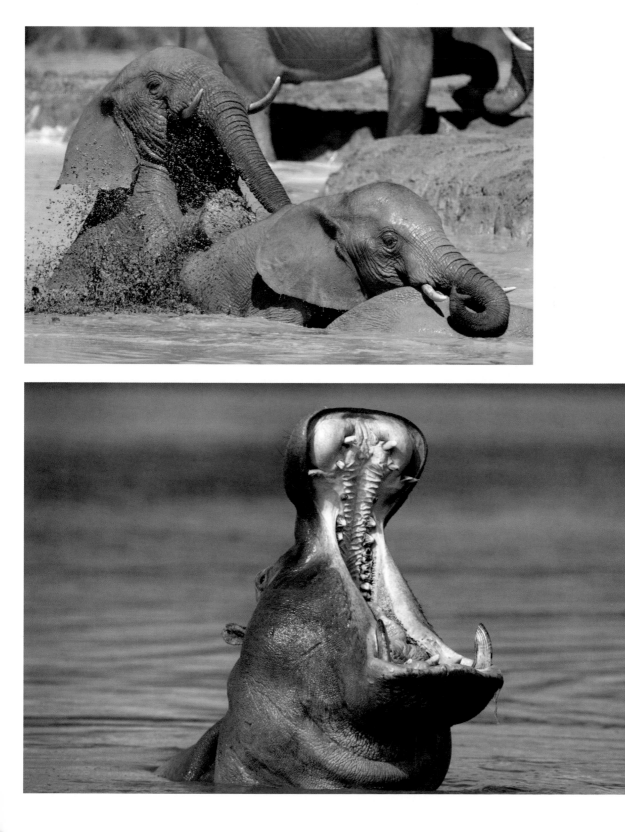

ANIMAL ACTION

One of the most important things to bear in mind if you want to improve your hit rate when photographing animal action is to give your subjects plenty of room to 'perform' within the frame. If we've been photographing animals or birds using a long telephoto plus an extender, for example, and it looks like we're suddenly going to see some explosive action, aggression or interaction, we usually whip off the teleconverter quickly so it's much easier for us to track the movement and capture all the action within the boundaries of the picture frame. Remember, you can always crop a picture at the processing stage, but you can't put back the tails or wing tips you've clipped by mistake at the edge of your image.

Another important reason for giving active subjects room in which to move is that the inclusion of background habitat detail can help explain the action more easily for the viewer by giving it some context. If you're photographing a monkey swinging through trees, for example, you need to pull back enough to suggest the extent of the monkey's forest canopy home rather than going in tight on a meagre couple of branches. Some of the most memorable action shots are where the animal is quite small in the frame, but positioned within the picture design in an interesting or arresting way.

There's no big secret to securing these shots – fast reflexes, fast shutter speeds, familiarity with your camera and the ability to anticipate what your subject will do next are the key ingredients. Try not to panic when subjects start moving at speed or you'll end up all fingers and thumbs and forget to stay well braced. Switch to focus tracking (predictive continuous autofocus), as this will help you lock focus and track a moving subject. Stay calm, breathe deeply and root yourself to the ground. If you're not in a hide or vehicle place your feet apart and tuck your elbows in to your body, as this stance will help you balance and track the action smoothly with your camera.

Wait until the action is just about to start before photographing, pan with the action as smoothly as you can and keep photographing until the action ends. Sometimes it happens so fast and so quickly you're working purely by instinct, so don't worry about what you're getting – just keep photographing. If you think you didn't get the shot first time, don't take your eye off the ball, as many animals repeat behaviour cycles over and over, so you may get a second or third chance at the image.

Given many subjects are active at dawn and dusk when light levels are tricky, be ready to increase your ISO to maximize shutter speeds and increase your chances of freezing subject motion. Alternatively, you can choose to turn low-light conditions to your advantage when photographing motion. The resulting slow shutter speeds (from 1/2sec to 1/30sec) will help create wonderful, impressionistic blur in your images of moving animals and wind-tossed flowers. This effect really enhances the feeling of speed and movement in still photographs. If you photograph like this while panning smoothly with your subject, the background will be blurred but there will still be some suggestion of sharpness in the subject you're tracking.

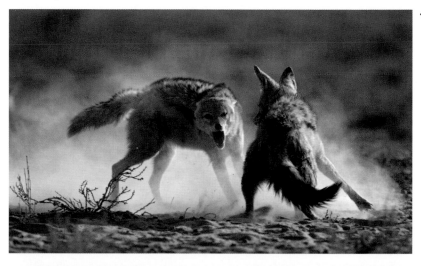

← Blackbacked jackals fighting, Kalahari, South Africa

Canon EOS-1Ds Mk II // 500mm lens with 1.4x converter // 1/1,000sec at f/6.3 // ISO 250

Shooting into the light can sometimes be a real bonus when photographing animal action. Here, the dry conditions meant these fast-moving jackals, squabbling in the vicinity of a lion kill, kicked up lots of lovely dust. The backlit dust helps to reinforce a sense of energetic speed, but further benefits come from the extra shutter speed you get when photographing action contre-jour in some situations, as here, where the setting is mid- to pale-toned and the light is enhanced by the veil of dust.

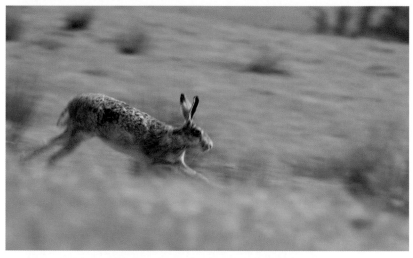

← Brown hare running, Lancashire, UK

Canon EOS-1Ds Mk II // 300mm lens with 1.4x converter // 1/80sec at f/25 // ISO 320

Select a slow shutter speed when panning with a moving subject. This will help blur the background to create a sense of speed in your picture.

← Black grouse aggression, North Pennines, UK

Canon EOS-1Ds Mk II // 500mm lens with 1.4x converter // 1/125sec at f/7.1 // ISO 800

This was a dull morning, making it nigh-on impossible to obtain enough speed to freeze interaction between the grouse. This shot was far from sharp, but we liked the sense of active aggression in it so we decided to enhance this by manipulating the image in postproduction using a motion blur filter. We rarely manipulate shots, but are always upfront about it when we do.

↘

FLIGHT

You need to fire off plenty of frames to get challenging flight shots right. Most people are better at it than they imagine, and quite often it's simply a question of having the confidence to try. Resign yourself to deleting more shots than you'll keep, and go for it.

As with all fast-moving animal action you'll need a fast shutter speed to freeze the flight motion. How fast depends on the prevailing lighting conditions and the type of bird you're photographing. Small birds swooping through the air on swiftly beating wings will move faster than larger ones gracefully riding the thermals. From the illustrations here you'll see any shutter speed – from 1/500sec for a slow-moving flock of swans to 1/5000sec for a fast-moving puffin – could be the order of the day. As a general rule, we photograph flight no slower than 1/1000sec and the ISO on our cameras will be set between 200 and 400 (depending on how bright it is), and sometimes even as high as 800 when the light is coming and going a lot.

When using a long lens on a tripod, a gimbal head will best enable you to follow the subject's flight path smoothly. Ideally we prefer to handhold for flight shots when we can. This gives us flexibility of movement when following subjects – our favourite lens for the job being a 300mm IS lens, with a 1.4x converter if we need a bit more focal length. We lock onto a flying bird using focus-tracking mode when it's in the middle distance and aim to hold focus on the bird as it gets closer. Start photographing just as it gets close enough to fill the frame. Remember to allow enough space in the frame for the bird's outstretched wings.

We generally use the centre-spot focus point for flight shots, as opposed to multi-spot focusing. Although multi-spot focusing can increase your chances of locking on to the subject we tend to opt for centre-spot in most situations because we can then deliberately focus on the head of the bird – the key bit we want in sharp focus. With multi-spot there's a risk the camera may focus on a different part of the bird and the head will not be sharp. If there's enough light, we also stop down a bit (say f/8 or f/11) to increase our chances of getting sharpness throughout from bill to tail to wing-tip.

It's not easy to concentrate on the design elements of your picture when simply nailing the shot in the first place is such a challenge. Nevertheless, successful flight pictures do still have a strong element of design to them and you'll soon be able to find time to consider these as you become more experienced. Start by concentrating on the position of the bird. Ideally, your subject should be flying into the frame, not out of it. If you can capture the bird banking, even better, since you'll get its head directed straight at the viewer in your image with the wings forming a pleasing diagonal shape.

↗ **Whooper swans in flight, Lancashire, UK**
Canon EOS 5D // 500mm lens with 1.4x converter // 1/500sec at f/11 // ISO 200

We used to wait for bright, blue sky days to do flight shots – not only for aesthetic reasons but also for sufficient shutter speed. These days, with digital cameras allowing us to produce good-quality images at high ISOs, we're exploring the possibilities of using more moody skies to match or set off the subjects we're photographing, as in this wintry, monochromatic shot of migratory swans.

→ **Puffin with sand eels, Farne Islands, UK**
Canon EOS-1Ds Mk II // 300mm lens // 1/5000sec at f/7.1 // ISO 800

Puffins are small, fast-flying birds so you need lots of speed to help you get a pin-sharp shot. Of course, it helps if you visit a colony where they breed in large numbers at the height of the season. This will mean lots of flight-shot opportunities to increase your chances of success, since they'll constantly be flying to and from their burrows to feed their young.

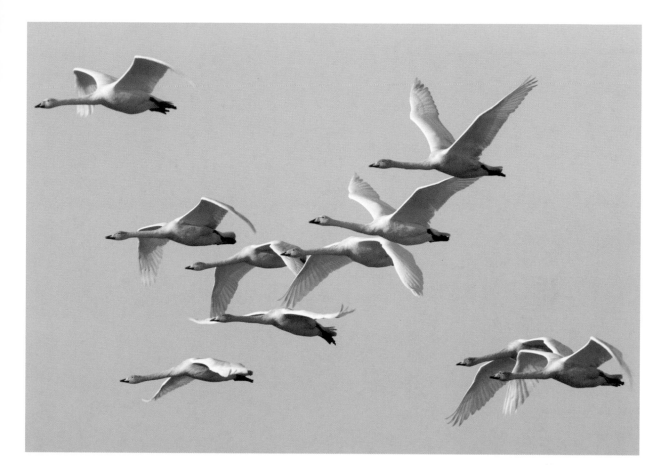

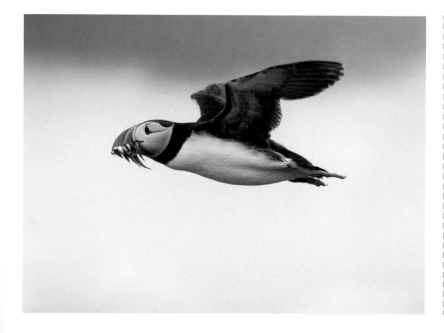

PRO TIP

Try to ensure the head of the flying bird, at the least, is pin-sharp. Some falling off of sharpness on the wing tips is acceptable, if you can't get all the bird sharp throughout in each shot, and can help reinforce the movement of the bird.

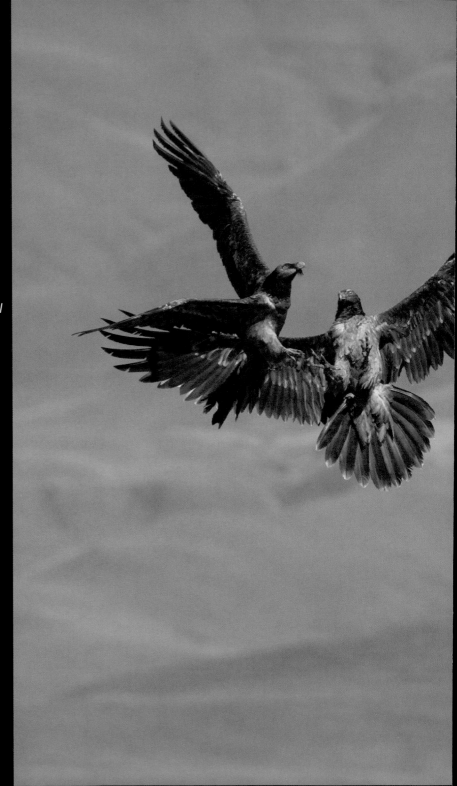

FLIGHT

On this shoot we discovered that bearded vultures can be a lot like buses. You hang around for ages with nothing coming into view, then, lo and behold, three come at once! We weren't complaining, however – it's a rare privilege to spend time in this cliff-top hide, with some of the rarest raptors in South Africa performing amazing aerobatics at your eye level, let alone photograph them. Pro-digital cameras come into their own for nailing flight shots like these. Bumping up the ISO doesn't mean a decrease in image quality so it's possible to achieve higher shutter speeds, and stop down for greater depth of field, much more easily than we would have been able to with film.

Bearded vulture adult and sub-adults, Drakensberg Mountains, South Africa
Canon EOS-1Ds Mk II // 500mm lens // 1/1250sec at f/8 // ISO 250

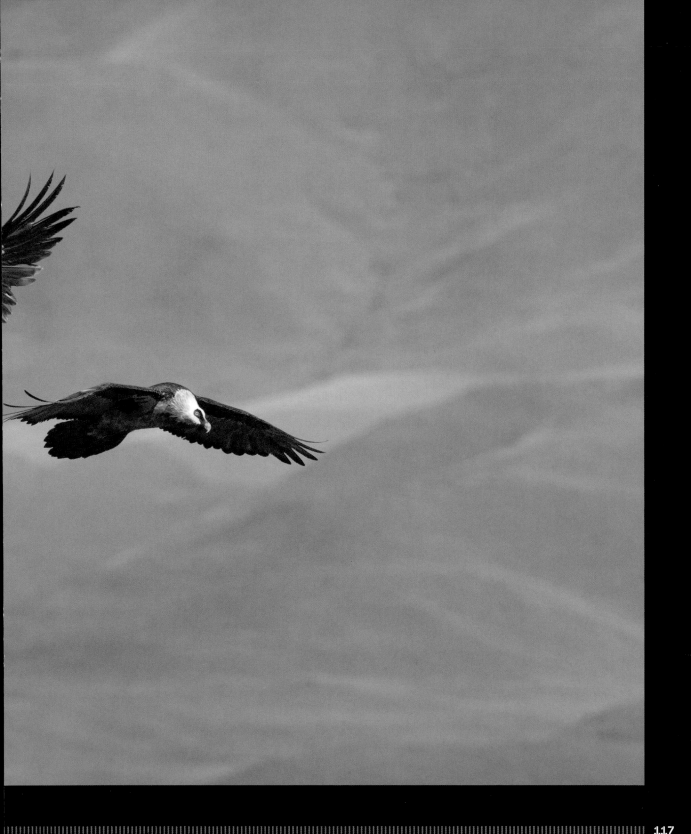

WILDLIFE WITHIN THE ENVIRONMENT

It's easy to become so focused on our subjects in wildlife photography that we overlook the amazing places in which they live. Yet some of the most evocative wildlife images are those where the subject is quite small in the frame – a polar bear crossing a vast expanse of ice, a train of antelope trekking desert dunes or a single red deer stag picked out on the top of a mountain. Such pictures often have much more resonance with the viewer than a simple, close-up portrait. Not only do they help convey the beauty or even the bleakness of your subject's immediate environment, but they also tell a story about your subject and its immediate relationship with its setting. Is the location harsh and unforgiving, for example, suggesting that survival in such a wilderness may be a critical issue for this species? Is the habitat one of lush abundance, offering a prospect of food and shelter, suggesting why this subject thrives there? These pictures convey a ton of information. You can see at a glance, for example, how well adapted a species might be to its surroundings because telltale detail like plumage or skin colour, blending well, or contrasting starkly with the surroundings shown, will convey key factual information about your subject's natural history.

It's not simply a question of documenting the interconnectedness between your subject and its surroundings, however; you also need to bring elements of design and composition into play if you're going to produce a successful picture.

The rule of thirds (see page 84) can be extremely useful when placing a wildlife subject within its surroundings in a picture. Remember that it often looks best if the subject is moving

into the picture rather than out of it and that odd numbers tend to work better in design terms if you're photographing small groups. Backlighting often works well for this type of picture, too, since their dark shapes will stand out crisply against the background of their habitat. Think about what you're trying to say or convey about a subject in your picture too as this will help decide where a subject should be placed in the frame and how large or small you want it to appear.

It really helps to think of these pictures as landscapes rather than wildlife pictures, even if the wildlife in the image is your main focal point, and to draw on the guidelines of good landscape photography. Don't divide a picture into two separate halves by placing the horizon slap bang in the middle. Instead, place your horizon a third or two-thirds of the way up the picture. Think carefully about foregrounds and lead-in lines, ensuring there is sufficient visual interest in the foreground to give good perspective and take the viewer's eye through the picture. This will help prevent images appearing flat and distant. Exclude dull skies completely from compositions where possible. The golden rule, if there is one, is to keep compositions simple and graphic.

PRO TIP

When animal subjects are very small in your picture make sure their outlines are clearly visible. Check their heads aren't down in long grass, for example, when you fire the shutter and their bodies aren't overlapping each other or obscured by vegetation.

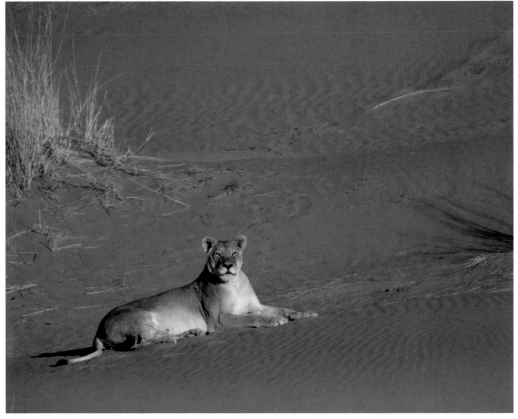

← **Lioness on dune, Kalahari, South Africa**

Canon EOS-1Ds Mk II // 500mm lens with 2x converter // 1/500sec at f/8 // ISO 100

The rule of thirds can help when you're positioning wildlife subjects in their environment within the frame.

← **Indo-pacific bottlenose dolphin, Shark Bay, Australia**

Canon EOS-1N // 28–80mm lens // 1/160sec at f/8 // Fuji Velvia 50

With our backgrounds in journalism, we regularly provide editorial clients with packages of pictures and words. Editors like pictures of animals in the landscape for a number of reasons: they want their readers to see where animals and birds live, they also want a variety of different pictures to give feature articles pace and, perhaps more importantly, they want an 'establishing shot', that instantly sets the scene for their readers. These are often used across double-spreads to kick off the article and, as such, can bring us a higher fee. Leave clear space when composing for text or headlines and avoid placing subjects in the middle of the frame. This dolphin shot was used across a double-page spread for a wildlife travel feature on Western Australia.

PHOTOGRAPHING WILDLIFE HABITATS

These days with so many pressures on the planet it's becoming increasingly important for wildlife photographers to photograph wildlife habitats as stand-alone subjects with the same care and attention used to photograph the subjects that inhabit them. Whether it's wetland, forest, peat bog or indigenous bush many of our precious wild spaces are rapidly disappearing as a result of habitat loss and human development and there's a growing demand for pictures celebrating what we stand to lose if they disappear.

Despite the demand for top-quality shots of wild environments, it's an area of wildlife photography that's often neglected. For one thing, wildlife photographers naturally gravitate towards photographing the wildlife rather than the conditions they live in, for another; it does demand a slight change of approach because photographing wildlife habitats is a lot like landscape photography.

More often than not we use wideangle lenses and standard short zooms for this sort of work, although long lenses come in useful where we want to compress a scene and make a wildlife subject appear closer to its surroundings. The benefit of using wideangle lenses is two-fold – images appear more three-dimensional and, by working close and low down to nature subjects wherever possible with short lenses, we can include lots of in-focus habitat detail. This is because you get loads of depth of field at small apertures when using short lenses. Bear in mind when you stop down the aperture, however, that you will still need enough shutter speed to freeze any movement if there's any moving wildlife in the picture or the wind is causing vegetation to blow about.

WIDEANGLE PRACTICALITIES

» Be careful when using wideangle lenses for habitat and environment pictures as you can sometimes get ugly vignetting in the corners. If you're shooting in RAW this can be 'cured' at the processing stage in some conversion software packages such as Lightroom.

» If you're photographing with a low sun behind you watch out for your shadow in the frame. If you can't get rid of it by switching position slightly use a tripod and remote release where possible.

» It probably goes without saying that horizons should be straight, although we do like to break this rule from time to time where we can get away with it just to create a sense of drama or tension, or even simply to create an arc or diagonal in a wide-angle habitat shot.

» Unless you're photographing in rainforests or woodlands, when overcast conditions are best, it can be good to pick blue sky days for photographing wildlife habitats as you'll often want to include sky in the shot – particularly where the topography's flat and featureless. Blank blue skies are fine – our clients tend to like them because they can run text over them – but in pure photographic terms a few fluffy white clouds punctuating the blue looks more interesting.

→ **Bass Rock with gulls, Scotland**
Canon EOS-1Ds Mk II // 28–80mm lens // 1/1000sec at f/8 // ISO 200

Look for fresh ways to photograph wildlife habitats. Here, Bass Rock, an important marine habitat and breeding site for gannets, is shot using a short lens through a curtain of greedy gulls flying behind a fishing boat.

← **Urban meadow, Merseyside, UK**
Canon EOS-1Ds Mk II // 28–80mm lens // 1/60sec at f/11 // ISO 100

Don't forget there's lots of good photographic potential for wildlife habitat shots in urban settings these days. Traditional habitat loss has, literally, forced nature to come to town.

↘

CLOSE-UPS

Close-up wildlife and nature photography opens up a whole new world of possibilities for us as wildlife photographers. Whether your interest is in accurately documenting the secret world of insects and mini-beasts with technically excellent record shots; whether it's celebrating the skin patterns or hide textures of larger animals in minute detail; or simply exploring the huge potential for artistic, abstract images showcasing colour, form and design in the natural world, this specialist area of wildlife photography can really grab your audience's imagination.

You need to be a bit of a perfectionist to specialize in close-up wildlife photography, however. In essence, you're asking the viewer to examine the world of nature more closely, so it's not just your subjects that will be magnified, but your mistakes, too. Our starting point, and number one rule, is to find subjects for close-ups that are pristine and at the prime and peak of condition – anything less is usually rejected.

Finding the perfect specimen is just the beginning. You will then need to juggle a range of technical skills, including careful focusing and use of lighting techniques, selective use of depth of field and, perhaps most importantly of all, a rock-steady camera set-up.

You also need the right equipment before setting out. This is so you can focus more closely on your subjects than you would normally be able to do with a conventional camera lens. We have two approaches we use when we need to do this. The first is simply to add an extension tube to our camera and lens, which we do particularly when photographing close-ups of flowers within larger groups or when stalking bees and butterflies.

← **Ramsons, UK**
Canon EOS-1Ds Mk II // 300mm lens with extension tube // 1/320sec at f/4.5 // ISO 160

We quite often fit an extension tube to a medium-length telephoto when photographing groups of flowers because it helps focus more closely and isolate specimens from within the overall mass. Save close-up work for windless days – our biggest bugbear when photographing flower close-ups is subject movement.

↗ **Karoo girdled lizard, South Africa**
Canon EOS-1Ds Mk II // 180mm macro lens // 1/400sec at f/5 // ISO 100

This sleepy guy was just emerging from a crack in the rocks to soak up the warm morning sun, and tolerated our close approach with a macro lens. Close-up wildlife work is about getting to subjects at just the right time.

In our case the prime lens used is usually our Canon 300mm L series f/4 IS lens because it's portable, has a long working range, so we're not in the face of sensitive subjects that will spook when a lens is thrust at their proboscis, and has in-built stabilizing technology – vital when photographing close-ups off the tripod.

Mostly, however, we use macro lenses for this sort of work. Our current favourite is a 180mm macro, which gives both the magnification we need and has a good working distance that's generally not going to disturb subjects unduly because it's thrust too close to them.

PRO TIP

If you plan to sell your close-up nature images take good identification guides into the field with you and identify subjects in situ. Believe us, it's much easier to label images correctly if you can look at the subject in its natural setting, than trying to do it at a later date when your memory has faded and with a close-up image that may only show one small part of the subject.

CLOSE-UP KIT

A versatile, sturdy tripod is our number one piece of kit, after a macro lens, when doing close-ups. The only time we don't use one is when we need to move around a lot – when following feeding insects from flower to flower, for example. Even in situations where we're working close to the ground, and it's not possible to get the tripod quite low enough, we still use beanbags to support our camera and lenses. This is because the smallest camera vibrations are magnified when you use macro lenses. Given that you generally need lots of depth of field for close-ups, which often means photographing at quite slow shutter speeds, we find ourselves locking up the mirror, using a remote release to fire the shutter release and being extra careful not to knock the tripod legs (or even breathe) to cut the risk of camera shake.

A tripod is useful, too, because it slows you down and helps you perfect things. We find using a tripod and looking at our subject critically through the lens buys us the time we need to make final tweaks. This process also helps reveal where we need to do any further tidying around subjects, which is usually more than you'd realize at first glance. It also enables us to double check depth of field (using our faithful depth-of-field button) and make one last check that we're happy with our focusing.

Getting the critical point of focus right is extremely important because, with close-ups, you can't afford to waste available depth of field in front of your subject by focusing too closely to your picture's main point of interest. This is a difficult thing to judge without experience, so you can start to see why the depth-of-field button can be such an ally.

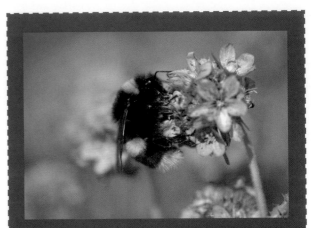

↗ **White-tailed bumblebee, Scotland**
Canon EOS 5D // 180mm macro lens // 1/500sec at f/5.6 // ISO 160

WHAT TO SHOOT AND WHEN

You don't need us to tell you that insects can be flighty, frustrating things to follow in the field. Picking your time is the key to success. For example, still mornings in summer or spring when butterflies and insects have not yet abandoned their overnight resting places and are fairly stationary, waiting to be warmed up by the sun, can be some of the best times to be out with your close-up kit. This is also the time you'll find spider webs intact. Be careful not to cast a shadow over a resting subject, or one that's stopped for a while to feed, as you run the risk of disturbing them. When the sun gets higher you don't need to give up photographing close-ups. Bright sun can be brilliant for revealing textures. In addition, you could try getting down very low and shooting subjects from a worm's eye viewpoint looking up through the vegetation at them against a bright blue sky. Alternatively, move your whole operation into the shade. If you need more light in shade conditions you can always bounce extra into the shadow areas of a picture using a piece of white card or a reflector.

→ **Southern hawker newly emerging from larval skin, UK**

Canon EOS-1Ds Mk II // 180mm macro lens // 1/8sec at f/20 // ISO 200

Depth of field can be limited when using a macro lens so it's crucial to consider carefully where you focus. If you have to sacrifice some sharpness for speed make sure critical areas such the head and eyes are pin-sharp.

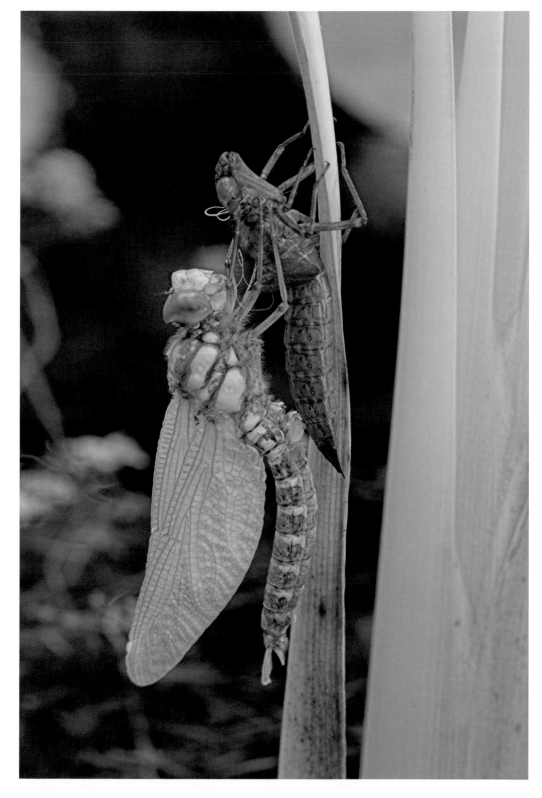

ABSTRACTS

Abstract wildlife pictures celebrate and concentrate attention solely on colour, pattern, texture and design in the natural world. Essentially, in an abstract image you're taking away the names and identities of species, allowing the viewer to see the world of nature in a fascinating and different way.

Because they're more about shape, form and texture than a clearly labelled, defined, or instantly recognizable animal or plant, these images quite often have the potential to sell more widely as general stock pictures than some of the more conventional, specialist wildlife images in the market.

Learning to find and isolate abstract images in nature is a good way to hone your compositional skills, because it forces you to look for the pictures within a picture. Of course, many abstract or pattern pictures are quite simple and immediately obvious, but in many cases it's the photographer who finds a new way of presenting his or her subject for the viewer.

If we're having trouble 'seeing' abstract images, we find it helps to look through our lens rather than simply relying on the naked eye. This helps us strip away anything extraneous, or distracting, and helps us to see potential abstracts more readily. Some people do this simply by making an artificial viewfinder with their hands, creating a frame to look through and assess how they'd look as a photograph. With static and still life subjects we tend to spend a fair bit of time just looking, getting into a subject and changing position to give us a new angle or perspective. We usually explore lots of different possibilities before we set up a tripod and start photographing for real. If you're stuck for ideas the websites of leading photographic libraries usually have some excellent examples of natural abstracts that should give you inspiration and a jumping-off point.

If you're doing pattern pictures you'll need to get lots of depth of field. It's particularly important the focus doesn't fall off around the edges of an image like this where there's no one single focal point. A depth of field preview button is, once again, essential here. You can help yourself maximize depth-of-field here by checking that the front of your camera lens is in parallel to the subject and not tilted. As a rough rule of thumb we'd generally be photographing at f-stops anywhere from f/14 to f/32 for abstract pattern pictures, depending on our subject, so we'd always use a tripod, mirror lock-up and cable release to help reduce camera shake and vibration.

Flat lighting will eliminate shadows for overall patterns but where you want to highlight texture, for example in a scaly reptile skin, low, raking light or a touch of fill-in flash will help.

You don't need bags of depth of field for every abstract nature picture, of course. In fact, removing sharpness from an image is another great way of creating an abstract picture because, in a way, you're blurring the subject's identity. The technique of differential or selective focusing can therefore be very useful when creating abstracts. This is where you open up the camera aperture to exploit the minimal depth of field this gives, so that only the one spot in the picture you select to focus on is sharp. The rest of the image falls away in soft focus. The best subjects for this technique are richly colourful ones. Flowers are ideal because the delicacy of their petals lends itself to the overall impression of softness conveyed in such shots.

← Reticulated giraffe skin, captive, UK
Canon EOS 5D // 300mm lens // 1/1.25sec
at f/1.0 // ISO 1.00

Once you start looking closely, the natural
world is full of wonderful abstract
patterns and stunning designs.

**← Female eider duck close-up,
Isle of May, Scotland**
Canon EOS-1N // 28–80mm lens //
1/1.00sec at f/1.1 // Fuji Velvia 50

At first glance this image is all about
abstract plumage pattern and colour until
you notice the brooding female's watchful
eye and begin to identify what's being
photographed here.

← Autumn leaves abstract
Canon EOS 5D // 1.80mm macro lens //
1/1.25sec at f/4 // ISO 400

Here, we've used differential focusing to
pinpoint just one edge of the leaf. The
shallow depth of field helps emphasize
form, shape and colour in an image rather
than 'labelled' content.

DOCUMENTARY PICTURES

Wildlife is never far from the news these days, whether the issue is climate change or the constant conflict between man and nature. It's not all negative stuff either; breakthroughs in scientific research, the success of a particular conservation campaign or the discovery of a new species can equally make the headlines.

◢ Red foxes culled, Victoria, Australia
Canon EOS-1N // 70–200mm lens // 1/250sec at f/7.1 // Fuji Velvia 50

Captions are often crucial to give documentary images necessary context. There were 18 fox carcasses suspended from this fence in Australia and we photographed all of them, as well as doing some close-ups, as here, for impact. Many nature-lovers might find this picture abhorrent in the UK, but in Australia, red foxes are an introduced species that have wreaked havoc on the indigenous wildlife. They are considered a pest that needs to be eradicated.

Good news or bad, these are all stories that can be told more powerfully and immediately through visual media, using illustrations, graphics and, in particular, documentary photographs.

There's certainly a growing demand for such pictures in the marketplace. Picture libraries are on the lookout for powerful images that document the effects of global warming and the demand for pictures of endangered species is up. In a world that's becoming saturated with conventionally beautiful animal images, pictures that perhaps encourage our complacency by conveying the idea that all is well, there's still a gap in the market for the more thought-provoking 'reality check' pictures.

There are two problems, however. The first is that most of us are drawn to wildlife photography because we want to celebrate the beauty of the natural world. Despite the fact we were both

↗ **Hunter with gundog, UK**
Canon EOS 5D // 17–40mm lens // 1/125sec at f/8 // ISO 200

PEOPLE IN DOCUMENTARY PICTURES

Be alert to the fact that photo libraries will generally only take pictures of people if you get a signed model release with your subject's permission allowing their picture to be used. This can sometimes be a headache, even when you mainly shoot wildlife. You can get round it if the person featured is anonymous, as here. When we needed a shot of someone hunting for a feature we were illustrating about its impact on wildlife we did get this chap's permission to use his picture. Nevertheless, we still shot some frames where we couldn't see his face because we wanted to submit them as general stock to one of our agencies. Faces can be distracting in a picture like this because viewers are drawn to them. They make us see the person as an individual rather than what they represent. Here, the attention is drawn solely to the gun, the spaniel and the man as symbols conveying the idea of hunting, shooting or countryside pursuits.

journalists before taking up wildlife photography, and still use our journalism with our pictures today, we tend more towards the pictorial style rather than reportage in our own work. The other problem is that audiences can only take so much reality, and many clients and end-users still seem to prefer pretty pictures to gritty ones.

In terms of practicalities, the lenses we use most for documentary work are our shorter ones, including 28–80mm, 17–40mm and 70–200mm zooms. For a start, these lenses are lighter, allowing us the freedom to move around in a fast-changing situation. Wideangle lenses also allow us to work close to subjects while at the same time including lots of sharp background context and detail, so as much information as possible is imparted in a single image. The wide angle of view is dynamic, three-dimensional and immediate, which is important in reportage work.

When you're using lenses like this at low angles, it allows the viewer to feel as though he or she is actually present at the scene. We do sometimes use longer lenses for documentary-style pictures, however. You can't always tell a whole story in a single image – quite often you need a portfolio or short 'essay' in pictures. Longer lenses help create a change of pace in a portfolio and permit you to include a telling detail or close-up in contrast to other images that show the bigger picture.

Don't try to convey multiple messages or ideas in one picture. To get your message across, the main thing is to make sure documentary images are bold and arresting. Avoid clichés if you want to make your mark in this area. Great subjects for documentary pictures don't have be global. You could start locally documenting the wildlife of a precious green space that's up for development. The key is to dig around for your own stories, illustrating them in an original way.

CAPTURING HUMOUR

We rarely set out with the intention of taking humorous pictures but we're always on the lookout for them. This sort of photograph is certainly not high art, but there's no denying the fact that humorous animal images are universally popular and sell well. They're also a way of stimulating a child's imagination and are often used quite widely in this market. If you're looking to make some income from your photography we'd certainly advise keeping an eye out for the style of shots that make it onto the better-quality humorous greetings cards, to get an idea of what's wanted. The top end is the sector of the market that will pay higher returns for your work, and, if you have a flair for this sort of thing, you could try submitting a portfolio of your best shots for consideration to the relevant picture buyers and designers.

You can set up humorous images in a studio, of course, if you have access to 'models' and all the necessary equipment, but unless you do it extremely well it can look a bit cheesy. This is not a route we've explored in our own wildlife photography since we prefer spending our time outdoors in the wild. Our own humorous shots have pretty much all been obtained opportunistically, cropping up during the course of our 'regular' work in the field. It's quite surprising how often funny moments occur when you're out there watching wildlife for long periods. You certainly need a good sense of humour to stay sane some days, given the endless frustrations and waiting around.

In terms of sales returns, we've certainly found it pays to keep alert to humorous opportunities when we're photographing. We also find when we we're giving illustrated

↗ **Giraffe with oxpecker, South Africa**
Canon EOS 5D // 300mm lens with 1.4x converter // 1/200sec at f/6.3 // ISO 100

LITTLE AND LARGE

Giraffes have to be one of the most iconic of Africa's big game animals and offer us lots of scope for saleable shots, many with a quirky touch of humour. Most of the time the comedy comes from their bizarre anatomical construction – in reality quite an amazing piece of evolutionary adaptation – but here the play is one of scale. As soon as the bird landed on the giraffe's neck we were ready, waiting until, sure enough, it climbed higher for the tasty ticks in the giraffe's ears. The giraffe's bemused expression reminds us of the bone-headed pantomime giant when bested by the little guy.

talks that dropping a few funnies in now and again lightens the mood or helps to emphasize certain key points.

So what do we look out for? Visual humour is simple, instant and, it has to be said, basic. The positive here is that all sight gags transcend the language barrier so the potential market for these pictures is pretty wide. For starters, any situation with very young animals is likely to prove a rich seam to mine; they're inexperienced, curious, have a keen mischievous streak and are magnets for trouble, just like any kids.

However hard you try, it's impossible not to anthropomorphize when observing wildlife in the field. Anything anthropomorphic has great potential for instant humour, so we keep an eye out for subjects displaying behaviour that could easily be interpreted as recognizably human as well as gestures and facial expressions that appear to mirror our own. Some animal species too, like penguins and puffins, are intrinsically comical, of course, while other species, like giraffes, are just amusing by design. Juxtapositions, like a very large animal next to an extremely small one, can raise a smile, too. The trick is learning to read a situation and, as ever with wildlife photography, being prepared and ready to act fast, with your camera primed for the unexpected. And when it comes to compositions – the usual rules apply whether it's a straight shot or a humorous one. Clean, uncluttered shots with simple content and saturated colour will help hammer home your punchline.

↗ **Young baboon peeping, Kruger National Park, South Africa**
Canon EOS 5D // 300mm lens // 1/125sec at f/6.3 // ISO 160

Young animals – and primates in particular – provide endless opportunities for anthropomorphic humour. We have found this type of image to be useful, both in terms of sales, and when giving illustrated talks.

→ **Puffin with sandeels, Farne Islands, UK**
Canon EOS-1Ds Mk II // 300mm lens with 1.4x converter // 1/2000sec at f/7.1 // ISO 800

When it comes to photographing humour, some popular species, like puffins, give you a head start because they're intrinsically comical.

05

WILDLIFE PHOTOGRAPHY AND THE DIGITAL DARKROOM

Bewick's swan, Lancashire, UK
Canon EOS-1Ds Mk II // 300mm lens with 1.4x
teleconverter // 1/640sec at f/13 // ISO 320

Wildlife photographs have always been manipulated.
The big difference with digital is that now control over
that manipulation rests with the originating photographer,
rather than some faceless film processing lab. How far
you take manipulation is down to you. For us, the natural
world is quite wonderful enough without us having to
invent our own version, we simply want to produce images
which are honest celebrations of its beauty. But that
doesn't mean we can't use the digital darkroom to
overcome the limitations of even the best camera
equipment, and optimize our images so that they best
reflect our creative vision.

CALIBRATION

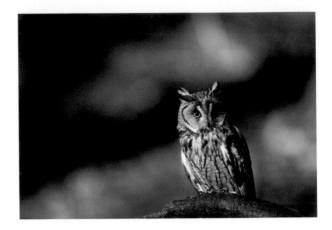

The digital darkroom allows us to enhance our images to best represent what we saw at the moment of capture. It also allows us to manipulate images to create something new. It's not always clear where enhancement stops and manipulation starts, but, regardless of how much image alteration you feel comfortable with, the aim is always to produce a convincing result. Before you even start work on an image, you need to ensure you can produce consistent, realistic colours.

Ideally, your digital darkroom should be a dimly lit room, with neutral wall colours. Direct light from a window or lamp shining on your screen will reduce your ability to discern subtle tones. Brightly coloured walls will affect your perception of colours, as will a garish choice of desktop background on your screen. Try to ensure you work in consistent lighting conditions, day or night. Blackout blinds over windows and subdued 'mood' lighting will help.

A properly calibrated monitor is essential. You can use free calibration tools such as Photoshop's Adobe Gamma, or Apple's Display Calibration Assistant to adjust brightness, black, white and mid-points, colour temperature and gamma, but these rely on judging by eye. Much more reliable is to use a system with a colorimeter or spectrophotometer. These devices attach to the screen and read coloured targets to create a colour profile for your monitor, based on International Color Consortium (ICC) standards.

To correctly interpret images sent to it, your printer also needs an ICC profile. Printers are supplied with generic profiles, but for the best results you can have custom profiles made for your preferred combinations of paper and ink. More expensive calibration systems allow you to use the same spectrophotometer used for calibrating your monitor to also produce profiles for your printer. An online printer profiling service is cheaper; this involves downloading a test image of colour patches, making a print from it, and sending this to the company for analysis and profile production.

A RECIPE FOR SUCCESS

» The range of colours (colour gamut) that is available for your images is defined by a 'working space'. Many digital SLRs offer a choice of sRGB or Adobe RGB (1998). We'd recommend the Adobe RGB (1998) colour space, which has a wide gamut and is widely used by publishers. Select this also in Photoshop (Edit>Color Settings).

» When calibrating your monitor you'll need to choose a colour temperature, which determines the warmth of your whites. 5,000K (D50) or 6,500K (D65) are both popular. We prefer 6,500K, which gives a more pleasing image.

» You also need to choose a gamma value, which affects overall brightness. Standard choices are 2.2 for Windows, 1.8 for Macs, but increasingly 2.2 is used for both.

» Recalibrate your monitor at least monthly, and whenever you change screen resolution. CRT screens should warm up for 30 minutes before calibration. After calibrating your monitor for the first time it may look overly red compared with how it left the factory, but you'll soon get used to it.

←Long-eared owl, captive, UK
Canon EOS-1Ds Mk II // 300mm lens // 1/200sec at f/5.6 // ISO 100

Long-eared owl in autumn – colour has such a key role in our
emotional response to an image, it's vital we can rely on accurate
colour management.

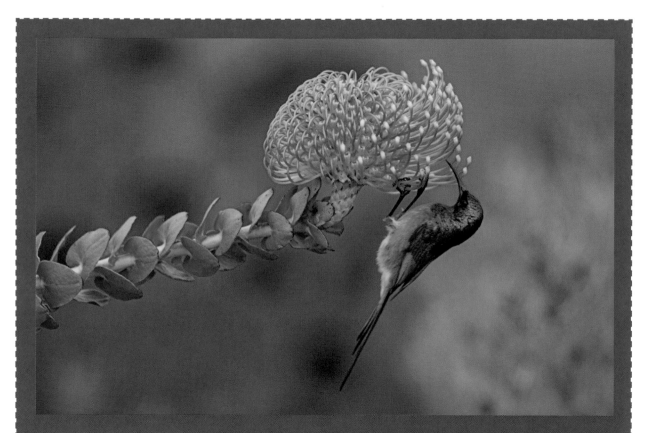

WHY COLOUR MANAGEMENT

From camera to printer, we represent the colour of a pixel by specifying the amount of red, green and blue that makes up the colour – giving it an RGB value. Trouble is, different cameras and scanners produce different RGB values when faced with the same subject, while different monitors and printers produce different colours from the same RGB values. 'Colour management' involves calibrating devices such as monitors and printers so that they work to a known international standard.

'Colour profiles' are produced to characterize the colour characteristics of each device and image, and it's the exchange of these profiles between devices that ensures they all speak the same colour language.

↑ Orange-breasted sunbird, Kirstenbosch National
Botanical Garden, Cape Town, South Africa
Canon EOS-1Ds Mk II // 300mm lens with 1.4x teleconverter
// 1/85sec at f/5.6 // ISO 200

DOWNLOADING

The easiest way to transfer images from your memory card to computer is via a card reader, either built in to your computer, or plugged in to a USB or Firewire port. You can connect your camera directly to your computer using a supplied cable, but this tends to be slow and laborious. Wireless transmitters are also available for transferring digital files remotely from camera to computer, but these are expensive, and can be subject to interference from other wireless devices, so are best kept for specialized shoots, such as when using a remotely controlled camera.

When you insert your card it should appear as a drive on your PC, and you can then drag and drop images to a folder. A number of software applications are available, which will launch automatically when you insert a card and streamline the process. Aperture and Lightroom are the two leading choices, and offer powerful image editing and cataloguing functions, as well as conversion of RAW files.

It's important to copy your images to a secondary back-up before wiping the card. We use an external hard drive, and also don't wipe cards until we next need them. That way, if our computer hard drive fails, we're doubly covered. If you do accidentally delete images on a memory card before copying them, don't despair, software is available to recover them.

← Once your images are on the computer and safely backed up, they need editing. Using a slideshow function is a good way of editing out obvious failures such as out-of-focus images or bad compositions. It's then worth a more careful inspection for sharpness, depth of field, etc. Zoom and compare functions are great for selecting between near identical images. Get into the habit of editing hard, or you'll waste a lot of time processing images that will only ever be mediocre.

SCANNING

If you're still shooting film, or have a back-catalogue of negatives, transparencies or prints, you can still enjoy the benefits of the digital darkroom, by scanning your images into digital form. But, just as with capturing images on a digital camera, it's important to produce the best-quality image you can at the scanning stage, rather than rely on rescuing a poor scan in Photoshop.

If your scan is destined to be used on the web, or output as a small print, there's no need to scan at the maximum available size, which will merely slow everything down and use up unnecessary storage space. But if you are scanning for publication or to archive your images, select the maximum resolution and largest possible bit depth. Select a colour space that matches your Photoshop setting (we recommend Adobe RGB), and save the scan as a TIFF file.

Prescan will give you an image preview, which allows you to choose which part of the image to scan. If you do crop the image at this stage, leave a little spare, to enable you to fine-tune your crop later. Make sure you crop out any film rebate, which can mislead image-processing software when it calculates levels, colour balance and so on.

You can make broad adjustments to contrast and colour at this stage, as this can be less destructive than having to make major corrections in Photoshop later. But be wary of using the dropper tools which most scanner software provides for setting darkest and brightest tones. It's too easy to clip data in the highlights and shadows, and safer to leave these fine adjustments

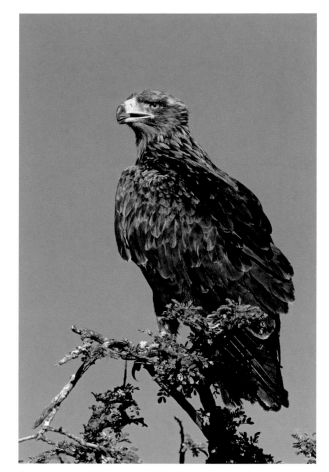

↗ **Tawny eagle, Etosha, Namibia**
Canon EOS-1Ds Mk II // 500mm lens // 1/250sec at f/8 // Fuji Velvia 50

This tawny eagle was originally captured as a dense Velvia 50 slide. It was scanned at a multisample setting of x16 to reduce shadow noise, and saved as a 16-bit TIFF for finishing in Photoshop.

for Photoshop. We'd also suggest turning off noise reduction and sharpening options, as these are better done in Photoshop.

Some scanners allow you to make multiple scans of an image, which are then averaged out. Although slow, this is useful for images with a lot of shadows, as it reduces the amount of speckled 'noise' in these dark areas.

RAW OPTIONS

RAW or JPEG?

If you're serious about squeezing the last drop of quality out of your wildlife photography then you should shoot in RAW, as this gives you maximum creative control. As a result you, not whatever camera you may be using, make the vital decisions about how your final images turn out.

RAW actually refers to a range of proprietary formats used by camera manufacturers (Nikon's Nef, Canon's CR2 and CRw, etc.). A RAW file contains all the information about the amount of light that was captured by the sensor. Extra information about white balance, contrast, saturation, etc., is tagged on, but not applied to the RAW data. If your camera is set to shoot in JPEG format, it's actually shooting in RAW, applying this extra information, and converting the image to a compressed JPEG. Although you can select picture style settings for white balance, sharpening, etc., once these are burned into the JPEG image they are difficult or impossible to change in Photoshop.

A RAW file is like an undeveloped piece of film – you can adjust parameters such as white balance, exposure, colour saturation, contrast and sharpening, and output the result as a TIFF or JPEG file without causing any significant degradation, and you'll always have the RAW file to go back to if you want to tweak something.

Ringed plover with chick, Applecross Peninsula, UK
Canon EOS 5D // 300mm lens with 1.4x teleconverter // 1/640sec at f/6.3 // ISO 100

Appealing images are often the result of fleeting moments, with no time to adjust camera settings.
Shooting in RAW gives us the opportunity to fine-tune these captured moments, without degrading the image.

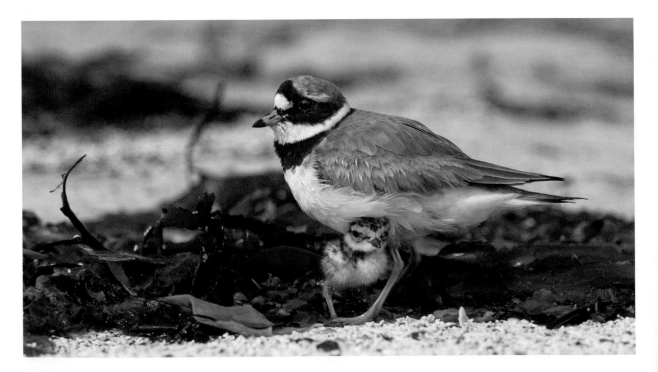

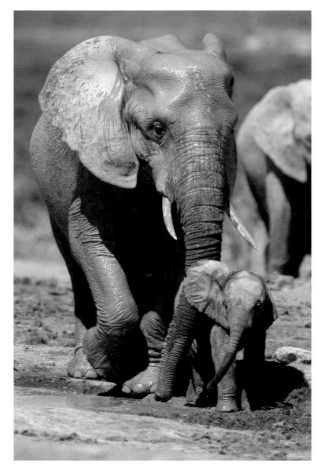

↗ **Mother and baby elephant, Addo, South Africa**
Canon EOS-1Ds Mk II // 500mm lens with 1.4x teleconverter //
1/200sec at f/7.1 // ISO 100

Elephants often come to drink in the unappealing bright sunshine
of midday. With a RAW file it's possible to tone down excessive
contrast and add a touch of warmth for a more pleasing image.

Converting your RAW files

Most of the image adjustments you make in a
RAW converter are carried out by moving sliders.
There's no right or wrong order, but it makes
sense to be methodical and broadly follow the
sequence of adjustments as they appear in the
software interface. For most images the basic
adjustments outlined here are adequate, but as
you get more experienced you can experiment
with more advanced options.

If you want to crop your image in the RAW
converter, rather than in Photoshop, do this first.
That way the histogram you use to guide tonal
adjustments will represent the relevant information,
not parts of the image you will later discard.

Next is white balance adjustment. Your image
will open with the white balance that the camera
selected (we leave our cameras set to auto white
balance AWB) applied to it as a starting point but,
unlike with a JPEG image, you can now adjust this
setting with the temperature slider. Lowering the
temperature slider can improve the blue of water,
warming can enhance sunsets, but don't overdo it
– you can enhance the effect of golden light, but
you can't create it convincingly if it wasn't there
to start with. The tint slider is less useful, but can
be used to alter the balance between greenish
and magenta colour casts.

UNDERSTANDING BIT DEPTH

Bit depth is a measurement of how much information
an image can contain. An 8-bit image has a possible 256
(28) different values for each of the red, green and blue
channels, making a possible 16.7 million colours. Most
DSLRs can capture RAW images in 12 or 14 bit, giving even
more colour information. But JPEGs are limited to 8 bit, so
when your camera converts, say, a 12-bit RAW file into a
JPEG it is reducing the number of tonal values per channel
from 4096 to 256. Shoot in RAW and convert to a 16-bit
TIFF and you retain all the tonal information.

A higher bit depth gives smoother tonal transitions in an
image. A high-quality 8-bit JPEG may look fine, but if you
need to carry out heavy processing in Photoshop its quality
may quickly degrade, producing unwanted artefacts such
as banding and noise. Not all image processing adjustments
can be carried out on 16-bit images, so you may need to
convert to 8 bit for some.

The exposure slider controls the overall brightness of the image. If adjusting this to give a correct overall exposure results in clipping the brightest tones, you can use the recovery slider to recover highlight detail. The blacks slider effectively defines your black point. You can use fill light to lighten shadows if they've lost too much detail, but be sparing, as this can reduce contrast. Use the clippings warning on the histogram, or hold down the Alt/Option key as you move exposure, blacks and recovery sliders, to see exactly where they introduce clipping. Try not to lighten exposure by more than one stop, or you may show up excessive noise.

The brightness slider adjusts the balance of pixels between darker or lighter and is most useful if you've had to make major exposure adjustments. The contrast slider mainly affects the mid-tones. We prefer to adjust contrast using Curves, but not all RAW converters include Curves. Again, watch out for clipping.

Saturation and vibrance tools boost colours, but need to be handled with restraint, as it's easy to overcook your image. Vibrance is more subtle, adding more saturation to the weaker colours and less to those already well saturated.

Noise reduction will reduce luminance noise (variations in brightness within tones) and colour noise (the speckled, coloured pixels that may appear in shadow areas, especially at higher ISOs). Go easy with these tools, as they also reduce overall image sharpness. We prefer to use Neat Image, a plug-in noise reduction tool in Photoshop.

If your image is showing lens-related problems such as chromatic aberration or vignetting, these can be dealt with easily. It's also possible to apply some sharpening.

JPEG ADVANTAGES ✔

- Smaller file size means more images to a card.
- Less likely for camera buffer to lockout when shooting at high frame rates.
- Ready for printing without further processing.
- Recognized by all imaging software.

RAW ADVANTAGES ✔

- Can easily change many parameters with little or no effect on image quality.
- 12- or 14-bit size means more tonal information.
- Ability to tweak exposure reduces need for bracketing in camera.
- RAW files are required for some photo competitions.
- Can be reprocessed if software improves in future.

JPEG DISADVANTAGES ✖

- Settings applied in-camera are difficult or impossible to change on computer.
- Opening and resaving degrades image because of compression.
- 8-bit maximum size means less tonal information.
- Heavy processing leads to image artefacts.

RAW DISADVANTAGES ✖

- Larger file sizes mean fewer images per card.
- Reduced burst rate before camera buffer locks out.
- May need special plug-in to be opened by some image software.

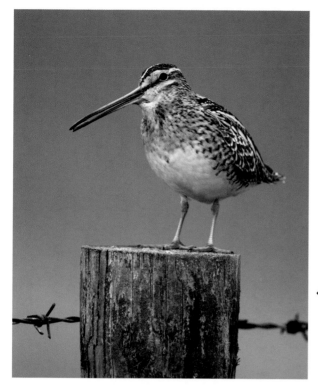

Sharpening is best applied right at the end of all image manipulation and after the image has been sized for its final output, but some photographers find using the RAW sharpening tool at a low setting helps deal with the slight softness that all digital cameras produce, without having any adverse effects later.

Once we're satisfied with our adjustments, we output the processed file as a 16-bit TIFF, for finishing in Photoshop. Only when we've then done any other necessary processing in Photoshop do we convert it to a more manageably sized 8-bit TIFF.

← Snipe, Upper Teesdale, UK
Canon EOS-1Ds Mk II // 500mm lens with 1.4x teleconverter // 1/200sec at f/7.1 // ISO 400

Subtle changes to white balance, contrast, saturation and so on can totally alter the mood of a picture, even a simple portrait such as this snipe. We'd rather have complete control ourselves than trust it to the camera.

SOFTWARE OPTIONS

There's a range of RAW conversion software available, including software supplied with your camera, Adobe Camera RAW which comes with Photoshop, and a number of third-party products, such as Bibble, Capture One and Breezebrowser. Two of the most powerful options are Adobe's Lightroom (our choice) and Apple's Aperture (Mac only), which offer RAW processing plus powerful image-editing and cataloguing tools. In fact, many images can be more than adequately processed and finished in Aperture or Lightroom, without the need for Photoshop.

Intuitive controls and what-you-see-is-what-you-get preview images make working with RAW files as easy as JPEGs. The choice of software really comes down to finding what works best for your personal workflow. If in doubt, try a few trial versions.

LEVELS

A simple way to improve the tonal contrast and brightness in your image is through the Levels adjustment. The Levels histogram displays the number of pixels at different levels of brightness, darker tones to the left, paler to the right. If your histogram doesn't occupy the full spread, then your image isn't making full use of the tonal range available. Simply by dragging in the black point and white point input sliders until they almost touch each end of the histogram, you can expand the tonal range of the image.

What you're doing is setting the darkest pixel to pure black and the lightest to pure white. Drag too far and you'll 'clip' information – so subtle details in the brightest parts of the image will get blown out to pure white, or shadow detail become pure black. To avoid this, hold down the Alt/Option key as you drag, and you will see a visual warning when you start to clip, at which point you can back up a little.

Once you've set the shadow and highlight sliders, use the mid-tone input slider to adjust brightness. Levels are a much more controlled way of adjusting contrast and brightness than Photoshop's simplistic 'brightness and contrast' controls. Most nature images look best if the brightest pixel is set to white and the darkest to black, but use your judgement, as sometimes you may not want so much contrast.

A histogram that butts up against one end indicates clipping, meaning data has been lost in highlights or shadows because of over- or underexposure. Try reprocessing the RAW file, adjusting exposure.

↑ **European roller, Etosha, Namibia**
Canon EOS-1Ds Mk II // 500mm lens with 1.4x teleconverter // 1/160sec at f/13 // ISO 100

The Levels histogram for this bird portrait is unusual, with three distinct tonal peaks. But it has a good range of tones from light to dark and no sign of combing. Just because a histogram doesn't show a classic normal distribution, it doesn't necessarily mean there's anything wrong with the image quality.

↑ Springbok, Etosha, Namibia
Canon EOS-1N // 300mm lens //
1/500sec at f/8 // Fuji Velvia 50

The comb-like, gappy histogram of this
springbok image indicates subtle tonal
transitions have been lost. It's been
caused by over-processing an 8-bit
image, and may result in a poor print,
with 'posterization' (banding). It's better
to shoot in RAW and process in 16 bit.

CURVES

Curves allow you to make similar contrast and brightness adjustments to Levels, but with the ability to target a specific range of tonal levels, such as shadows or highlights. It's a powerful tool and not as daunting as many photographers appear to find it. Just don't get carried away; most images only require slight nudges of the graph.

As with Levels, you can apply Curves at the RAW processing stage if your software allows. But by applying it as an adjustment layer in Photoshop, you can use masks to target specific areas of the image.

The straight-line Curves graph represents the 0–255 tonal scale, with highlights at the top right, shadows at the bottom left, and mid-tones in the middle (this can be reversed in some software). You control the contrast by clicking and dragging parts of the curve. Making a portion of the curve steeper increases its contrast, less steep decreases contrast. If there are specific tonal ranges within your image that you want to adjust, you can click on those tones within your image and the relevant part of the Curves graph will be indicated.

In older versions of Photoshop you need to set black and white points in Levels first, because Curves doesn't have a clipping preview. Since Photoshop CS3 the Levels histogram is superimposed on the Curves graph, and you have the option to adjust black and white point sliders here, with a clipping warning.

You can also use Curves to colour correct your image, by selecting individual Red, Green or Blue colour channels and adjusting them. For example, you can decrease the blue content of shadows to warm them up, without affecting the rest of the image.

↗ **Grey wolf, captive**
Canon EOS-1N // 300mm lens with 1.4x teleconverter // 1/200sec at f/4 // ISO 200

This captive grey wolf was photographed in very low light, producing a flat, low-contrast image. Using Curves allowed us to adjust specific tonal areas, to bring out detail in the fur.

THE SHADOW/HIGHLIGHT TOOL

This is another powerful tool for selectively adjusting tones, using sliders, which some photographers may find more intuitive than Curves. You can bring out details in shadows and highlights, and add a touch of mid-tone contrast to avoid your image becoming muddy.

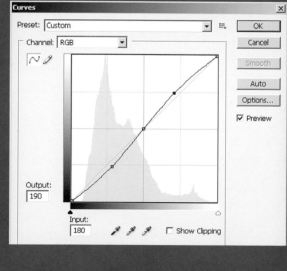

THE S-CURVE

One of the most common Curves adjustments we use in wildlife photography is the S-curve. This boosts contrast in the mid-tones without losing detail in highlights and shadows, and often enhances the appeal of an image. It's simply achieved by dragging down on a point midway between the centre of the graph and the bottom left (black) corner, to darken shadows, then dragging up on a point half way between the centre of the graph and the top right (white) corner to lighten highlights.

↑ **Puffin landing, Farne Islands, UK**
Canon EOS-1Ds Mk II // 300mm lens
// 1/1600sec at f/6.3 // ISO 400

DODGE AND BURN

The old darkroom techniques of dodging and burning – lightening and darkening selected parts of a print – can easily be applied to digital images in Photoshop. Levels and Curves give you a lot of control over brightness and contrast, and by using layers and masks it's possible to extend that control to target specific areas of your image. The latest generation RAW conversion applications also allow you to make localized tonal corrections. But if these methods don't give you all the control you want, there are a number of other methods for dodging and burning you can try.

Our preferred technique for dodging or burning is to use masked layers. For dodging, we create a new Levels adjustment layer, which we name 'Dodge'. We select Screen mode, which lightens the whole image by one stop, then mask this in black (Edit>Fill>Use Black). We then select an appropriately sized soft-edged brush, set to opacity 20 per cent, and paint in white over the area we wish to dodge. We can vary the brush size to cover a larger or smaller area, and the opacity to give more or less exposure adjustment.

To burn, we follow the same procedure, creating another Levels adjustment layer, named 'Burn', but this time select Multiply mode. In both cases, if you make a mistake, simply paint it out by changing brush colour from white to black.

Another simple method is to create a new layer, and select the Soft Light mode. Then use a brush tool at 20 per cent opacity, to paint in white anything you want to dodge, or paint in black to burn. Use a soft-edged brush and build up dodging and burning gradually.

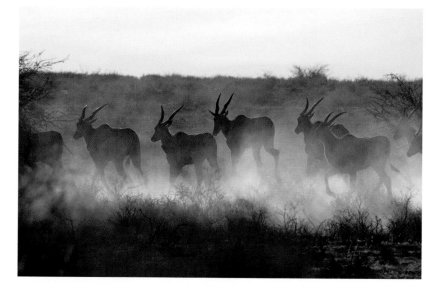

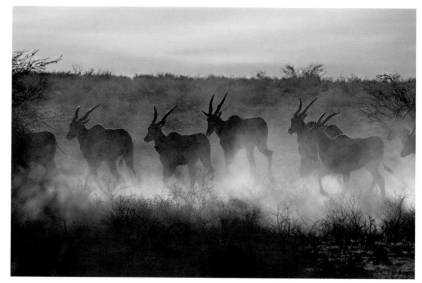

Dodging mistakes

Perversely, the one technique we don't recommend for dodging and burning is to use the dodge and burn tools (nor the sponge, which increases or decreases colour saturation). Even when using a soft-edged brush and a very low exposure setting, it can be very difficult to apply these tools without leaving obvious signs of manipulation. If you insist on using these tools, only apply them to very small areas, such as dodging the catchlight in a bird's eye, and where possible use the option that allows you to burn only shadows, or dodge only highlights.

Another technique we don't recommend is creating a selection using a lasso and then using the brightness slider to lighten or darken. Again, it's difficult to do this without leaving telltale signs around the edges of your selection.

← **Rabbit in thrift, Skomer, Pembrokeshire, UK**
Canon EOS-1N // 500mm lens // 1/125sec at f/8 // Fuji Sensia 100

Careful use of dodging and burning helped bring out the fur detail in this black rabbit, photographed among thrift on Skomer Island.

↑ **Eland, Kgalagadi, South Africa**
Canon EOS-1Ds Mk II // 500mm lens // 1/800sec at f/9 // ISO 250

Achieving a well-balanced exposure when shooting into the light can be very difficult, as with this dawn shot of eland, fleeing a hunting lion. The delicate tonal variation and colours of the sky were lost in the initial RAW conversion, but using the multiply layer technique it was easy to burn in the sky while leaving the rest of the image untouched.

COLOUR ADJUSTMENTS

For wildlife photographers, colour adjustment is generally about reproducing natural colours as accurately as possible. But there's almost never a single 'true' colour in nature, as the quality of light can dramatically alter the colour appearance of an animal, plant or landscape. That's precisely why we often photograph in the golden light of dusk or dawn, because we don't necessarily want our whites to be perfectly white, or our mid-greys completely neutral. So be very careful about using the automated tools available in some software to remove colour casts.

We try to make most colour adjustments during the RAW processing stage, but will sometimes fine-tune colours in Photoshop. Using adjustment layers with masks allows us to apply colour adjustments locally. So, for example, we could slightly reduce the colour saturation of a background, in order to make the main subject stand out more, or enhance a blue sky without affecting the colour balance of the rest of the scene.

With such subtle adjustments to colour we can enhance the mood of an image and the viewer's emotional response to it. Subtlety is the key as it's all too easy to create artificial-looking images, especially by over-saturating colours.

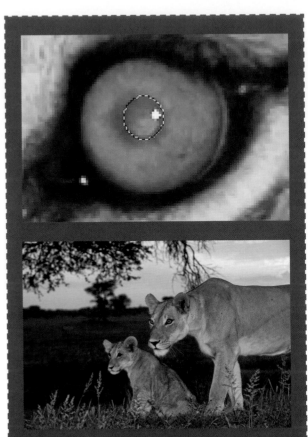

Canon EOS-1Ds Mk II // 70-200mm lens // 1/160sec at f/8 // ISO 400 // flash

EYE SURGERY

» *Use a lasso tool, feathered by one pixel, to select the eye or eyes.*
» *For overall lightening or darkening of eyes and immediately surrounding fur or feathers, create a Levels adjustment layer and drag the middle tone slider.*
» *Red-eye caused by flash can be repaired using special tools in RAW conversion software or the latest versions of Photoshop.*
» *To repair red-eye and other unnatural flash effects manually, lasso the pupil, use the Hue/Saturation tool to desaturate colours, then choose the Selective Colour tool, select 'neutrals' and drag the black slider to the right.*
» *Use the Hue/Saturation tool to boost iris colour.*

COLOUR TOOLS

Colour balance

» Easy to use for global colour changes and quick corrections of colour casts.

» Can be applied to just shadows, highlights or mid-tones.

» Changing one colour changes other colours as well.

Hue/Saturation

» Can alter hue and saturation of specific colours.

» Temporarily dragging saturation slider to extreme right can reveal colour casts.

» But too much saturation looks fake and reduces detail.

Auto Colour

» Quick and easy contrast and colour correction.

» But no control over exact effect.

Levels

» Can adjust individual RGB colour channels.

» Can use threshold tool to avoid colour clipping.

» Can use eyedropper tools to remove colour casts.

» But eyedropper tools can neutralize warmth that you actually want to retain.

Curves

Everything Levels can do plus...

» Allows precise targeting of colour adjustment on specific tones.

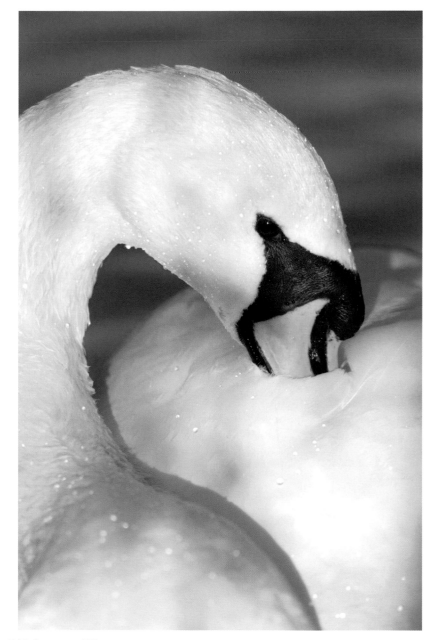

↗ **Mute swan, UK**
Canon EOS-1Ds Mk II // 300mm lens with 1.4x teleconverter // 1/640sec at f/6.3 // ISO 100

Some colour tools, such as Colour Balance, allow you to apply changes just to highlights, shadows or mid-tones. In this example of a mute swan photographed in golden light, we wanted to remove the warmth from the mid-toned water to give a better blue, but retain the sweet light effect on the bird's 'white' plumage.

CONVERTING TO BLACK AND WHITE

Perhaps the most dramatic colour adjustment we can make to a wildlife image is to remove the colour altogether. This can help concentrate the viewer's attention on interesting pattern and texture, or on subtle tonal detail as in a very high-key or low-key image.

Simply converting your RGB files to grayscale usually produces flat images, lacking in contrast. More sophisticated methods allow you to adjust the amount each of the three RGB colour channels contribute to the black and white tonal information. Red, for example, gives more contrast than green or blue.

Photoshop includes a powerful Black and White tool, which can be applied as an adjustment layer, and also allows you to add a tint. Photoshop Elements offers a good Convert to Black and White tool, which allows you to select from a range of styles, and to tweak the individual colour channels and contrast.

An alternative option in Photoshop is to use the Channel Mixer. Select this as an adjustment layer and check the Monochrome checkbox to get a black and white image. You can now adjust the three colour sliders to vary the effect, making sure that the three colour percentages add up to around 100 per cent. The Constant slider allows you to tweak overall brightness.

If your software doesn't offer these options, you can simply use Hue/Saturation, dragging the saturation slider to -100. This usually produces an overly light and flat image, so it's often necessary to dodge and burn (ideally using Levels or Curves adjustment layers) to bring out tonal contrast.

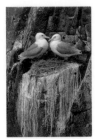

↗ Before

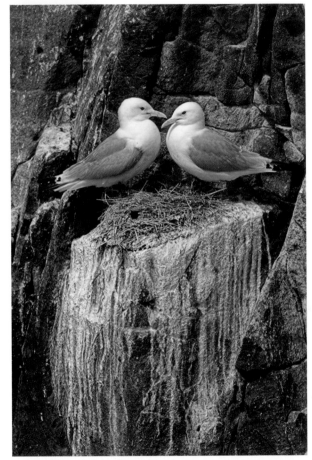

↗ **Kittiwakes, Farne Islands, UK**
Canon EOS-1Ds Mk II // 500mm lens with 1.4x teleconverter // 1/400sec at f/11 // ISO 100

Converting to black and white and increasing contrast in Curves emphasized the interesting textures of the rock and nest in this shot of nesting kittiwakes. By using layer masks we were able to retain the delicate colour of the birds' plumage and the characteristic yellow bills – otherwise the birds might have been overpowered by their surroundings.

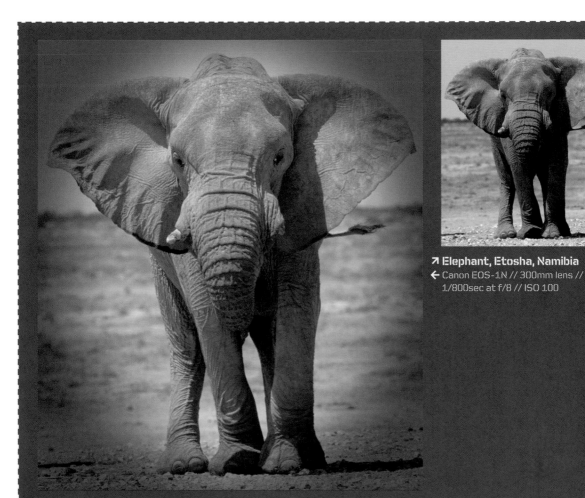

↗ **Elephant, Etosha, Namibia**
← Canon EOS-1N // 300mm lens //
1/800sec at f/8 // ISO 100

SEPIA TONING

*Most image manipulation software and some digital cameras allow you to
produce a sepia effect at the touch of a button, but it's easy to create one
yourself with more control. Simply desaturate your RGB image, use Levels or
Curves to make it a little lighter and reduce contrast, and then Colour Balance
or Variations to increase red and yellow to give you a brown. In this case we
added a vignette effect to emphasize the effect of an antique print.*

CROPPING AND RESIZING

Michelangelo didn't paint all his pictures in a standard 3:2 format, and there's no reason why your own masterpieces need be constrained to the shape of a 35mm frame or an A4 print. Cropping is an aesthetic decision which allows you to use your creative judgement to bring out the full potential of an image. Often a particular image will demand to be a certain shape, but experiment with less frequently used formats such as squares or letterboxes. Bear in mind the principles of composition. Consider which elements of the image you want to focus attention on, where they should be placed within the cropped frame and whether cropping can be used to emphasize patterns such as strong diagonals or curves and so on.

If there are parts of your image you definitely don't want to include, it's worth cropping these out before you carry out RAW conversion, levels adjustment, etc., as you don't want the tonal information in these parts affecting the histograms you use to make tonal judgements. This is certainly the case where the top of your image includes some blown-out sky, for example. It's also necessary if you need to use a straighten tool to correct a crooked horizon.

Otherwise, we'd recommend leaving cropping until after you've done other adjustments, as changes to contrast, colour etc. can make you change your mind about the best crop, and resizing back up will degrade the image. We maintain the maximum image size possible throughout processing, and archive at this size. We then use copies of these master files to resize for specific outputs.

↗ **Giraffe, Etosha, Namibia**
Canon EOS-1N // 300mm lens // 1/400sec at f/5.6 // ISO 100

A narrow vertical crop emphasizes the tall, thin, graceful shape of these silhouetted giraffes.

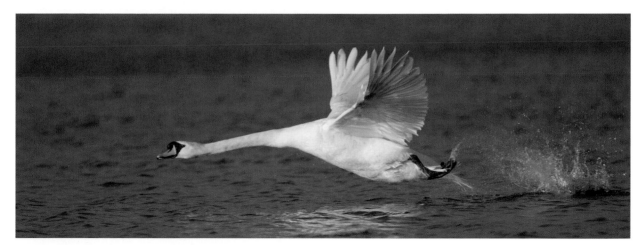

↗ **Mute swan, UK**
Canon EOS-1Ds Mk II // 500mm lens // 1/3200sec at f/5.6
// ISO 400

A narrow 'letterbox' crop complements the fast horizontal motion
of this mute swan taking off.

Interpolation

A digital image has no absolute size or resolution,
just a certain number of pixels in each dimension.
A 6x4in image at 300dpi is exactly the same as a
12x8in image at 150dpi – it's an 1800x1200 image.

If you wanted to print this image at 12x8in,
but with a resolution of 300dpi, you need to
'interpolate' – which basically means asking the
software to invent new pixels. In Photoshop's
Image Size dialogue you must check the Resample
Image box before entering the resolution, height
and width dimensions you require.

Interpolation isn't perfect and does
introduce some image degradation, so it's best
to keep it to a minimum. For upsizing, select
Bicubic Smoother as the re-sampling method.
For downsizing we'd recommend Bicubic (Bicubic
Sharper is designed to maintain sharpening when
downsizing, but we prefer to apply sharpening
ourselves). Check the Constrain Proportions box
so you don't accidentally stretch your image.

RESOLUTION RECOMMENDATIONS

» For monitor or web use it's the actual pixel dimensions
(number of pixels on the long and short sides) of an
image that matter, the pixels per inch (ppi) is irrelevant.

» This is also true for digital projectors. Resize images
to suit the specific projector's resolution (for example
1024x768).

» For inkjet prints aim for a minimum resolution of
240ppi, though you can get away with a little less.

» For supplying magazines, agencies, etc., 300ppi is
standard, but again, it's the actual pixel dimensions
of the image that matter.

SHARPENING

Sharpening won't compensate for poor technique and make a blurry shot sharp, but it will deal with the slight softening that all digital cameras and scanners introduce to an image. Sharpening works by increasing contrast at edges within the picture, adding clarity and definition.

Sharpening should be applied after all other image manipulation and image resizing has been carried out, as it is irreversible and the correct amount depends on the size of the output image. However, sharpening can reveal fine dust and defects, so it may then be necessary to carry out a little cloning, or healing brush work, to remove these. In fact, we archive our master image files with no sharpening, and only apply sharpening to copies of master files when we wish to make prints or publish them on the web. Otherwise we always supply clients with unsharpened images so they sharpen them once they've resized them.

There is a bewildering number of different techniques for sharpening. The Unsharp Mask (USM) is a widely used option. Because sharpening can exaggerate noise, and noise is most evident in the blue channel, it can be worth applying USM in a selective way only to the red and green channels. Alternatively, you can convert your RGB image to LAB mode, select the Lightness channel and apply USM just to that, avoiding the colour channels altogether; then convert back to RGB.

Photoshop CS2 introduced a Smart Sharpen filter, which now offers a more sophisticated choice of how to deal with different types of blur, and allows you to apply sharpening to highlights or shadows individually, so you can reduce sharpening in shadows, where it may exaggerate noise.

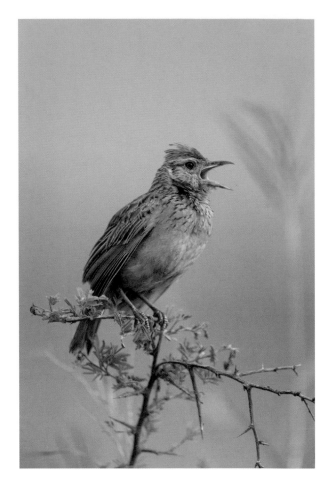

↗ **Rufous-naped lark, Ithala, South Africa**
Canon EOS-1Ds Mk II // 500mm lens with 1.4x teleconverter // 1/250sec at f/5.6 // ISO 400

An image with fine fur or feather detail, such as this rufous-naped lark, may need a little more sharpening than most shots. By applying the sharpening to a duplicate layer it was possible to mask sharpening from the out-of-focus background.

← Over-sharpening produces unwanted haloes and noise.

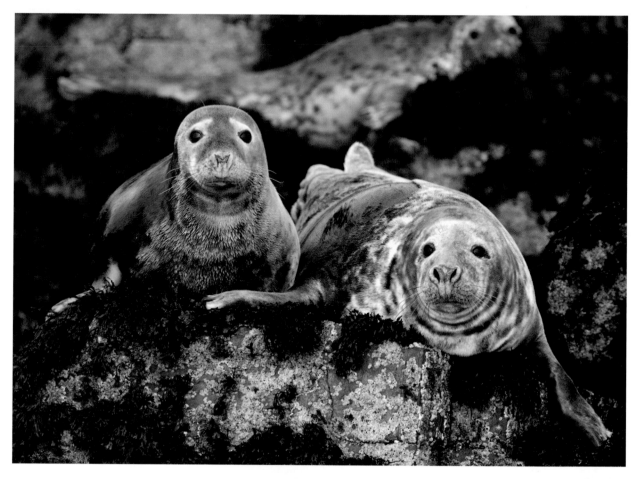

↗ Grey seals, Farne Islands, UK
Canon EOS-1Ds Mk II // 300mm lens //
1/640sec at f/6.3 // ISO 400

The smart sharpen tool is particularly
useful for images with significant dark
tones, such as these grey seals, as it
makes it easy to avoid over-sharpening
these areas and exaggerating noise.

HOW MUCH TO SHARPEN

» Amount controls the intensity of extra contrast. Less than 50 has little effect,
more than 150 can produce artefacts. Web images may need 50–100, prints
150–300.

» Radius controls how many pixels away from an edge will have contrast
increased. One is a good starting point, greater than two risks haloes.

» Threshold determines the difference in contrast between neighbouring pixels
required before sharpening is applied. At 0 everything is sharpened. Below
three watch out for noise appearing.

» Over-sharpening looks unnatural and produces artefacts.

» An image for printing should look slightly over-sharpened on your screen.

» Choose a threshold of 0 to enhance fine detail such as feathers and fur.

» Use layer masking to avoid applying low threshold sharpening to areas of
smooth tone, such as sky or out-of-focus background.

WORKFLOW

A well-designed workflow helps make your image manipulation more efficient, so you spend less time at the computer and more time photographing. It ensures you catalogue your images correctly, so they are easy to find, and back them up carefully, so you don't lose everything if your hard drive crashes.

There's no such thing as a one-size-fits-all workflow. What suits us might not suit you – it depends on your cataloguing and back-up systems, on the software you use, and on personal preferences for which tools and methods you adopt to carry out specific image manipulations. Our workflow is constantly evolving as new versions of software offer improved ways of doing things. And it's flexible – for example, sometimes we will keyword a batch of similar images in Lightroom, often we prefer to do each individually in Photoshop.

We store our digitally corrected master image files as 8-bit TIFFs, along with the original RAW files, on two external hard drives, so if one fails we have a secondary back-up. We also periodically update a third external hard drive, which is stored off-site, in case our office burns down! We also create low-res JPEGs, which we use on our online searchable database. By keywording all our images it's easy for us (and clients) to find what we're looking for fast.

↗ Our workflow includes a step to create low-resolution JPEGs, for use on our online database. The database, searchable by keywords, is useful for clients, but also helps us when we're looking for a selection of images from, say, a particular location.

↗ **Red fox with cubs, captive, UK**
Canon EOS 5D // 300mm lens with 1.4x teleconverter // 1/200 sec at f/5.6 // ISO 200

We use metadata (file info) to record all relevant image information, such as the fact that this fox with cubs was photographed in captivity.

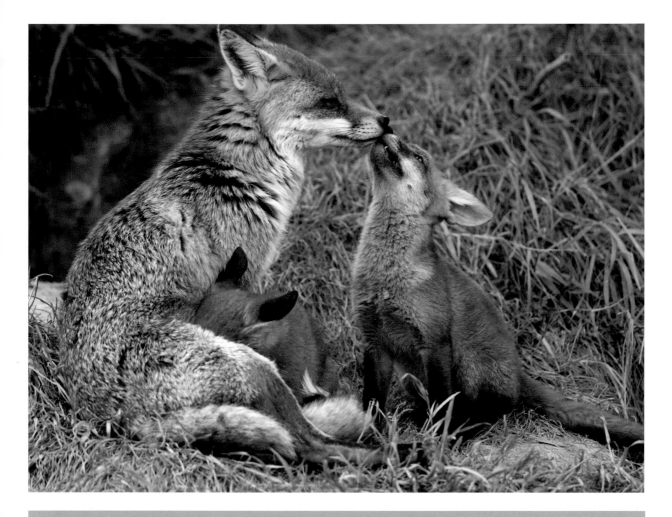

OUR BASIC WORKFLOW

» Copy RAW files from memory card to folder (named 'RAW') on PC. Create temporary backup copy on external hard drive.

» Import RAW files into Lightroom and edit.

» Optimize 'keepers' using white balance, tonal and colour controls in Lightroom.

» Export as 16-bit TIFF files to folder (named 'Conversions').

» Open 16-bit TIFF in Photoshop.

» Clean up using clone and healing brush tools.

» Apply targeted tonal adjustments.

» Apply targeted colour adjustments.

» Apply noise reduction if required (we use Neat Image plug-in).

» Apply metadata (file info including keywords and copyright info).

» Convert to 8 bit and save to folder (named 'Masters'), renaming according to our cataloguing convention.

» Rename corresponding RAW files in Lightroom.

» Copy master TIFF and RAW files to two external hard drives (our archives).

» Use Photoshop Action to create 450x300 pixel JPEGs (quality 7) for our online database.

» Delete temporary back-up copy, reformat memory card, and delete files in 'RAW', 'Conversions' and 'Masters' folders.

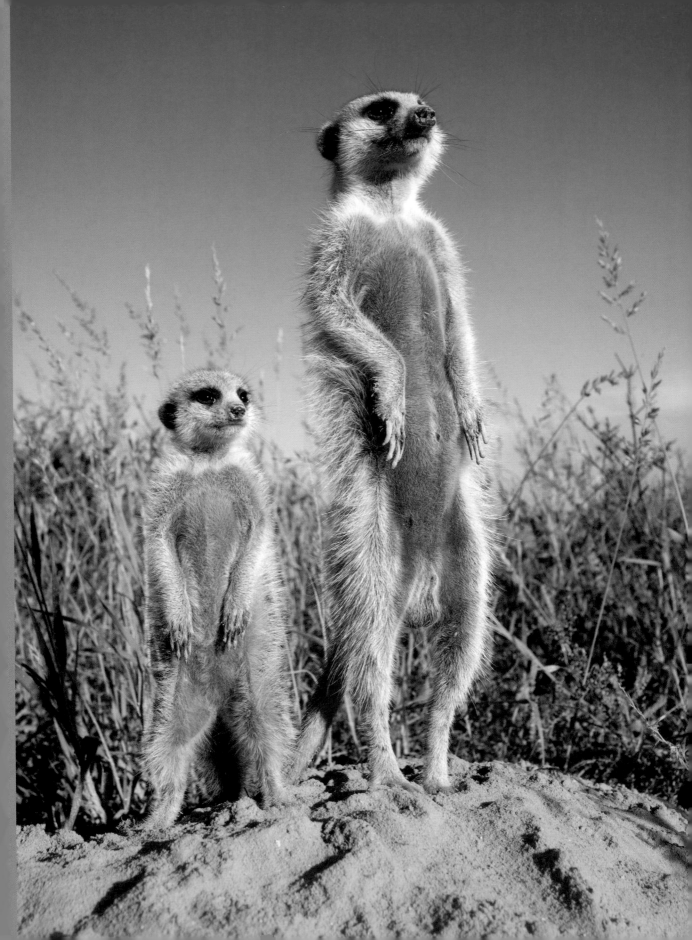

06

THE NEXT STEP

Meerkats, Northern Cape, South Africa
Canon EOS-1Ds Mk II // 28–80mm lens // 1/60sec at f/13 // ISO 125

Success on the business front comes by taking things forward with each piece of work you do. Every job helps build your credentials towards securing the next. We recently visited a meerkat research programme, which gave us a rare opportunity to photograph these animals up close. We were only given special access because we had a magazine commission. But commissions are less common than you might think, as it takes several years to build your reputation and client base.

SELLING YOUR PICTURES

It's always a thrill to get paid for your pictures – and it isn't that difficult in the internet age to make some pocket money from selling your work. If you want to make any serious money, however, or even make wildlife photography your sole source of income, then it gets a whole lot harder. There's no escaping the fact that commercial wildlife photography is a tough field to break into. You need to be doggedly determined.

When we started out we had no real experience and hardly any pictures to speak of, but we were ready for a new direction in life, had belief in ourselves, however naïve, and a real desire to give it our best shot. Perhaps more importantly we also had a fallback position if things didn't work out. We could always pay the mortgage if things went belly-up by returning to full-time freelance journalism. Our advice now to people starting out is to make sure they have a good, secondary source of income even if it's only for the first few years until they're established. Equipment and time in the field is an expensive outlay. It takes several years to build up your pictures and client base to the point where you can start to see any real financial returns.

It's an extremely competitive and crowded marketplace. The one thing that will help you get a head start is to develop a niche or unique selling point in your work that will give you some sort of edge on the competition. In our own case, because of our established backgrounds in journalism, we have been able to specialize by offering clients not just our pictures, but complete packages of pictures with words where required. Whatever it is, find a way to make your images, and your way of working, a little bit different from the rest of the crowd.

Selling your wildlife pictures is as much about successful marketing as it is about having brilliant images in your collection. There's an old saying that money is made in the office and not in the field, and sadly it's true. You may have the best pictures in the world but if you don't get them under people's noses they'll never earn you a bean. On the whole, wildlife photographers are happiest living a fairly reclusive life for long periods out in the field, but if you're going to make reasonable money from your passion, selling yourself and your images is going to comprise a huge chunk of your routine. We spend a frustrating amount of time in the office sending out proposals and contacting prospective clients. It can be a slog. Rejection's never easy to deal with and can seriously dent your confidence – if not your bank balance. When you're successful, on the other hand, it's extremely satisfying, as well as rewarding to know that people out there really like your work.

↗ **Baby elephants at waterhole, South Africa**
Canon EOS-1Ds Mk II // 500mm lens with 1.4x converter // 1/800sec at f/7.1 // ISO 200

Popular and iconic subjects like elephants sell over and over, but you need to find a way to make your pictures stand out from the crowd by photographing common subjects in a fresh and eyecatching way.

→ **Robin on boot, UK**
Canon EOS-1N // 300mm lens // 1/80sec at f/6.3 // Fuji Velvia 50

Photograph for the market. This is a simple, set-up shot – we took a frosty old boot we'd found to a local reserve in winter where the robins were quite tame. It's a simple idea, but has sold regularly for Christmas cards.

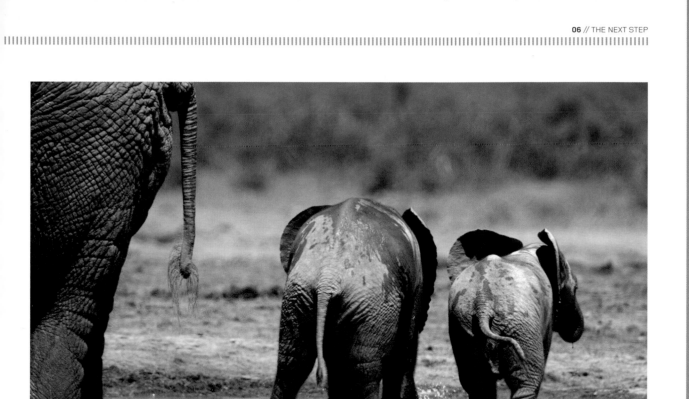

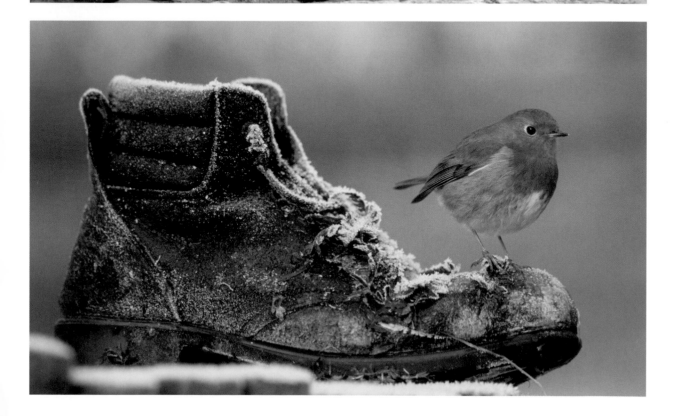

THE STOCK MARKET

Sales from stock libraries make up a good, and growing, portion of our earnings, but we could never afford to sit back and simply wait for our quarterly sales returns in order to survive.

If you're thinking of selling work through a picture library bear in mind agencies will want their cut of each sale, which can be as high as 60 per cent, and that you'll need to have a few hundred pictures lodged with an agency before you start to see even a small regular return.

Placing your work with a good stock agency, however, will definitely help your pictures reach audiences and clients around the world they wouldn't otherwise be able to reach – plus you won't have the additional hassle of any admin.

If you're planning to submit your pictures to an agency we'd advise you to research the market carefully, first assessing whether the content of your work and its photographic style is best suited to a specialist natural history photo library or a generalist. For example, if you take lots of detailed images of rare insects your work will obviously sell better through a specialist nature agency, whereas a collection of humorous images of popular species will probably bring greater rewards if placed with a large, general agency. The ideal would be to place your work with a number of agencies across the spectrum. Most agencies will understandably want exclusivity from the images you place with them, but don't get tied up with contracts that could make selling your work elsewhere more difficult.

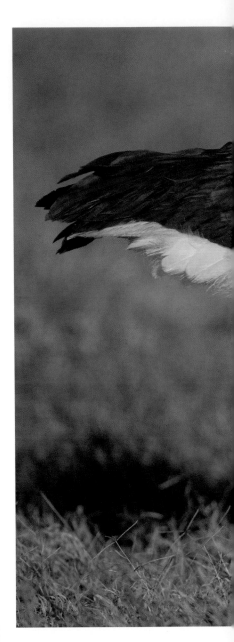

PRO TIP

We took the decision to get with a highly regarded specialist agency as soon as we could when we first started out. Although it took time to see real financial gain it really helped give the clients we marketed to directly more confidence in our work because they knew and trusted the picture library 'brand' name even where our own names were new to them.

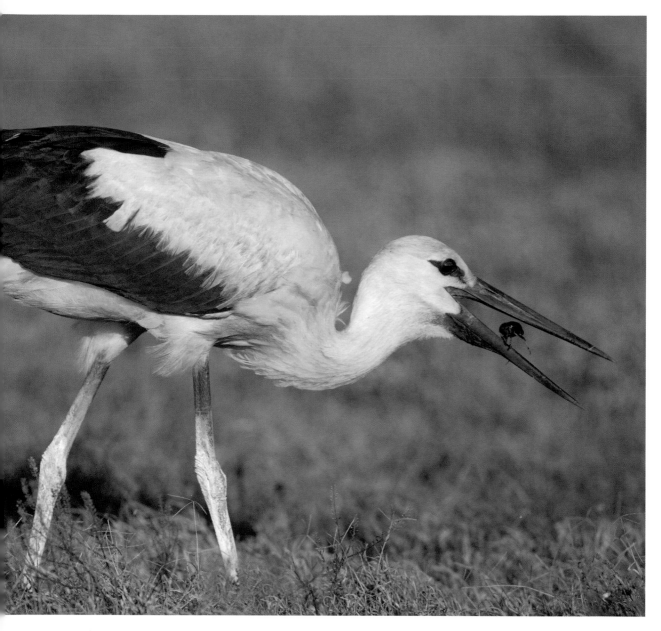

↑ **White stork eating beetle, Eastern Cape, South Africa**
Canon EOS-1Ds Mk II // 500mm lens // 1/2000sec at f/5.6 // ISO 200

If you want to place your pictures with a specialist stock agency, aim to document as much animal behaviour in your images as you can. Most natural history photo libraries already have strong portrait coverage of all but the rarest species. We were photographing elephants one afternoon, but stopped immediately when we noticed a flock of white storks had just flown in to feast on the beetles that were around in some numbers in this part of the reserve. Behaviour like this can be fleeting so you need to respond quickly to changing opportunities when out in the field.

SELLING YOUR PICTURES YOURSELF

There are strong incentives in selling your pictures yourself since you get to keep 100 per cent of the fee, and you're developing direct contact with clients that could provide repeat business. The downside is there's a lot more donkeywork involved and you need to be immune to people saying no or shutting doors in your face a lot of the time.

Whether you're aiming for the magazine, book, card or calendar market (or a mix of all four), you can find marketing leads quite easily these days simply by scouring the internet. In the UK, *The Freelance Photographer's Market Handbook* – which is updated each year – can be a very helpful starting point on companies to approach, but it's by no means exhaustive. You can also keep up with trends in the marketplace and receive sales leads if you become a member of the Bureau of Freelance Photographers (**www.thebfp.com**). We often find our own leads by attending relevant trade fairs or quite simply making a habit of checking out who produces any quality cards, calendars or wildlife books that catch our eye in the shops.

Unless you've got comprehensive coverage in a subject, books can be the hardest sector to target successfully and don't always pay well. The card and calendar market can be tough to break into, too, but clients are quite loyal when they like your work so it's well worth the initial effort long term. The trick to selling into calendars is hitting picture buyers with your submission just as they're seriously looking to buy and providing a professional service. Contact companies first to check what they require and when — you'll need details of the sort of species they're looking for, the formats they use (it's no good

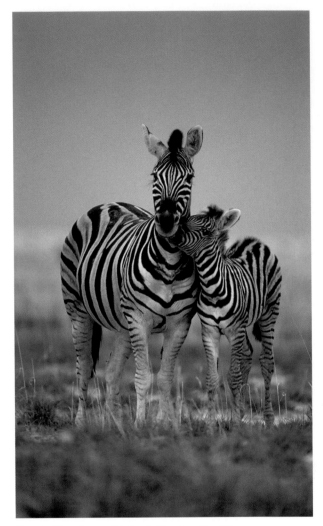

↗ **Burchell's zebra with foal, Etosha, Namibia**
Canon EOS-1N // 500mm lens // 1/160sec at f/7.1 // Fuji Velvia 50

Popular animals photographed with their young are strong sellers in the card and calendar market, but the images must be well executed and colourful, with clean or attractive backgrounds and immediate visual appeal or charm.

PRO TIP

If you want to earn a living from your pictures do your best in every job and turn individual and one-off customers into repeat and regular clients.

THINK LIKE A PICTURE EDITOR

We frame a lot of pictures with magazine editorial in mind as a possible end-use, not only because we provide clients directly with packages of pictures and words ourselves, but because we know magazine picture editors are looking for certain types of images when sourcing pictures from photo libraries or our online database. For starters, it helps to compose wildlife pictures that could be used as double-page spreads – leaving lots of space around subjects and with clean background areas so there's space for the designer to run a headline and even some small areas of text.

↑ **Young brown hare, UK**
Canon EOS-1Ds Mk II // 500mm lens with 1.4x converter // 1/200sec at f/5.6 // ISO 320

sending great uprights if all they use is landscapes) and how they like to view initial submissions. If possible look at samples of their work beforehand so you know the style of picture they like and tailor your submissions to suit their tastes, not your own.

There are two ways of selling into the magazine market and we use both in our own business. The first is to provide magazine editors with a complete package of pictures and words. This can involve a lot of work if you're not confident or experienced in the writing side, but it's reasonably rewarding if you become a regular contributor to a number of titles, and is attractive to clients because it's simpler and more economical to source material this way. The trick is being able to supply material that's perfectly targeted to

the particular readership of each title. You certainly need to familiarize yourself completely with a title before making your pitch to the editor.

The second approach is to market your images directly to the magazine's picture editor or picture researcher – the person responsible for sourcing the photographs for each issue. If you aim to sell your pictures regularly to some of the thousands of magazines out there, bear in mind that most rely heavily on seasonal material – snow-scenes in winter, bluebells and bunnies in spring etc. Topical issues will always be top of their agenda, too. The catch here is that magazines work well ahead (for a monthly the average is about three months in advance of publication) so you need to market your seasonal and topical photographs with this long lead-in time in mind.

DEVELOPING YOUR BUSINESS

It's boring but you need to be obsessively organized. The first step towards developing a successful wildlife photography business is to have efficient office and computer systems for everything you do, and brilliant back-up and storage for the crown jewels – your pictures.

Keep on top of things – that includes your pictures as well as the paperwork. Aim to edit, process, keyword, code, file and archive pictures as soon as possible after capture. Pictures are your priority and should be ready for the market as soon as possible.

A fast-loading website that's simple to navigate, and which instantly summarizes your work and where you've been published for a busy picture editor, is your shop-window on the world. A website is a much better investment and marketing tool than promotional literature, like calendars and cards, since these soon date and get dog-eared. Including a quick link to our website in an initial email is an amazingly fast, efficient way to introduce and promote our work, both for a prospective client and us.

We deliberately went for a businesslike website (www.toonphoto.com) rather than a really beautiful one, because we wanted it to work hard for us. The aim was to target it mainly at commercial clients and picture editors rather than fellow photo enthusiasts. Early on we took the decision to invest in the addition of an online, searchable database of our pictures. This paid its way in terms of sales generated in a matter of weeks. Without going over the top, try to include something on your website that gives some insight into your own personality. Many photography websites look great, but seem to lack a true sense of the author's identity.

Technology's wonderful, but it doesn't do face-to-face that well yet and we've had clients say they've come to us because they got a good sense of what we'd be like to work with.

OUR TOP BUSINESS TIPS

» Don't undersell your pictures or your time – if you do you may make a sale today, but you'll make things harder for yourself and fellow photographers tomorrow.

» Keep your sales pitches and proposals short.

» Include low-res JPEGs, rather than hi-res TIFFs, when putting together small, sample selections of pictures for submissions on spec. Include an index print for easy reference when sending images out on CD or DVD.

» Adhere strictly to deadlines, stick tightly to your brief and submit work that's well presented and clearly labelled. Label everything with your email address or name and telephone number in case things get lost.

» Chase up outstanding proposals and payments routinely.

» Never sell your copyright in an image outright. Your aim is to make as many sales as possible from an image over your lifetime. Instead sell only clearly specified, and mutually agreed, rights as to how and where that image can be used. For example, an international greetings card company may request exclusive world rights for five years, a British calendar company, on the other hand, may only require exclusive UK calendar rights for one year. Negotiate your fees accordingly.

↗ **Buzzard in flight, captive, UK**
Canon EOS-1Ds Mk II // 300mm lens // 1/2000sec at f/6.3 // ISO 200

In addition to selling pictures and picture/text packages we also run photographic workshops – as do many wildlife photographers these days. It can be beneficial to develop your business in this way for a range of different reasons. Not only does it help to ensure you don't become reliant on just one area of your business performing well in order to make ends meet, but it also helps raise your profile.

→ **Gemsbok sparring, Kalahari, South Africa**
Canon EOS-1N // 400mm lens // 1/180sec at f/8 // Fuji Velvia 50

Be clear what you want to get out of a photographic career. For us it's always been about having the freedom and flexibility to return to our favourite places, as well as visit new ones, in order to improve our photography and enjoy yet more incredible encounters with our subjects.

GLOSSARY

Angle of view
The amount of a scene included in an image, determined by the focal length of the lens. A wideangle lens includes more than a standard or telephoto lens.

Aperture
The opening in a camera lens through which light passes to expose the sensor or film.

Aperture priority
Automatic metering mode in which the photographer sets the aperture size, and the camera sets a corresponding shutter speed to give a balanced exposure.

Artefact
A flaw in a digital image.

Aspect ratio
The ratio of width to height in an image.

Available light
Natural light, without flash.

Backlighting
A situation where the main source of light is behind the subject being photographed, often producing a halo and/or silhouette.

Bit depth
A measure of the number of bits (units of computer data) used to create the colour of a single pixel in a digital image. A 24-bit (or 8 bits per colour) RGB image has a palette of 16.7 million colours.

Bracketing
Taking a series of identical pictures, changing only the exposure, usually in third or half f-stop increments, to ensure that one will be correct.

Buffer
In-camera memory that stores images temporarily before they are written to a removable memory card.

Bulb (B) setting
Shutter setting in which the shutter stays open for as long as the release button is depressed. Used for long exposures.

Burst size
The maximum number of frames that a digital camera can shoot in quick succession before its buffer becomes full.

Cable release
A device used to trigger the shutter of a tripod-mounted camera at a distance to avoid camera shake.

Calibration
The process of matching a device's colour characteristics to an accepted standard.

Catchlight
A small highlight in the eye of an animal.

Centreweighted
Camera metering system which emphasises the light reading taken from the central part of the viewfinder image.

Chromatic aberration
An image defect showing as coloured fringes, caused by the dispersion of white light passing through a lens.

CMYK
A mode for describing colours based on a mixture of Cyan, Magenta, Yellow and Black (called the Key colour), used in the printing industry.

Colour cast
A colour tint (usually unwanted) that evenly covers an image.

Colour management

The control of all devices from image capture to reproduction, to ensure final results are reliable and repeatable.

Colour profile

Colour space information embedded into a digital image file, used by the colour management system to ensure consistent colours.

Colour space

Describes the mode used to represent colours, such as RGB, CMYK or LAB.

Colour temperature

The colour of a light source expressed in degrees Kelvin (K).

CompactFlash

A digital storage memory card.

Compression

The process by which digital files are reduced in size. Can be lossless, preserving image quality, or lossy, resulting in decreased image quality.

Contrast

The difference between the highlight and shadow areas of an image.

Depth of field (DOF)

The zone of acceptably sharp focus immediately in front of and behind the plane of exact focus. Increased by using a smaller aperture.

Digital ICE

Digital Image Correction and Enhancement, a system to automatically remove defects, such as dust and scratches, when scanning images.

Digital negative

A digital image file such as Adobe 'dng' which requires processing before use, similar to a RAW file, but in an open format that does not need brand-specific software.

DPI (dots per inch)

Measure of the resolution of a printer or a scanner.

DSLR
(digital single lens reflex)

A digital camera that allows the user to view the scene through the lens, using a reflex mirror.

Dynamic range

The ability of the camera sensor or film to capture a full range of shadows and highlights.

EXIF (Exchange Image File Format) data

Information on camera settings and exposure stored with a digital image file.

Exposure

The amount of light falling on the sensor or film, controlled by a combination of aperture, shutter speed and ISO.

Exposure compensation

An adjustment of exposure to override the values suggested by the camera's meter, used when photographing very light or very dark subjects, which can mislead the meter.

F-stop

A measure of lens aperture as a proportion of lens focal length. A large f-number means a small aperture, a small f-number a large aperture.

Fill-in flash

Flash balanced with available light to fill shadow areas or add highlights to dark eyes.

Film speed

Relative sensitivity of film to light, expressed as an ISO rating.

Filter

Transparent or translucent glass, plastic or gelatin placed in front of the lens (or in a slot in the barrel of long telephoto lenses) to alter the colour or amount of light passing through.

Flare

Bright patches or spots formed by strong light reflections within a lens pointed at the sun or a bright light source.

Focal length

The distance, usually in millimetres, from the optical centre point of a lens element to its focal point.

Grayscale

A digital image with no colour information, only shades of neutral grey.

Histogram

A graph used to represent the distribution of tones in an image.

ICC profile

A profile describing the colour characteristics of a particular piece of hardware, such as a monitor, based on International Colour Consortium standards.

Interpolation

A software process to increase an image's pixel dimensions by creating new pixels based on the colour of existing nearby pixels.

ISO

Film speed rating based on standards set by the International Organization for Standardization. The higher the ISO number, the faster the film, enabling it to produce a correct exposure with less light or a shorter exposure.

JPEG (Joint Photographic Experts Group)

A digital image format that compresses the file, with consequent loss of quality.

LCD (liquid crystal display)

The flat screen on a digital camera that allows the user to preview digital images.

Macro

A term used to describe close-up photography and the close-focusing ability of a lens.

Matrix metering

Camera metering system that interprets light readings taken from multiple segments of the viewfinder image in order to establish a correct exposure. Also known as evaluative metering.

Megapixel

One million pixels, the standard unit used to describe the resolution of digital camera sensors.

Memory card

A removable storage device for digital cameras.

Noise

Coloured interference on digital images caused by unwanted electrical signals.

Non-destructive

Software image alteration processes that do not damage the original image data.

Panning

Moving a camera horizontally to keep a moving subject in the viewfinder and blur the background.

Pixel

'Picture element', the smallest unit of information used to produce a digital image.

Plug-in

A software 'add-on' that can be used by Photoshop, or other image editing programs to carry out additional functions, such as RAW file import and conversion, sharpening, noise reduction, or creative effects.

RAW

An unprocessed digital file direct from the camera.

Red-eye

Unnatural colouring of an animal's eyes, caused by reflection of light from a flashgun.

Resample

To change the resolution of an image through interpolation, either by resampling down, to discard information and create a smaller file, or resampling upwards, to invent new pixels based on existing neighbouring pixels, and thereby increase file size.

Resolution

The number of pixels used to capture an image or display it, usually expressed in PPI (pixels per inch).

RGB

A common mode for representing colour images, in which each pixel is described by a mixture of Red, Green and Blue.

Rule of thirds

A compositional device that places the key elements of a picture at points along imagined lines that divide the frame into thirds.

Shutter

This mechanism controls the amount of light reaching the film or sensor by opening and closing when the shutter release is fired.

Shutter priority

Automatic metering mode in which the photographer sets the shutter speed, and the camera sets a corresponding aperture to give a balanced exposure.

SLR (single lens reflex)

A type of camera that allows the user to view the scene through the lens, using a reflex mirror.

Spotmetering

A metering system that measures the light needed to correctly expose an image based on a very small part of the scene.

Stop down

To close down the lens to a smaller aperture, hence increasing depth of field.

Telephoto lens

A lens with a large focal length and a narrow angle of view.

TIFF (Tagged Image File Format)

A widely supported lossless file format for storing digital images without compression.

TTL metering

Exposure metering based on measuring the actual amount of light passing through the lens, as used in most SLR cameras.

White balance

A function that compensates for the different colour temperatures produced by different types of light.

Wideangle lens

A lens with a short focal length and wide field of view.

FURTHER READING

Among the many photographers that continue to inspire us and fire our imagination is Canadian photographer **Freeman Patterson**, who has a wonderful eye for picture design, subtle detail, abstracts, artistic composition and colour. Although not strictly a wildlife photographer, many of his images are drawn from nature. The work provides a fresh and compelling take on the world as seen by the individual photographer and his books are full of refreshingly non-technical advice on developing a creative eye. Try *Photographing the World Around You* by **Freeman Patterson** (Key Porter, 2nd Edition, 2004) for starters.

Everyone has their own taste in wildlife imagery, ranging from the traditional to the avant garde. For an introductory sample of the latest in top-class images, the annual *Wildlife Photographer of the Year Portfolios* (BBC Books) include the cream of the competition entries.

Frans Lanting has firmly established himself at the peak of the profession, for good reason, and his first published portfolio, *Eye to Eye* (Taschen, 2003), remains an outstanding collection of animal portraits, mostly at close range. *Frans Lanting: Jungles* (Taschen, 2005) and *Life: A Journey through Time* (Taschen, 2006), both edited by **Christine Eckstrom**, are equally compelling.

Mitsuaki Iwago's images of animals from all corners of the planet are original, intimate and often show an exhilarating disregard for the 'rules' of successful photography. So-called 'bad light' never discourages Iwago, and the resulting images say as much about the wild habitats as the wildlife itself. *Wildlife* (Chronicle, 1998) is a good Iwago primer.

Among many excellent South African photographers, **Richard du Toit** deserves special mention for his consistently excellent work, documenting wildlife behaviour in our favourite part of the world. *African Wildlife Themes* (Struik, 2001) is a good introduction to his work.

If 'know thy subject' is one of the basic commandments for successful wildlife photography, then good field guides and natural history texts are essential reading. Two specialist suppliers worth trying are Subbuteo Natural History Books (www.wildlifebooks.com) and NHBS Environment Bookstore (www.nhbs.com) – if they don't have it, it probably doesn't exist!

If you're simply looking for ideas of what to photograph this month, then *Nature's Calendar* by **Chris Packham** (HarperCollins, 2007) should get you started, with details of top UK wildlife sites featured in the BBC series of the same name. For details of more nature reserves close to your home, visit the websites of organizations such as the RSPB (www.RSPB.org.uk), wildlife trusts (www.wildlifetrusts.org), Natural England (www.naturalengland.org.uk), Scottish Natural Heritage (www.snh.org.uk), the Countryside Council for Wales (www.ccw.gov.uk), the Northern Ireland Environment Agency (www.ni-environment.gov.uk), the Wildfowl and Wetlands Trust (www.wwt.org.uk) and the Woodland Trust (www.woodland-trust.org.uk).

There are countless 'how to' guides to getting the most out of the likes of Photoshop and Lightroom, some more readable than others, so have a browse to find those that suit you. **Scott Kelby**'s books, such as *The Photoshop CS4 Book for Digital Photographers* (New Riders, 2008), are easy reading and full of useful 'recipes' to achieve a range of image corrections and manipulations, though some may find his light, jokey tone a little irritating. For more comprehensive, but rather drier, coverage of Photoshop, **Martin Evening's** *Adobe Photoshop CS4 for Photographers* (Elsevier, 2008) is hard to beat. If you want to concentrate on the Photoshop functions that are most useful for wildlife photographers, then *Photoshop CS3 for Nature Photographers* by **Ellen Anon** and **Tim Grey** (Wiley Publishing, 2007) is highly recommended.

WILDLIFE ORGANIZATIONS

For licences to photogaph protected species in the UK, contact the following organisations:

Natural England, Wildlife Management and Licensing Service
Tel 0845 601 4523,
or email wildlife@naturalengland.co.uk
(www.naturalengland.org.uk – navigate to the wildlife and licensing service section by clicking on 'Conservation' on the homepage)

Countryside Council for Wales, Habitats and Species Team
Tel 0845 130 6229
(www.ccw.gov.uk navigate to the section on Species Protection by clicking on 'Landscape and Wildlife' on the homepage)

Scottish Natural Heritage
Tel 01463 725000
(www.snh.org.uk – navigate to the section on licensing by clicking on 'Our Work' on the homepage)

Northern Ireland Environment Agency, Biodiversity Unit
Tel 028 9056 9605
(www.ni-environment.gov.uk - download licensing application forms at www.ni-environment.gov.uk/ biodiversity/sap_uk/wildlife.htm)

If you intend to photograph in US national parks or National Wildlife Refuges with a view to selling your images, you theoretically may need a permit, assuming you admit to being a pro! For more details visit:

US National Parks Service
Tel 202 513 7092
www.nps.gov

National Wildlife Refuge System
Tel 703 358 2365
www.fws.gov/refuges

For permits to photograph commercially in Canadian parks, visit:
Parks Canada
www.pc.gc.ca

For advice on wildlife photography in Europe, try the following national sites:

Austria: www.vtnoe.at
Belgium: www.bvnf.be
Denmark: www.nfd.dk
Finland: www.luontokuva.org
France: www.ascpf.com
Germany: www.gdtfoto.de
Hungary: www.fotonatura.hu
Hungary: www.naturart.hu
Netherlands: www.nvnfoto.nl
Norway: www.norskenaturfotografer.com
Poland: www.zpfp.pl
Slovakia: www.wildlifephoto.sk
Spain: www.aefona.org
Sweden: www.naturfotograferna.se
Switzerland: www.aspn.info
Switzerland: www.naturfotografen.ch

↘

ABOUT THE AUTHORS

Steve and Ann Toon are an award-winning husband and wife team of freelance wildlife photographers living in the Northumberland National Park in the UK. Both are experienced former journalists and magazine editors. The couple has been working together as professional nature photographers for some ten years now, specializing in the wildlife of southern Africa as well as subjects nearer to home. They spend several months a year photographing in Africa, which is fast becoming something of a second home for the couple, and are particularly interested in using their journalistic background to document and highlight conservation stories.

Their articles and images have been published extensively, both in the UK and overseas, and the couple is currently represented by four photographic agencies in addition to marketing their work directly via their own searchable online database at www.toonphoto.com. To date, Ann and Steve have had two books published in addition to this one, including the photographic title, *Wildlife Photography Workshops*, by GMC Publications, and the natural history title *Rhinos*. Their second natural history title, *Giraffes*, is due for publication this year (2009).

Ann and Steve run photographic workshops in the north of England and are visiting lecturers on the Wildlife Photography BA (Hons) degree course at Blackpool and the Fylde College. Their number one wildlife photography destination remains the Kalahari – and this is where the couple first decided to give up their nine-to-five jobs and pursue nature photography as a full-time career – but they are happy photographing anywhere in the great outdoors away from their office, whether that means the African bush or their own backyard.

INDEX

Photographs are indicated by page numbers in **bold**.

To request a full catalogue of Photographers' Institute Press titles, please contact:

Photographers' Institute Press, Castle Place, 166 High Street,
Lewes, East Sussex BN7 1XU, United Kingdom
Tel: 01273 488005 Fax: 01273 402866